THE
STUDIO PHOTOGRAPHER'S LIGHTING BIBLE

RotoVision

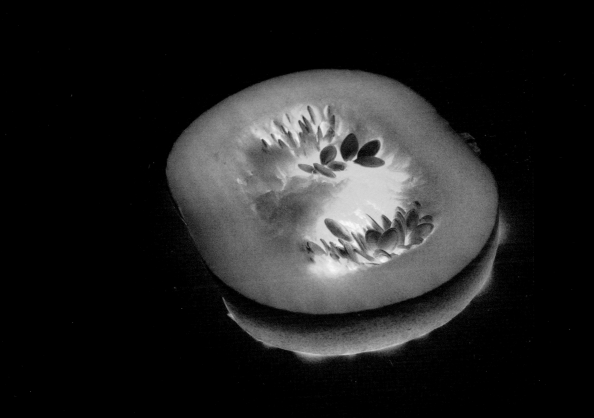

A RotoVision Book

Published and distributed by RotoVision SA
Route Suisse 9
CH-1295 Mies
Switzerland

RotoVision SA
Sales and Editorial Office
Sheridan House, 114 Western Road
Hove, BN3 1DD, UK

Tel: +44 (0)1273 72 72 68
Fax: +44 (0)1273 72 72 69
www.rotovision.com

10 9 8 7 6 5 4 3 2 1

ISBN: 978-2-940378-23-4

Art Director: Tony Seddon
Photography: Calvey Taylor-Haw

Reprographics in Singapore by ProVision Pte. Ltd.
Tel: +65 6334 7720
Fax: +65 6334 7721

Printed in Singapore by Star Standard (Pte) Ltd.

Using this book
The case studies and lighting diagrams in this book illustrate
general concepts and techniques rather than specific setups.
It is not intended that they be followed precisely. Lights and
softboxes may be positioned on the opposite side from that
shown to the same effect.

Unless otherwise noted, all the lens, f/stop, and shutter-
speed specifications are accurate for a full-frame, 35mm
SLR camera.

THE
STUDIO PHOTOGRAPHER'S LIGHTING BIBLE

Calvey Taylor-Haw

CONTENTS

BEST PRACTICE & RESOURCES

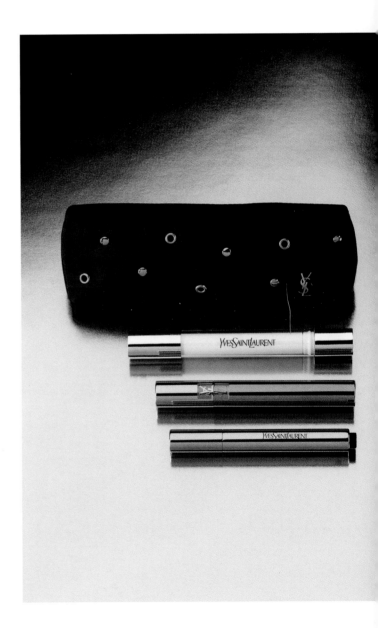

I began my photographic career in 1976, a time when the advertising scene was young, creative, and breaking new ground. The fees were high. Opportunities for photographers were plentiful, and the glamor was irresistible. I have probably spent half my time since then ensconced within four white walls, a gray floor, and a white ceiling; an area with no windows, low light levels, and little contact with the outside world. "Are you a convict?" you might ask. No (although many an art director would argue that I rob their budget with my fees). I am a Studio Photographer! To provide some insight into the life of that strange breed, two definitions. *Studio*: The workroom of a painter or photographer. *Studious*: Assiduous in study, painstaking; paying careful and deliberate attention to detail.

I do not intend this book to be a dull manual that sends the reader off into a deep sleep, but rather, an in-depth, informative, and fun exploration of the lighting techniques used by many of the world's leading studio photographers. It will not only explore the basic lighting techniques for shooting many different subjects in the studio, from ice cream and perfume bottles through to the human form, but also give in-depth tips for shortcuts to help you anticipate problems before they happen.

This book will take a look at the various kinds of lighting available today: the different types of continuous lighting, the vast array of light shapers and reflectors, the merits of electronic flash, and the changing requirements of the digital photographer versus the photographer shooting large-format film. It will also look at the use of home-built light shapers and the clever use of everyday objects as a means of transmitting or reflecting light. It is all good fun, and great for kindling a creative, pioneering spirit, stoking that do-it-yourself feeling.

Photography is a combination of artistic visualization and technical manipulation using situations and light. Very often a photographer sets his or her style by the way they light their images. Their lighting becomes, if you like, their photographic handwriting; it is unique to them. The very essence of photography is light. Light creates the effects. Without it we cannot create an image. Light falls onto the CCD chip or film after passing through the lens of the camera. These light receivers are sensitive to the intensity and amount of light, and record the image. It's as simple as that. The studio provides a controlled environment in which the photographer can manipulate the light that falls onto these receptors. In a studio, he or she can have complete technical and creative freedom, allowing them to manipulate the way the subject looks and the mood it conveys to the viewer. The photographer can make it look shabby, classy, or beautiful. With so many options for control over the final image, the satisfaction is addictive.

Studio photographers tend to be careful and considered, have great planning skills, and be mindful of the quality of the final image they produce. They have the creative freedom to light and shoot almost any vision they may have. These days the range of light shapers and reflectors available to help us in this is very impressive. We are spoilt for choice. When you learn to use the tools at your disposal correctly, to experiment with them and understand them, your creativity will know no boundaries. I cannot express the sheer excitement I still have, to this day, when I close the studio door, put on some music, turn on the photographic lights, and paint with light. Magic!

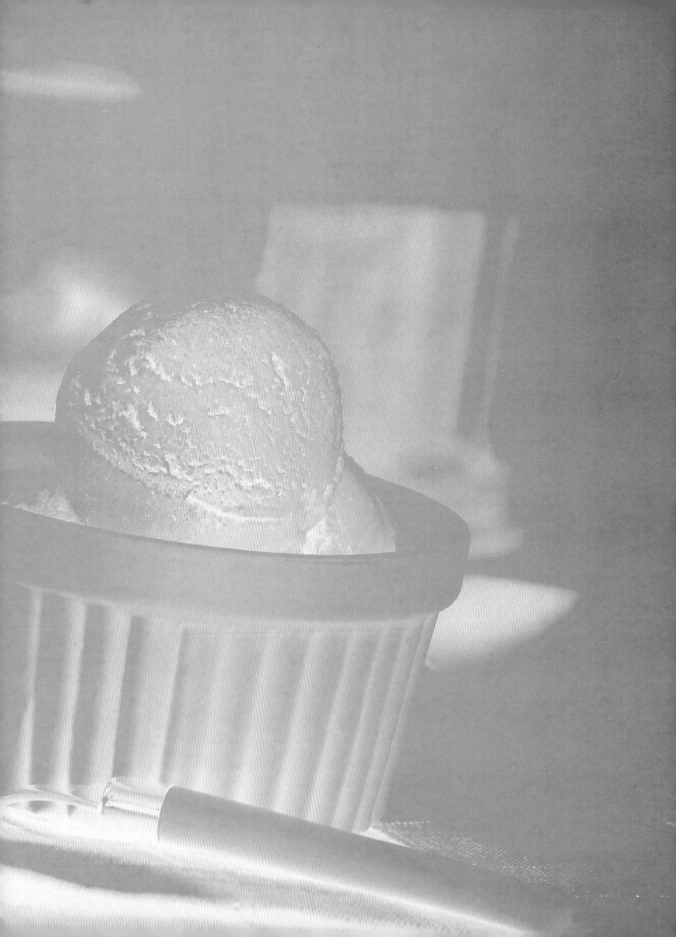

SUBJECTS
& GENRES

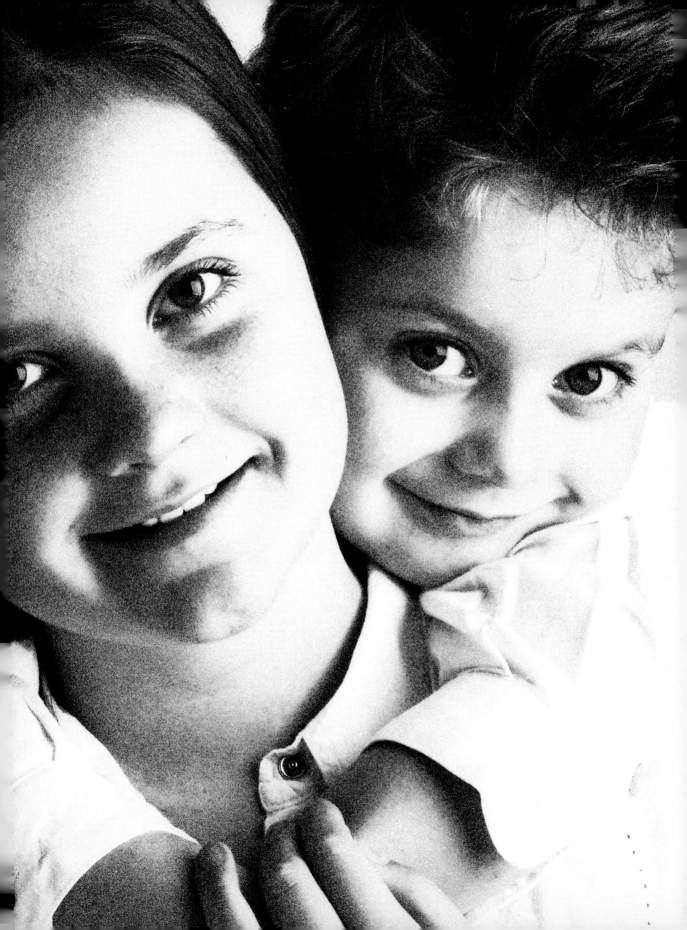

PORTRAITS

Shooting a portrait is a classic use of the photographic medium. Portraits can be formal, or the photographer can take a more casual approach. The latter has become the more popular choice in recent years. Whichever style you choose, the same basic lighting principles apply. Both formal and casual looks are governed mainly by the facial expression of the sitter and, to a lesser extent, the clothes they are wearing. The appropriate style depends on the purpose of the portrait, and this should be discussed with the sitter or client before the shoot. A corporate report, for instance, may require a formal shot, while a fun approach might be more suitable for a wall-hung portrait or an editorial illustration.

The essential skill for the portrait photographer is to make the subject feel completely at ease, relaxed, and confident. This is a very personal matter between photographer and sitter. However short the photo session may be, a personal relationship between photographer and subject must be made. Turn on that charm, tell those dreadful jokes. Get this relationship right and the subject will be putty in your hands. I have been told on many occasions that the "cringe value" of being witness to one of my portrait sittings is immense!

The face is the point of first contact for humans. In a split second we can gauge a person's mood by looking into their eyes or spotting the start of a smile. It fires our inner emotions and determines how we react to or interact with that person. To anticipate the next move of the subject's face, or to capture their smile at just the right time, is a valuable skill.

No two human faces are the same. The emotions, the moods, the personality, all are reflected in a person's face. Those fleeting glances, that smile, the twinkle in the subject's eye captured on film are magic moments, recorded for life the instant the shutter fires. It is this ability to read a face that makes a truly great portrait photographer.

BEAUTY

In a beauty shot, lighting is the critical factor. It is likely that the subject will be a professional model and used to the photographic studio with all its accompanying lights and equipment. This will make your job that much easier, of course, but you still have to get the chemistry flowing between subject and photographer.

Where possible, I always telephone and speak with the model prior to the shoot. This allows us to familiarize ourselves with each other, and I can discuss the required clothes, or "wardrobe" as it is known, if the model is supplying his or her own. I usually ask that they wear very little, or no makeup, as this allows me to start with a blank canvas. If there is no hairdresser attending the shoot, I also let them know how I need their hair to be. However, if the photography is for a cosmetics or a hair-care client, then both hair and makeup artists will be booked for the shoot.

The shape of the face determines, to a great extent, how the subject will be lit. Prepare your basic portrait lighting setup prior to the model arriving. This will allow you to spend time chatting to the model when they arrive, making them feel at ease and relaxed. While this is happening, look at and study their face closely. Look out for blemishes, the shape of their nose, their good and bad points. On no account tell them of these. The last thing you want is the model feeling self-conscious. This is a sure recipe for disaster, and a sudden slap around your face will come as a surprise, believe me.

The makeup artist, art director, and anyone else involved in the visual look of the shots should also be involved and briefed at this point. It is essential that your assembled team understands the look required and all work together to achieve that result. Keep an eye on the makeup being applied and make observations and comments. A good makeup artist and hair stylist should always keep the photographer involved. This is teamwork, after all.

Based on your visual perceptions, start planning how you are going to fine-tune your lighting setup to suit your subject. As you have already completed the basic setup, you will have plenty of time to choose a suitable background to complement the model's hair color and clothing, and to fine-tune and introduce lighting to fit the style of your shot. All this can be done while the makeup artist is carrying out their job. This can take a couple of hours or more. Obviously, if you are working to a specific design brief, make sure your background and chosen style meet the client's requirements. Models, makeup artists, and hair stylists can be extremely expensive, so you don't want to have to reshoot. My final tip for a successful shoot is: always treat the model and stylists with courtesy, keep them fed and watered, and you will achieve some great shots.

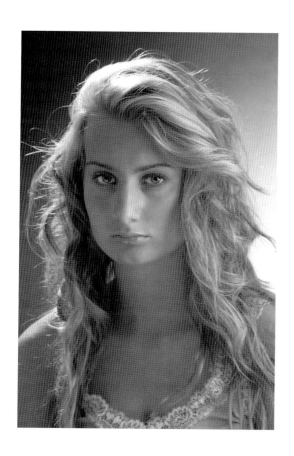
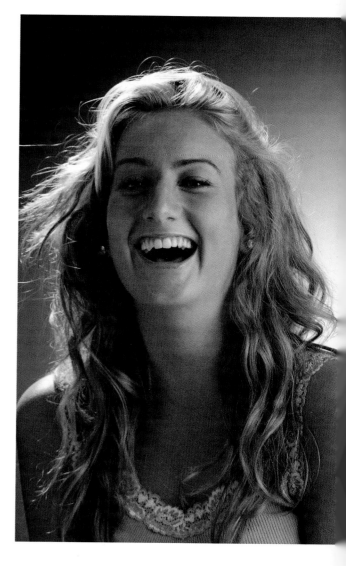

Hair

I was asked by a well-known hair-care product company to photograph Amber modeling a new hair-color range. I wanted to show the richness and depth of the product when applied to her hair. The client wanted Amber to "engage" with the audience and capture the reader's attention. The shot was for use on a point-of-sale show card, in a leaflet, and possibly in editorial. I booked my usual makeup artist. The clients supplied their own hair stylist, and Amber visited their technical center prior to the shoot to have the color applied. This meant that on the day of the shoot we had only to style the hair and apply the makeup.

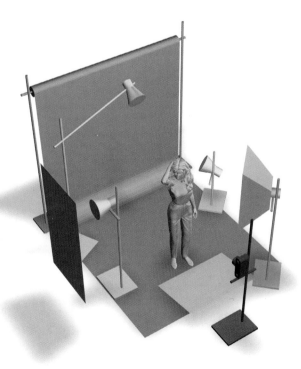

Technique

For the key light I used a softbox to light Amber from the front and to the right. I placed a hair light—with medium honeycomb grid and barndoors to stop stray light hitting the lens—high and from the rear to highlight the top of her head. This gave contrast and depth of color to the hair. I placed a white, flat polyboard 3m (10ft) away to the left, with one light and reflector bounced from this to fill in the left of Amber's face. I clamped a white reflector in front of her to throw light under her chin. We chose a gray paper for the background, lit with one light and a silver reflector at 30° to the right, about 1m (3ft) away. I set this to produce a flash about 1.5 stops brighter than the front light. Because I wanted Amber to be animated in some of the shots, but remain in sharp focus, I used a shutter speed of 1/200 sec. The speed of the flash also took care of freezing the action. As always, I masked the lights (you can use either black card or barndoors) to avoid lens flare.

150mm lens ▷ f/16 ▷ 1/1200 sec

Equipment

- 📷 Large softbox 100 x 100 cm (3¼ x 3¼ft)
- 📷 Hair light with medium honeycomb grid on boom arm and stand
- 📷 Barndoors
- 📷 Lights with reflectors x 2, 26cm (10¼in)
- 📷 White, flat polyboard, 2.5 x 1.2m (8 x 4ft)
- 📷 White reflector, 100 x 50cm (3 x 1½ft)
- 📷 Gray background paper

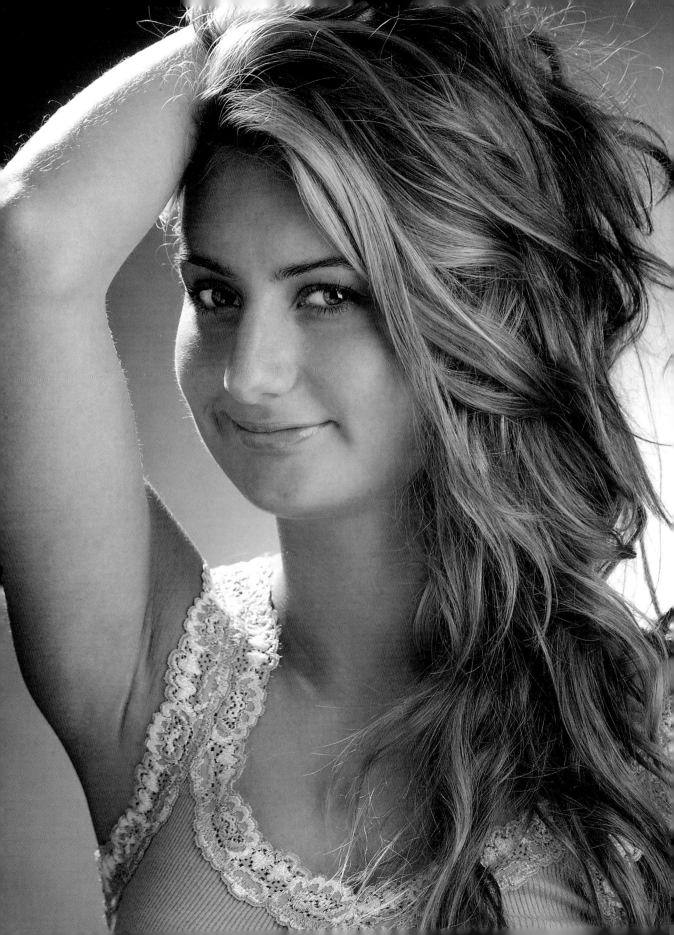

CHILDREN

"Never work with children or animals." Never was a truer word spoken!

I could end this chapter here, but, if you do have the patience of a saint, capturing that candid, relaxed shot of a child can be very rewarding. If you don't, stick to still life!

Children are unpredictable, like an effervescent volcano ready to erupt, but handled in the right way they can be fabulous subjects for the camera. The secret to success is to have your lighting setup completed before they are due to arrive. Their boredom factor will increase at an alarming rate if they have to stand around waiting for you to fiddle with the lights. By all means do the final adjusting of levels and meter readings with them present; in fact, I use this time to gain their confidence, show them the different lights, joke and play with them. If they have your trust and are finding things fun, the shoot should go well. It is also a good practice, where possible, to choose their clothing prior to the shoot. Bright, coordinated colors can make a great difference to the finished photographs. If you are unable to choose the clothes before the shoot, get the parents to bring along a selection of clothes for you to choose from. It will be time well spent. Some sweets for bribes and some tasteful toys are also a useful ploy. But, be warned, you will have only very limited time to get your shots. Once a child has decided enough is enough, it will be precisely that. You may as well all pack up and go home. In general, I would say you will have only an hour to get the shot, no more. It is uncanny that I have, on many occasions, got my best shots within the first half-dozen or so frames. On other sessions I have had to work quite hard and gradually get the child to relax and act up to the camera. The novelty of showing them a Polaroid of themselves, or their photograph on the computer screen, will very often get them to work well for the camera.

My last tip: keep the number of adults in the studio to the minimum—ideally just Mum or Dad and the photographer. Any more and the child will become overwhelmed, with Mom, Dad, Auntie Pat, Brother Johnny, Nan, and Grandpa all chirping away in the background. Believe you me, this will become a great family outing if you let it, and sure enough, you will be mumbling those great immortal words, "Never work with children or animals!"

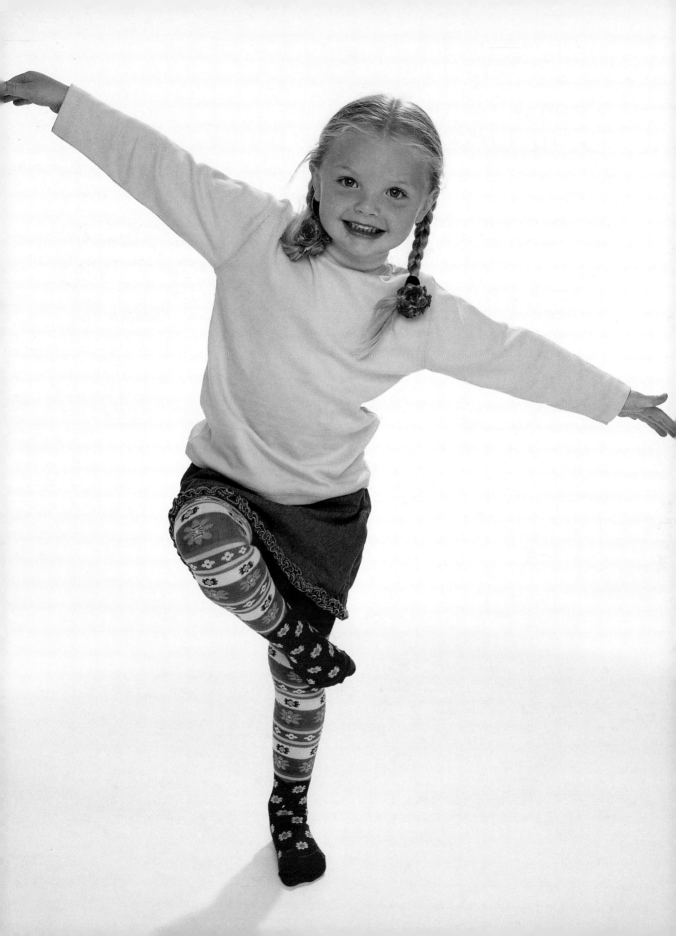

Children's Portrait

Hebe and Sebastian's parents wanted a striking portrait to hang on their living-room wall. It was to be printed onto canvas to a width of 120cm (4ft). It needed to blend in with their decor, but at the same time to be a focal point in the room. We chose a monochrome effect with a hint of blue. The original was actually shot digitally in full color and these color images were produced as prints, cropped in a different way, for the parents to send out as gifts to the grandparents. The monochrome print was produced in Photoshop. I changed the contrast, added background on the right, cleaned up the eyes and skin, and added a grainy filter over the image. Finally, I added the blue tone. To obtain the width required, I supplied the photographic lab with a 34MB file on CD, and they interpolated the image up to the correct resolution.

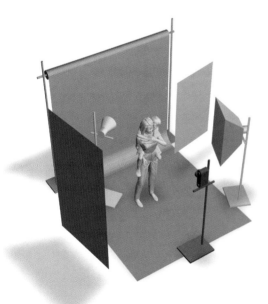

Technique

The lighting on this shot was actually quite simple. The contrast and grainy effect were mostly achieved in Photoshop. I knew the real work was going to be in getting the children's expressions absolutely right. Hebe and Sebastian's eyes really had to engage with the viewer. Their expression needed to be deep and meaningful for the full impact to be achieved. I will let you into a secret: I failed to get the result on the first session. Remember the "children and animals" thing? I asked for them to return the following day. Realizing the gravity of the situation and their possible loss of pocket money, Hebe and Sebastian really did work well together for me and we got the result we were looking for in 15 minutes! I set a large softbox 1.8m (6ft) to the right and only slightly forward of the children, and a large, white polyboard about 60cm (2ft) from Hebe's face, to the left. I set two large, white reflectors low down in front to throw light up into their faces and under their chins, and positioned one white background light behind them to light the white paper background evenly, but to fade out toward the right side.

120mm lens ▷ f/22 ▷ 1/200 sec

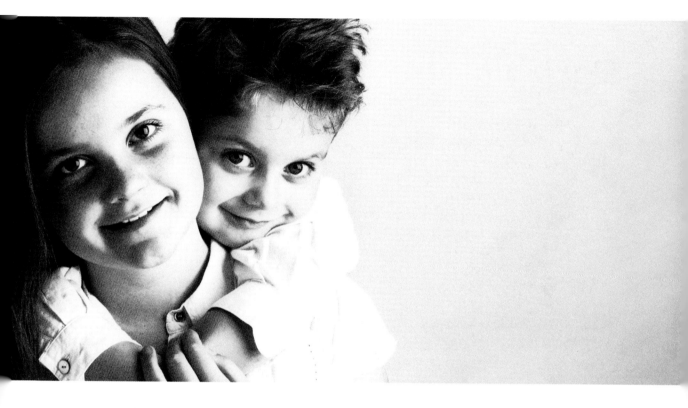

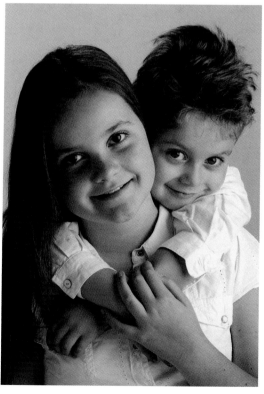

Equipment

- 📷 White softbox, 1.5 x 1m (5 x 3¼ft)
- 📷 Background reflector, 21cm (8¼in)
- 📷 White polyboard, 2.5 x 1.2m (8 x 4ft)
- 📷 Polyboards x 2, 1.8 x 0.9m (6 x 3ft)
- 📷 White background paper

Family Portrait

Here, getting the family to relax and work together is key. Remember, if the portrait involves young children, it is important to set up your lighting beforehand and to work swiftly: a child's attention span is short! Studio space may limit the number of people you can shoot. You will need at least 9 x 15.25m (30 x 50ft) to shoot eight or so people in comfort—many family portraits include four generations! If your studio has the height, you can use a couple of hair lights with 30° honeycomb grids. Ideally these should be on large boom-arm stands. They will add backlight and depth to the hair, but be careful as they can create flare in the lens. Use barndoors or flags to stop this. Always make sure lights and stands are stable; weight them with ballast, and tape cables to the floor to avoid trip hazards. A broken light is expensive; a claim for personal injury even more so.

Technique

The Jacob family were easy to work with—happy and fun. Getting all four to look at the camera at the same moment was a bit tricky. Take time to really explain what you expect sitters to do, and when. I usually tell them to look at the camera after a count of three, but shoot on two. I find most people move their eyes on two, and I get the shot. Try it. Clothing is important, as usual. I asked the Jacobs to wear muted colors with a hint of blue to contrast with their complexion. I used a simple setup—a white paper background scoop-lit evenly from each side with linear strips. Alternatively, you could use round, wide-angle, 16cm (6¼in) reflectors. I stacked two softboxes from the front and to the right to light the entire group evenly, and one strip softbox to the left as a fill. The softboxes were around 1½ f/stops brighter than the strip, and the background lights 1 stop brighter than the softboxes.

100mm lens ▷ f/16 ▷ 1/200 sec

Equipment

- 📷 Softboxes x 2, 100 x 100 cm (3 x 3ft), stacked
- 📷 Strip-light softbox, 100 x 30cm (3 x 1ft)
- 📷 Linear strip lights x 2, 30cm (1ft)
- 📷 White background paper

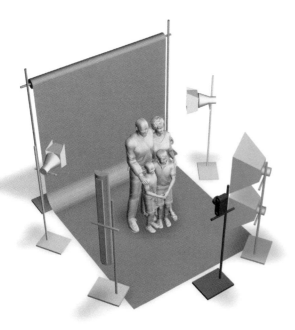

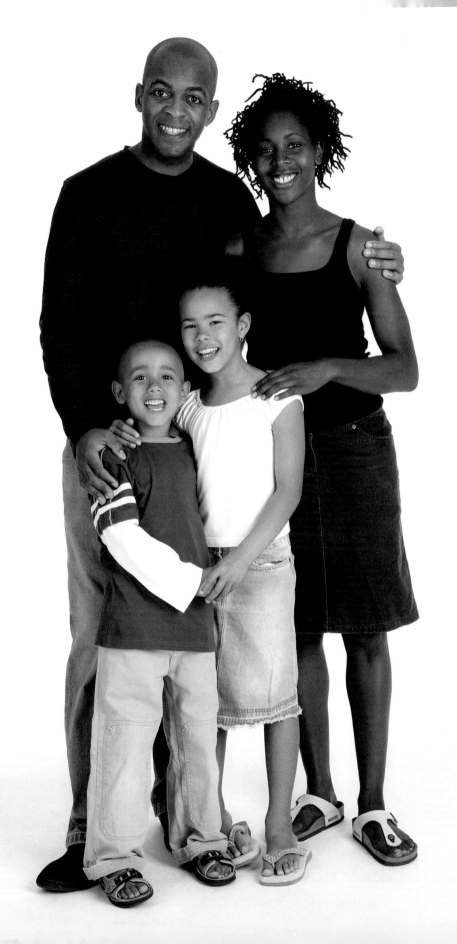

STANDARD PORTRAIT LIGHTING

With the very extensive range of light shapers available today, photographers have almost limitless ways to light a portrait creatively. However, over the years a tried-and-tested formula for the standard portrait has become established. Whether you wish to cross its "recognized boundaries" is entirely up to you, but what you must do is decide which lighting best suits your subject.

As I have said before, by far the most important feature of a portrait is the eyes, so take great care to light them well. If the eyes are inadequately lit, they will look lifeless and your subject will be in danger of looking expressionless.

The second important facial feature is the mouth. Everyone conveys mood through this expressive feature, intentionally or unintentionally. Always try to capture this in your shot. You should also take care with lighting your subject's hair. Shiny, well-groomed, beautifully lit hair will really bring your subject to life.

One final point—I have found that most adults are concerned about having a double chin or looking jowly. They won't thank you if their chin and neck look as though they have "gone south," so do throw light up into this area to soften the shadows.

I have included a series of shots here to illustrate the basic effect a single light has on a face when placed in different positions. I have started at the top with just the main light, in this instance a medium-size softbox. You will notice that as the light starts to illuminate the eyes, the face starts to come alive. Gradually, as I introduce fill-in light and start to accentuate the facial features, the character in the face is revealed. What a difference in the overall shot when I eventually bring the hair to life! I asked my subject to change their mouth position and you can see how, with just a little smile, the portrait really starts to engage the viewer. With the creative genius of the photographer and his or her lighting skills, coupled with a relaxed and animated subject, you have an almost infinite palette with which to produce a great portrait. It is a very rewarding genre of photography, and being able to capture the "moment" will produce a photographic record of that fellow human being at a specific time in their life, which will last their lifetime, and beyond.

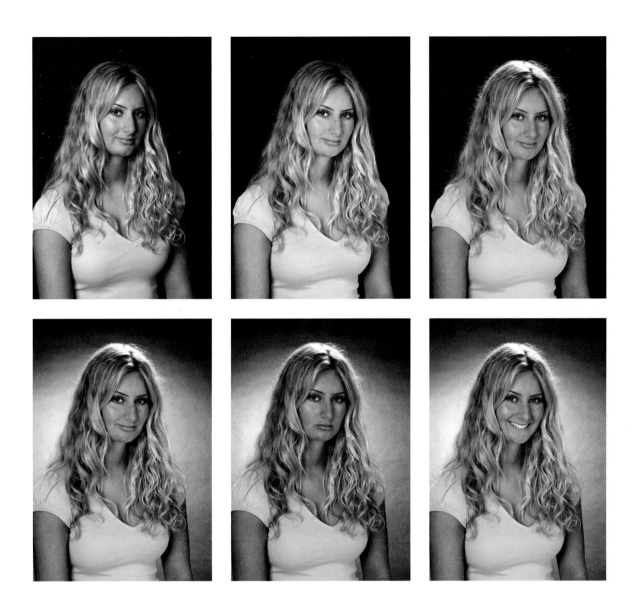

TALKING POINT...
The makeup artist

THE PHOTOGRAPHER

In a beauty shot, lighting is the critical factor. A professional model is likely to be familiar with the photographic studio and all the accompanying lights and equipment. This makes the photographer's job that much easier, and helps the model to settle in and relax. You still need that chemistry to flow between subject and photographer though, so spend some time chatting.

The use of a competent theatrical or photographic makeup artist is essential for successful beauty photography. A makeup artist can enhance a studio portrait sitting considerably, too.

I always insist that the model arrive wearing no makeup. I then sit them down, together with the makeup artist, to discuss the job in hand. If a hair stylist has been booked, I include them in these discussions. I may have "tear sheets" from magazines or other reference material to give an idea of the style and direction I want the shoot to go in. We all study the model's face and discuss the camera angles I plan to use.

Remember, eyes are very important. You must accentuate them, along with the bone structure and mouth. I rely heavily on the makeup artist's skills. Long faces require more shading around the chin and careful use of blusher applied high on the cheekbones. Make sure the hair and eye color blend nicely with the makeup. With digital capture, photographers can retouch images themselves.

This is great for removing skin blemishes, cleaning up and whitening teeth and eyes, and some minor blending of the skin tone.

THE MAKEUP ARTIST

For beauty and portrait assignments, a competent makeup artist is a vital part of the photographer's team. Training can take from two to three years, and degree courses are most likely to be run by art schools. I went to the London College of Fashion.

The makeup artist has to consider many factors before applying any makeup. I start by asking for a brief description of the style required. Tear sheets or visuals showing a similar style will always help me achieve the desired result. The next factor I consider is the lighting setup. I need to understand this, as it is the lighting that determines how strong the makeup should be. I also take into account whether the shoot will be color or black-and-white. When shooting in the latter, I have to be careful to control any red makeup, as black-and-white film is sensitive to red. In addition, the optimal tonal value of the makeup may differ depending on whether the shot is full-color or monochrome. Lastly, I study the model's face. If the model has a great complexion and excellent bone structure, these just need to be enhanced to bring out their form. Weak cheekbones can be enhanced by shading the lower face, which can also help define the jawline. Makeup can be useful in completely changing a model's look: highlights and shadows can be painted on to give a multitude of effects.

The eyes are another area over which I can exert a surprising influence to accomplish many different looks. The photographer needs to set up the lighting for the shoot so that I can sit the model in it at various stages of the application process. This allows me to judge the effect of the makeup accurately. The photographer will want to comment on the effects and probably shoot a test shot. Remember that it's easy to add more makeup if required, but it is a real pain to remove it. Always work as a team. If you are both positive and happy, you will make each other's jobs that much easier.

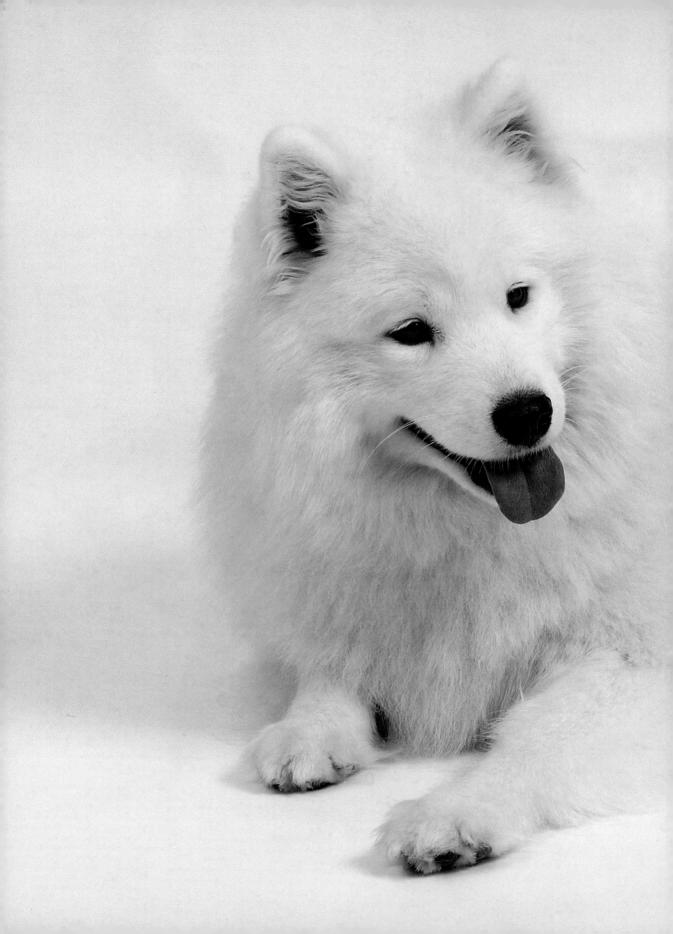

PETS

If you don't have a love of animals, then don't attempt to photograph them! You will require those great virtues, patience, patience, and more patience, together with a sympathetic understanding of your subject. Most animals are unpredictable and uncooperative, but, if you are anything like me, you will take that as a challenge. I tend to keep the lighting fairly simple when photographing pets—say one key light, a fill light, and some lighting for the background. I have always used flash and found this does not worry animals, but you will need to test this out with each individual pet. At all times, the welfare and comfort of the animal is paramount. It helps to keep an air of calm in the studio. Animals are great at sensing stress, and this will be obvious in your shots. There is nothing worse than a shot of an animal looking distressed, and such a shot will do your reputation no good at all. So, get some squeaky toys, dangly bits, lots of treats, a pet, and it's lights, camera, action!

Cats

Getting a good shot of a cat or kitten is relatively easy by virtue of the fact that they are beautiful animals to start with. However, each cat has a very different character and it is difficult to predict how each feline beauty is going to react in the studio environment. Always have the owner present and be very careful not to spook the animal. The use of some catnip applied to the background will prolong the cat's interest in staying on the set. It is best to photograph cats on a table. You can use paper—although they may slip on this—or fabric for the background. Hand-hold the camera and use a standard 50mm lens or a short telephoto lens. This will enable you to be mobile and follow the cat's movements easily. Your shots will look best if you shoot them at the cat's level. I have found them to be fairly oblivious to flash lighting. Take time to calm the cat, and all should go to plan.

Technique

The British Blue is a very photogenic breed. I decided to photograph this cat on a background with a contrasting color. I chose a mauve satin quilt, which looks good with the British Blue's gray coat. The lighting is much the same as that used in the classic portrait (see page 26–27). I used a diffused light for the key light, from the front and to the right, at approximately 45° to the subject. I also used a fill light and an effects light, undiffused, to add a bit of sparkle to the background. Watch out for "red eye," or more accurately "green eye," in pets. To avoid this, do not place your light too close to the lens—raise your front light, and move it away from the camera. Make sure you flag the effects light to stop any lens flare. If the cat is black, its fur will absorb light, so be careful to balance your lighting well or you will have a good shot resembling a sack of coal with two piercing eyes!

70mm lens ▷ f/11 ▷ 1/200 sec

Equipment

- 📷 Softbox, 100 x 100cm (3¼ x 3¼ft)
- 📷 Fill light, diffused umbrella, or softbox
- 📷 Light with medium silver reflector, 26cm (10¼in)
- 📷 Black flags as required
- 📷 White, medium-size polyboards
- 📷 Suitable background on raised surface
- 📷 Gray background paper

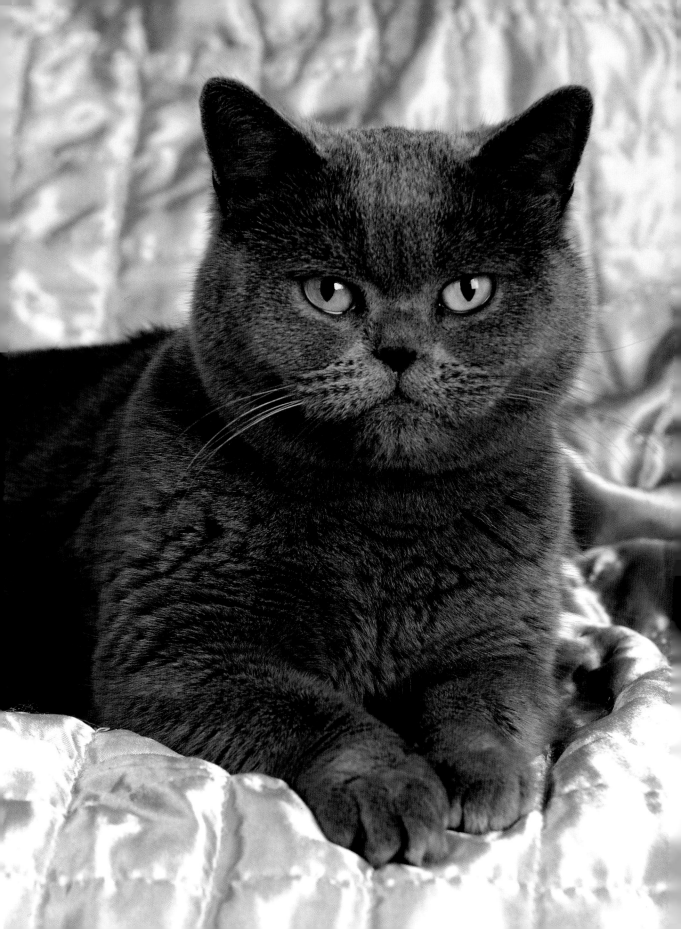

Dogs

My personal approach to animal photography is to keep it simple, with a minimal look. I like nice white backgrounds, with the pet as the star. I don't like settings using cushions and wicker pet baskets, though of course the look is fine, and many pet owners love that approach. Whichever style you choose, the basic principles of lighting will be the same. Dogs can be great subjects. They have bags of character, can produce superb expressions, and, to a certain extent, can be told what to do. As with other animals, I have not, as yet, experienced any trouble with using flashlights. I have, however, encountered some very timid dogs, to the point of being unphotographable. Never let a pet get distressed in the studio environment—its welfare must be paramount. One last thing: treats and squeaky toys are the tools of the trade.

Technique

Following my own personal taste of having fairly minimal, uncluttered backgrounds, I set up a white paper scoop, 2.7 x 2.5m (9 x 8ft). Dogs can be very active, so I used some large white polyboards on each side of the background to form a makeshift "pen" to limit the dog's movement. I used a large softbox from the front and to the right of camera, and placed a key light over to the left, bounced into a silver umbrella. The background I lit from each side with linear strip lights. You could use 21cm (8¼in) silver reflectors in place of these. Set the background lights about half an f/stop brighter than your front light. The silver umbrella should introduce highlight into the dog's glossy coat. If you are photographing a black dog, its coat will absorb a lot of the light, so be careful to check your lighting via Polaroid or on screen. Use the dog's favorite toys and treats to encourage cooperation.

70mm lens ▷ f/16 ▷ 1/200 sec

Equipment

- Large softbox, 100 x 140cm (3¼ x 4²/₃ft)
- Key light with silver umbrella
- Background lights x 2
- Linear strip lights or wide-angle reflectors
- Black flags as required
- Large white polyboards x 4, 2.5 x 1.2m (8 x 4ft)

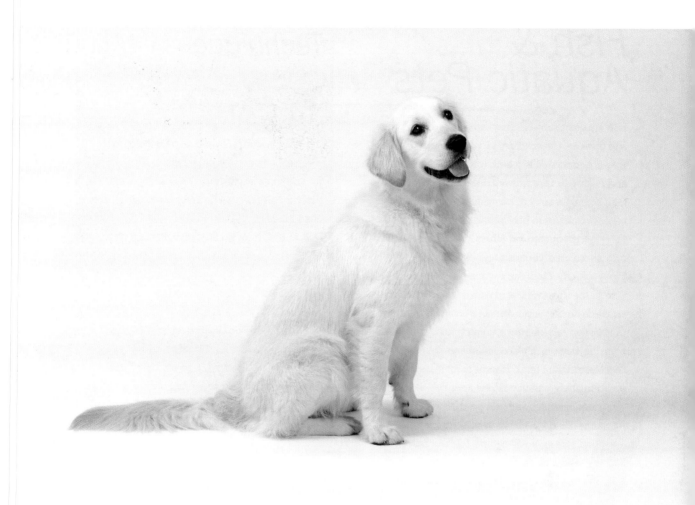

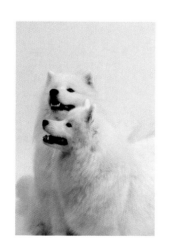

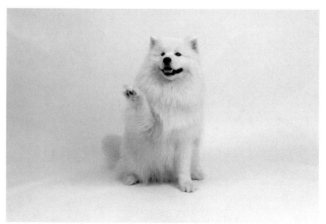

TALKING POINT...
The assistant

THE PHOTOGRAPHER

I am not a pet photographer, but through my work as a commercial photographer I have been commissioned many times to shoot dogs, cats, frogs, and even chickens, for various advertising campaigns. It helps to like animals, you need the patience of a saint, and I have always found it essential to have a studio assistant. Animals can often sense nerves or tension in the photographer and will not perform as well for camera. I always think the shots work best if you get down to the pet's level, eye to eye. This will involve lying on your stomach in most instances, unless your set is elevated. Keep your lighting as uncomplicated as possible, and try to restrict the animals' movement by penning them in. Dark fur, hair, or scales will absorb lots of light, so with these you need to balance lighting carefully. A light or shiny coat will reflect light, so be careful that the highlights aren't overexposed. Check with Polaroids or on-screen to avoid these pitfalls.

THE ASSISTANT

For animal shoots my role is very specific. My main concern is the animal's welfare. Studios tend to get very warm and animals can dehydrate very quickly, so I make sure that they have adequate water. This "watering" extends to keeping the photographer supplied with a good brew as well!

I always try to talk with the pet's owner before a shoot to find out a bit about the animal's personality, its likes and dislikes. This insight helps me reassure the pet, put it on set, and generally help position it for the photographer. Having the owner on set can be a big help with this as well! What is absolutely essential is having copious supplies of treats and a full working knowledge of pets' toys. Controlling the pet's movements is vital, and I use all the bribes and enticements I can.

As the lighting for pet photography is generally kept fairly simple, unless the shoot is for a very specialized job, I don't have many technical tasks. However, before the shoot I always make sure that all the lighting is secure and can't be knocked over, and that all the cables are taped down with gaffer (duct) tape. Animals will knock anything over if given half the chance, and I've worked with some huge dogs capable of causing havoc.

For me, the final job of the day is to clear up all the hair or fur. With the amount dogs and cats can shed, this can take a couple of hours.

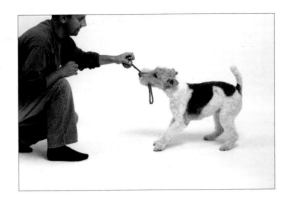

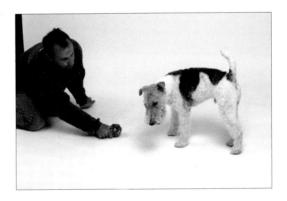

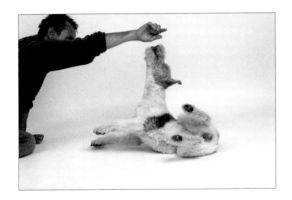

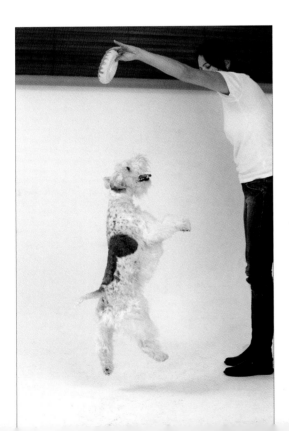

FOOD & DRINK

When they find out I photograph food, most people are quite fascinated and ask me about all the tricks of which they have heard. Yes, we do use a few tricks, but in reality, such tactics as substituting mashed potato for ice cream are very rarely used. The most important aspect of photographing food is to keep it authentic: it needs to look real and appetizing. Photographing food and drink successfully requires the use of special techniques and skills to enhance its appearance, and lighting is a critical factor in achieving this. Drinks photography also uses unique lighting disciplines. You will need to be meticulous in your approach, have good lighting skills, and a comprehensive understanding and knowledge of food and drink. A keen eye for color and styling is also a prerequisite. Working with a competent food stylist is essential in all but the simplest food shoots. In this chapter I will give you a thorough understanding of what is involved.

Stews & Tagines

Photographing food and drink does not appeal to every photographer. It has a reputation for being highly specialized, requiring special skills and knowledge. There is some truth in this, but I would say that, as with so many photographic disciplines, an eye for color, patience, and attention to detail, not only in the presentation of the food, but also in the selective lighting of different areas of the set, are the core skills required. You must, using light, bring out the textures and contrasts in the food. The purity of the light source is important. I have always preferred a slightly warm light. This makes the food look more inviting. A green or magenta cast can make food look quite unappetizing. In more recent times, the warm lighting approach has given way to very clean, pure, white light with a slight blue hue. Styles do change from year to year. It can be extreme shallow depth of field and pure, cold lighting one minute; warm lighting, all in focus the next. Follow the flow or use you own creative instincts.

Technique

I shot this egg-and-tomato tagine from above, at an angle of approximately 45° to the casserole dish. The lighting was very simple; I used only two lights. I set up the shot using a similar-sized casserole dish, having been briefed by the home economist as to what the cooked dish would look like. You can fill the mock-up dish with uncooked vegetables—just make sure they are to the same depth as the finished dish so that you set the lighting accurately. High up and to the back left, I placed a light with silver reflector, and diffused with Tough Frost, together with a Straw 1 colored gel to add warmth. I placed a softbox at an angle of 45°, close to, and to the right of the dish. To reflect light into the left of the casserole dish I used a whiteboard. Take care that the edge of the dish doesn't cast a shadow across the food.

200mm lens ▷ f/11 ▷ 1/200 sec

Equipment

- 📷 Large softbox, 100 x 100cm (3¼ x 3¼ft)
- 📷 Light with silver reflector
- 📷 Tough Frost or Trace
- 📷 Straw 1 colored gel
- 📷 Whiteboard, 50 x 50cm (1⅔ x 1⅔ft)

Barbecues

A lot of the time I am asked to photograph single dishes to illustrate recipe books or magazine articles. However, occasionally I am commissioned for a composite shot featuring more than one recipe. These can be fun to set up as they require the creation of mini sets, as for the barbecue shot here. If the sun were guaranteed to shine, this would be a great shot to do outdoors, but the sun is an unreliable creature, and it is possible to imitate an outdoor look in the studio. The key is to create a warm sunlight feel, using colored gels over the key light. I find that straw gels give the best subtle sunlight effect. You will need to experiment with the strength. Use a gobo or cookie in front of the gelled key light to create a dappled effect. One little tip: a very simple way to create a fire-glow effect in the coals of a barbecue is to place small pieces of scrunched-up red and gold foil strategically among the coals. You may need to fiddle with these in order for them to reflect light as you want.

Technique

This barbecue shot was taken in the studio. The coals were not lit, by the way! It was for an editorial piece in which some of the copy was to run over the background, so I set up a blue paper background to provide the "blank" area required for this, and placed old clay tiles around the barbecue. I set up the basic layout of props without the food in place. For an overall light I used a large softbox placed to the right of the set. For the key light I used an ellipsoid spot with a Straw 2 gel and gobo on the right, and at 90° to the camera. This lit the kebab skewers. On the left I placed a light with a silver reflector to light the rice and wine bottle, and also to spill onto the blue background. I set this about 2 stops brighter than the key light, and the key light about 1½ stops brighter than the softbox. I added a white reflector to reflect light onto the right of the background. Once I was happy with the balance, we placed the cooked food onto the set.

5 x 4in camera ▷ 240mm lens ▷ f/16 ▷ 1/125sec

Equipment

- 📷 Softbox, 100 x 140cm (3¼ x 4²/₃ft)
- 📷 Ellipsoid or zoom spot
- 📷 Light with silver reflector, 26cm (10¼in)
- 📷 Gobo or cookie
- 📷 Colored gel (straw or warm)
- 📷 Large white polyboard

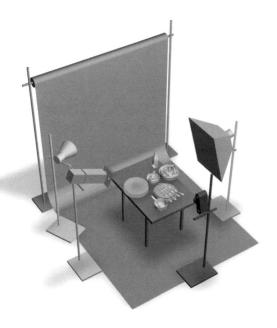

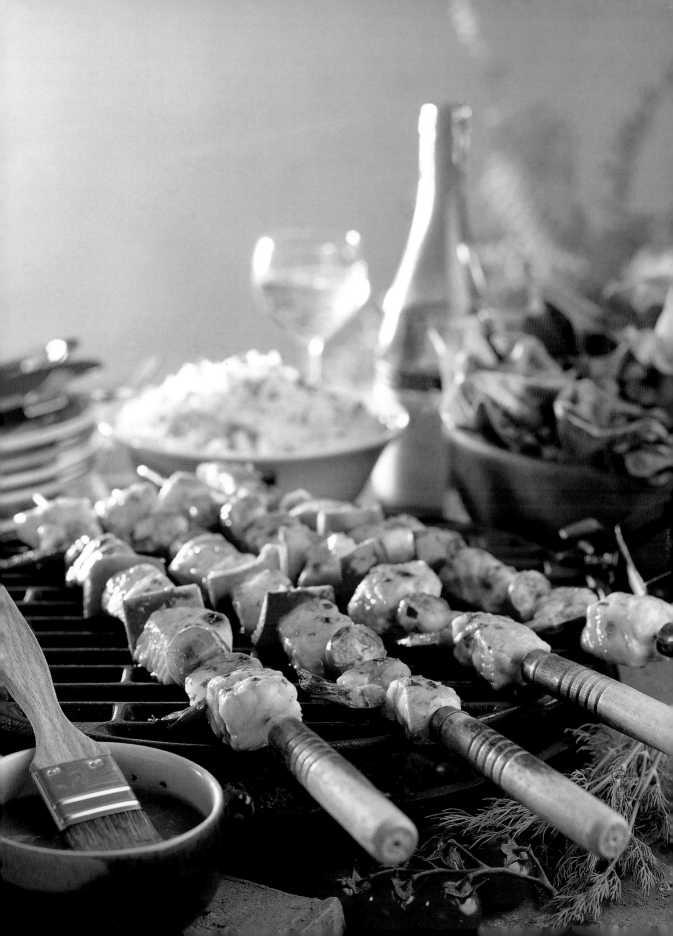

Soups

It is very important, when shooting food or drink, to understand how the finished dish or drink is supposed to look. The home economist, or food stylist, will most probably have done some research, or even produced the dish prior to the shoot to check that the recipe works. It is usual for recipes to be tested before they are photographed and published, so it is generally possible to check how a dish should look. I always have the number of the recipe tester or author to hand in case of crisis! I always mix and produce drinks before I put the set and the lighting in place. Knowing how the food or drink will look allows you to choose appropriate colors for the backdrop and plate, and a style of glass that will bring out the best in the drink. It is also essential to know what size plate, bowl, or glass will be required. A 6in pizza will look lost on a 12in plate. Being armed with all this information will enable you to plan and apply your lighting skills to bring out the color and texture in the dish.

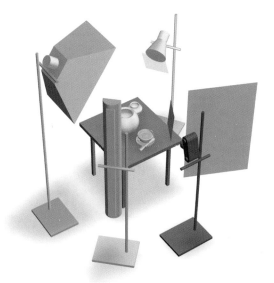

Technique

This delicately flavored soup from Colombia is actually a breakfast dish, and apparently a great hangover cure! I chose an all-blue background to bring out and contrast with the white of the bowl and the yellow of the egg. For this shot I used three lights: a softbox overhead and slightly to the left; a softbox strip over to the left (you can see it reflected in the front of the bowl); and finally, a light with silver reflector and some Tough Frost placed in front of it. This last light I placed low and from the rear, right-hand side, and set at approximately 1½ stops brighter than the softboxes. You must flag this light carefully to stop any stray light falling on the lens. I also used a small mirror, clamped to reflect light into the front and lower half of the bowl, to add sparkle to the spoon. You will need to play around with the balance and position of the lights and mirror to find the best effect.

200mm lens ▷ f/11 ▷ 1/200 sec

Equipment

- Softbox, 100 x 100cm (3¼ x 3¼ft)
- Softbox strip, 100 x 30cm (3¼ x 1ft)
- Light with silver reflector, 26cm (10¼in)
- Tough Frost or Trace
- Small mirror, c. 12 x 12cm (4¾ x 4¾in)
- Clamps and stands
- Black card flag

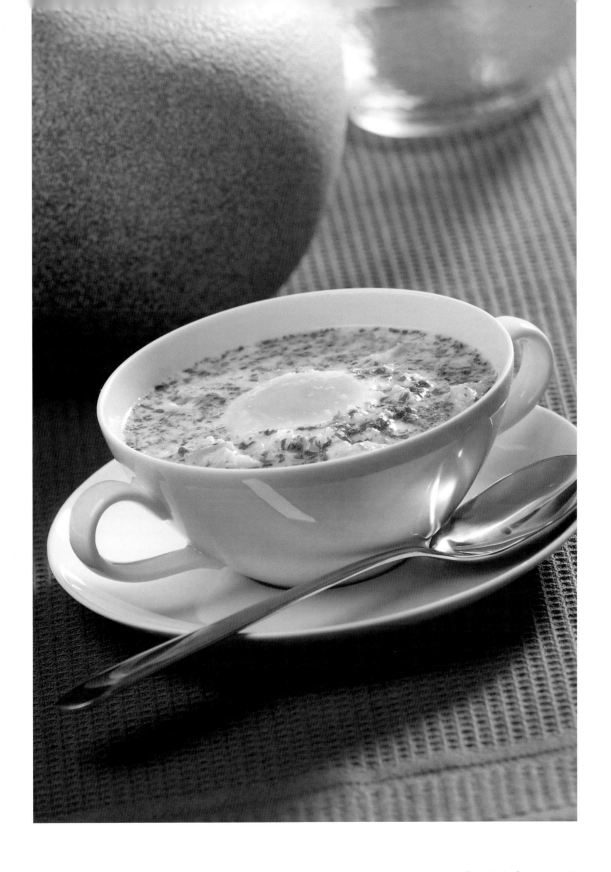

Glasses of Wine

Photographing drink requires a particular set of skills, but once mastered, you will find they can produce some very satisfying shots. As with food, your main aim will be to make the drink look as appetizing and natural as possible. Achieving this comes with its own set of problems, but to me, it is the skill in overcoming these that makes the photographer's job so fulfilling. Lighting technique is critical to the finished shot. If a drink is being shot on its own, there are many techniques you can use to bring it to life, but if it is within a set, among other dishes, you will need to employ carefully placed reflectors and controlled lights. Backlighting is perfect for clear drinks in glass, but does not lend itself quite so well to opaque liquids. You will often need to create a refreshing cool, frosted, look. There are tricks that will help you achieve this. Ice creates further problems, but there are simple answers to these too. First, let's look at backlighting wine in a glass.

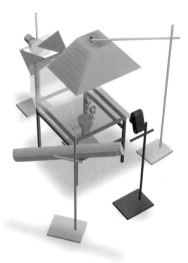

Technique

I shot these three images to illustrate a book on wine. For each, I used the same Perspex still-life table and lights, with colored gels and black card to create the different colors and shadows. Make sure your wine glasses are spotlessly clean; grubby glass looks awful. A less obvious problem is the small air bubbles that sometimes form in wine as you set up a shot. To avoid this, mark the position of the glasses with Blu-Tack, then refill the glasses with fresh wine and replace them just before you shoot. I placed a softbox above the set and a softbox strip light to the right of the set, both set about 1½ f/stops below the setting for the backlights. Next, I placed one light under and one light behind the Perspex table. To create the shadow area I cut some black card to shape, and placed that in front of the lights. You can introduce colored gels as well. Experiment, but remember, balance the lights carefully to hold the edges of the wine glass.

150mm lens ▷ f/22 ▷ 1/125 sec

Equipment

- 📷 Softbox, 100 x 100cm (3¼ x 3¼ft)
- 📷 Strip-light softbox, 100 x 30cm (3¼ x 1ft)
- 📷 Lights with silver reflectors as required
- 📷 Perspex still-life table
- 📷 Black card
- 📷 Colored gels as required
- 📷 Clamps and stands
- 📷 Cutting mat and knife or scissors

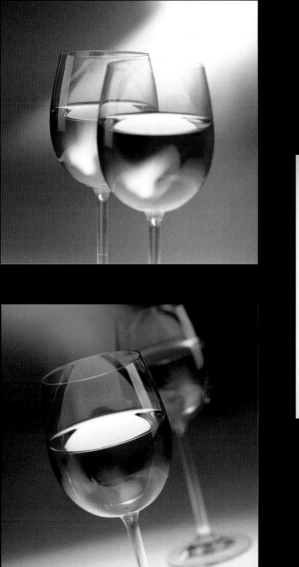
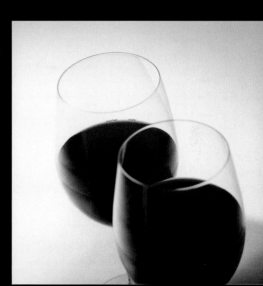

Wine Decanter

Very acceptable results can be achieved through backlighting drink in this way. This style will work not only with wines, but with any clear drink, including spirits and cola. If you find that the drink is too dense and you are having to use a very bright backlight to penetrate the liquid, causing other areas to overexpose, just dilute the drink with water. You may need to experiment to get the density correct. Make a large jug of the final mix so that you have enough to replenish the drink with, should you need to clean a glass or expel air bubbles. Cut black card or colored gels to shape, and stick these to the underside of the Perspex to create any shadows you want. If you find that the shadows are too dense, create a frame with your masks attached and move away from the Perspex until you get the desired effect. Clamp the frame in position when you are happy. The possible effects are infinite and very simple to achieve.

Technique

Once again I used opaque Perspex for these shots, but you could use glass backed with Tough Frost or similar. I shot the contemporary wine decanter using one backlight with barndoors, in this case a linear strip with a flash tube placed to point vertically down from the top to produce a "shaft of light" effect behind the Perspex. This created a lovely gradation in the gray tone. On the left front I placed a softbox strip light, and on the front right a softbox. Both softboxes were vertical and on the same level as the table. You may need to place black polyboards or velvet around the set to stop reflections in the glass. Place a large black polyboard in front of the set, with a small hole cut in it for the camera lens to poke through, to stop the camera being reflected. The other shots are variations on the same theme. Simple, but effective!

150mm lens ▷ **f/22** ▷ **1/125 sec**

Equipment

- 📷 Softbox, 100 x 100cm (3¼ x 3¼ft)
- 📷 Strip-light softbox, 100 x 30cm (3¼ x 1ft)
- 📷 Linear strip light with barndoors
- 📷 Flash tube, 25.4cm (10in)
- 📷 Perspex still-life table or similar set
- 📷 Black polyboards or velvet cloth

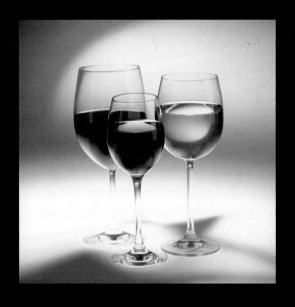

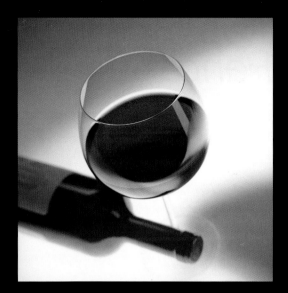

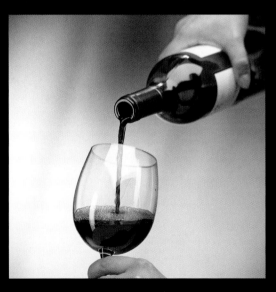

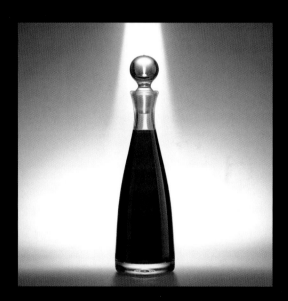

Bacon, Eggs & Beans

In 80% of my lighting setups I use a softbox of some description. This provides a great light source for even, overall lighting, and I use it first to give general illumination to the set. After discussing the food content and colors with the stylist, I can then choose the props. I compose the shot to fit the format and brief, adding or taking away props and trying different layouts until I am happy. The food stylist will have given me a rough, quickly made dish to enable me to fine-tune my lighting setup. I start to add other lights, perhaps trying different reflectors, or "light shapers" as I like to call them. Experiment with their intensities, and use white card reflectors to light detail areas. Small mirrors are also good for this. Gold mirror card is great for creating hot spots. Start with a basic setup of say, three light sources, then experiment. You will soon find that creating a successful lighting setup will come naturally and easily.

Technique

This shot of the classic English breakfast is another simple four-light setup. I used a clever trick to create the warm, dappled glow on the toast and other areas. I placed the softbox directly overhead; a white background to the rear of the table; two lights to bounce light off this and create a soft-toned backlight; and lastly, a light with a silver reflector to the right of the set. The clever trick is this: place clear glass bottles or glassware in front of this last light, at different distances from it. I used milk bottles, as the poor quality of the glass diffuses the light nicely. Fill the bottles with water, as they will then diffract the light better. You will notice that, by rotating and moving the bottles, you can cast dappled-light hot spots onto the food. With a bit of patience you will be able to direct this light onto any area you wish.

5 x 4in camera ▷ 240mm lens ▷ f/22 ▷ 1/125 sec

Equipment

- 📷 Large softbox
- 📷 Lights x 2 with silver reflectors, 26cm (10¼in)
- 📷 Assorted glass bottles, jars, and glasses
- 📷 White reflector boards
- 📷 Black flags as required
- 📷 White background paper

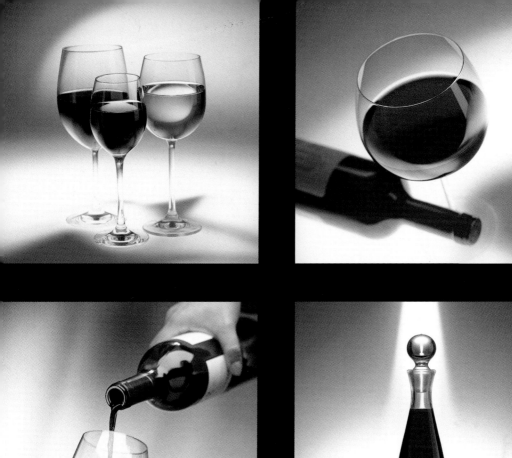

Apple Pancakes

I mentioned, in the introduction to this section, that having a good sense of color, style, and visual design is a prerequisite for the food photographer. The food is the star. The props chosen must complement the food to be shot; it is important to avoid the shot looking too busy. Don't cram it full of cutlery, pepper shakers, saltshakers, and other tableware. Set up your shot using the main plate or dish. Once you have this positioned correctly in the viewfinder, start introducing your table accessories to the shot. It is far better to have just a hint of these coming into the periphery, to add atmosphere and mood. A coffee cup and coffeepot can suggest a brunch or breakfast setting. A candle and, let's say, napkin and napkin ring will suggest a formal dinner, and so on. The type and style of lighting you use will set the scene in a similar way.

Technique

I propped and lit this shot to convey the feeling of a late-morning breakfast or brunch. As you can see, I have used the lighting to produce an airy feeling, and a shallow depth of field to soften the props in the background. The syrup on the pancakes is the key to making them enticing. I used just three lights: a large softbox over the top and to the right; a light with silver reflector to the rear left, lighting the rear of the coffee cup and pancakes; and a third light, with wide-angle silver reflectors positioned to bounce light off the blue paper background, to add a subtle hint of blue light to the tablecloth and cup. Finally, I positioned white card reflectors to add highlights to the syrup. I set the backlight around 1 stop brighter than the softbox—the bounce off the background should be at least 2 stops brighter.

200mm lens ▷ f/8 ▷ 1/200 sec

Equipment

- Softbox, 100 x 140cm (3¼ x 4²/₃ft)
- Light with silver reflector, 26cm (10¼in)
- Light with wide-angle silver reflectors
- White card reflectors
- Clamps and Blu-Tack
- Black flags
- Mid-blue background paper

Bacon, Eggs & Beans

In 80% of my lighting setups I use a softbox of some description. This provides a great light source for even, overall lighting, and I use it first to give general illumination to the set. After discussing the food content and colors with the stylist, I can then choose the props. I compose the shot to fit the format and brief, adding or taking away props and trying different layouts until I am happy. The food stylist will have given me a rough, quickly made dish to enable me to fine-tune my lighting setup. I start to add other lights, perhaps trying different reflectors, or "light shapers" as I like to call them. Experiment with their intensities, and use white card reflectors to light detail areas. Small mirrors are also good for this. Gold mirror card is great for creating hot spots. Start with a basic setup of say, three light sources, then experiment. You will soon find that creating a successful lighting setup will come naturally and easily.

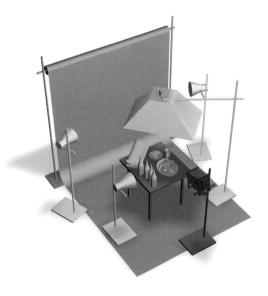

Technique

This shot of the classic English breakfast is another simple four-light setup. I used a clever trick to create the warm, dappled glow on the toast and other areas. I placed the softbox directly overhead; a white background to the rear of the table; two lights to bounce light off this and create a soft-toned backlight; and lastly, a light with a silver reflector to the right of the set. The clever trick is this: place clear glass bottles or glassware in front of this last light, at different distances from it. I used milk bottles, as the poor quality of the glass diffuses the light nicely. Fill the bottles with water, as they will then diffract the light better. You will notice that, by rotating and moving the bottles, you can cast dappled-light hot spots onto the food. With a bit of patience you will be able to direct this light onto any area you wish.

5 x 4in camera ▷ 240mm lens ▷ f/22 ▷ 1/125 sec

Equipment

- 📷 Large softbox
- 📷 Lights x 2 with silver reflectors, 26cm (10¼in)
- 📷 Assorted glass bottles, jars, and glasses
- 📷 White reflector boards
- 📷 Black flags as required
- 📷 White background paper

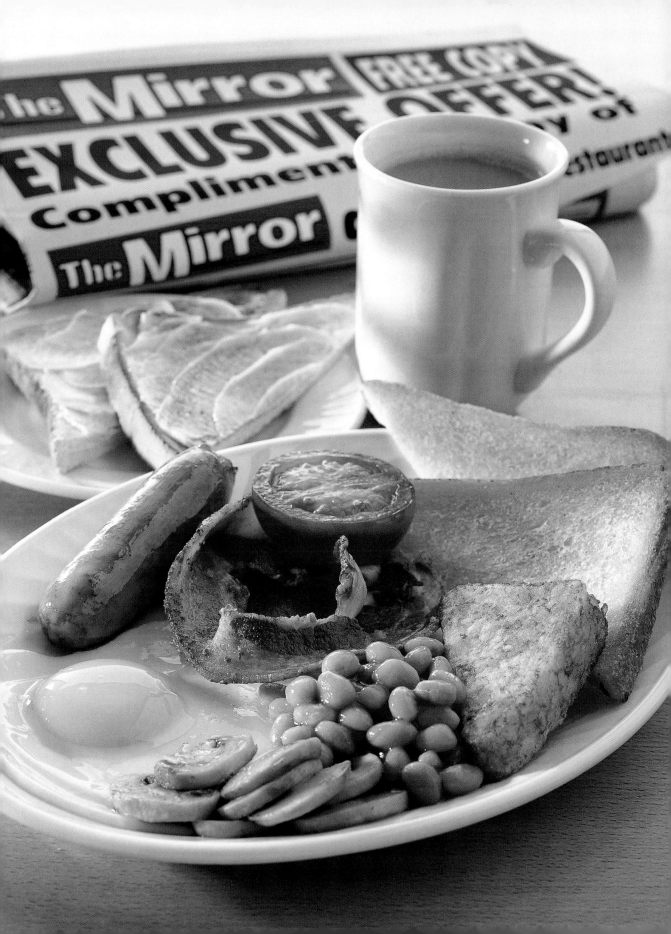

Ice Cream

Warning. Don't shoot ice cream unless completely mad! Of all the books I have done photography for, one of my favorites was a book of ice-cream recipes, but we sure burnt the midnight oil shooting it. There is no real difference between lighting ice cream and any other still-life subject; it is just a case of working very quickly alongside a competent food stylist at the point of capturing the shot. You won't have time to make any changes, so it is essential to have all your lighting tested and all your props in place before you put the ice cream on set. I also find it useful to keep the studio temperature down. Keeping your modeling lights on low will help. Use artificial ice cream, set on an identical plate, to set up your shot. My preferred method is to prepare loads of ice-cream scoops, place them on plastic trays, and put these in the freezer. When they are well frozen, choose your "heroes," place them on the plate, add any other decorations or props required, and place on the set. Just before shooting, get the stylist to blow air gently onto the ice-cream surface through a straw to melt any ice crystals. Good luck!

Technique

All the photographs here were taken using the same basic lighting setup. Remember to mark the position of the setup plate accurately—I use children's play bricks and Blu-Tack. Again, I used just three lights. I set a softbox overhead and slightly to the right, and used a light with silver reflector to bounce off the background. If you want a colder look, use a blue or white light; for a warmer look, use a yellow light. On the left I positioned an ellipsoid zoom spot with gobo to dapple the light. You could use the glass bottle trick (see page 60) if you wish. Add any necessary fill-in using mirrors or small white card reflectors. Set the backlight around 2 stops brighter than the softbox, and the side light around 1 stop brighter. Depending on the feel you want, you could also use a Straw 1 warm filter.

200mm lens ▷ f/11 ▷ 1/200 sec

Equipment

- 📷 Softbox
- 📷 Ellipsoid zoom spotlight
- 📷 Gobo
- 📷 Light with silver reflector, 26mm (10¼in)
- 📷 Card or mirror reflectors
- 📷 Colored warm-up filter if required
- 📷 White background paper

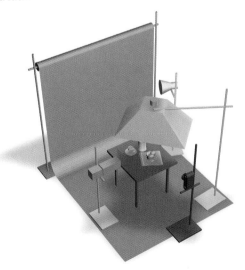

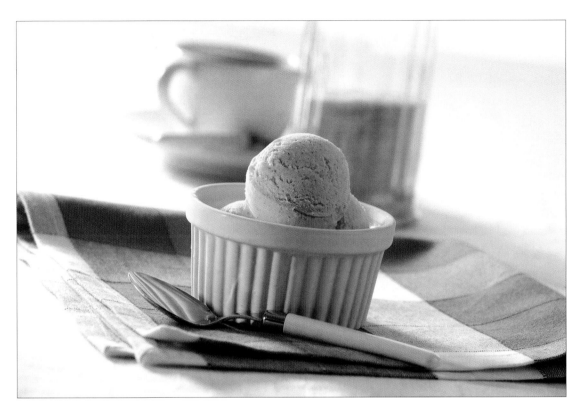

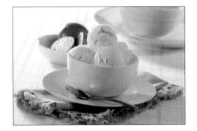

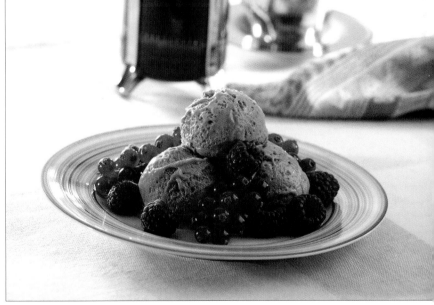

Honeydew Cooler

Many drinks, especially smoothies and shakes, can produce the most vibrant, luminescent, colorful shots. Bright, high-key lighting is the order of the day to produce that outside, fresh, sunshine look. This can be achieved very simply, many times with only two lights. Think about it. In the summer months I often shoot drinks outside using just the light of the sun. Take this light source and add some white reflector boards, and that's all you need. In the studio I use one large softbox to give soft, overall light to the set, and often use just one high-key light, maybe with some Tough Frost placed in front, to replicate the sun. Use some white reflector boards to throw light into the shadow areas, and with a little experimenting you will get a great result.

Technique

I shot these honeydew smoothies using only two lights. I laid out the set on a tabletop covered with a textured white tablecloth, and set light-blue background paper behind the table to throw a very subtle blue cast onto the cloth. I relied purely on stray light for this. The softbox I placed at an angle of 45° to the table, to the front left. At the back right of the set I placed a light with silver reflector and one layer of Tough Frost. Be very careful to avoid any flare into the lens. This will require the accurate positioning of black flags along with some trial and error, but it is essential to maintain correct contrast in the shot. Do some test shots to get the light intensity to your liking. When you are happy, mark where your glasses are and replace them with fresh drinks. Add any decoration you want, and shoot. Sit down, relax, and enjoy a honeydew cooler or two.

200mm lens ▷ f/11 ▷ 1/125 sec

Equipment

- Softbox, 100 x100cm (3¼ x 3¼ft)
- Light with silver reflector, 26cm (10¼in)
- White card reflectors
- Black card flags
- Tough Frost or Trace
- Light-blue background paper

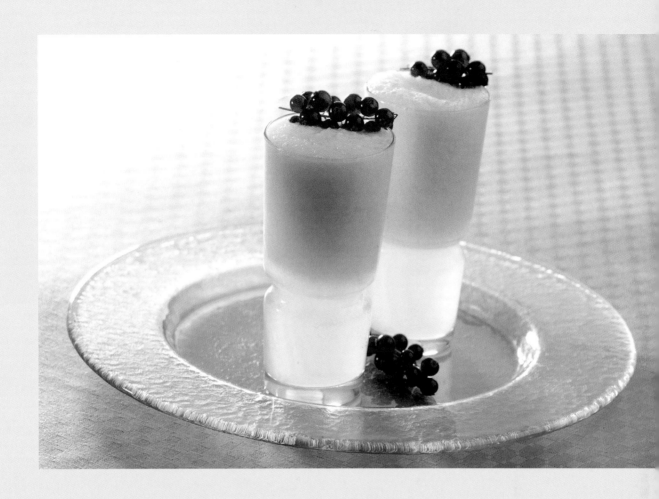

TALKING POINT...
The food stylist

THE PHOTOGRAPHER

I have always had a great love of food. I have also been lucky enough to travel the world, which has enabled me to sample the tremendous gamut of culinary delights we humans prepare and eat. This weird and wonderful variety never ceases to amaze me. Fancy a squirrel or a slice of snake? It probably comes as no surprise that food photography has been a mainstay of my business for many years. The keys to success are meticulous attention to detail in arranging the food, and considered lighting. By this I mean using light to bring the key elements of the food alive. Avoid strong shadows with a subtle use of fill-in lighting. Make sure the food looks very fresh, not dry and wilted. Keeping

the studio and lights cool will help. Keep plenty of Blu-Tack to hand: you can use this to add support to the food where needed. Communicate and work closely with your food stylist. Set up your lighting on a mock dish, and when you are happy with it, replace this with the fresh, finished food.

THE FOOD STYLIST

I often feel like a plumber, arriving at the photo studio with my toolbox of equipment. The correct tools for the job are essential. All professional food photographers will have a fitted kitchen and appliances in their studio, but I always prefer to use my own knives, tweezers, blenders, and other items. I know they are sharp, and I am familiar with using them.

I think the key to a successful food shoot is getting along just fine with the photographer. I discuss the job in hand with them—the food, color, plate size, etc.—and then prepare a mock dish for them so they can set up the lighting. We work in parallel, constantly checking how the other is doing time-wise. Then, in a crescendo, we place the finished dish on the set, carry out some last minute "tweezer work" and oiling, and take the shot. The tricks we use are numerous, but the main one is probably to undercook the food, especially vegetables. To add shine and life to the finished dish, we give it a delicate oiling.

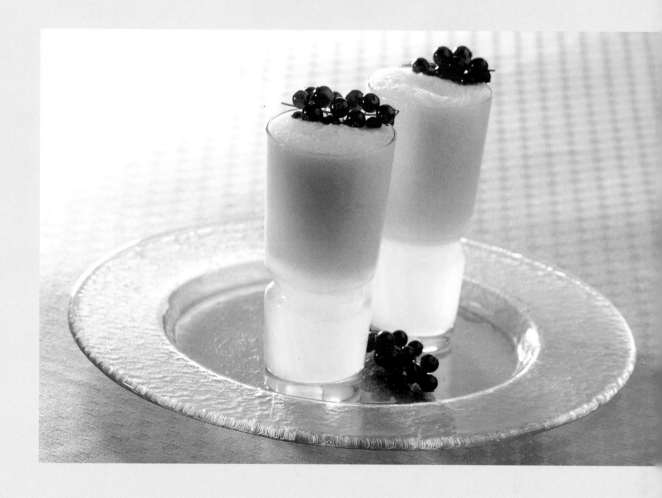

Watercress Soup

I have already explained that on many occasions I only use two lights when photographing drinks. The same is true of many food shots. Don't over-complicate your lighting for the sake of it: there is a danger of the shot looking false. There are occasions when, say, there is an area of deep shadow and the only way to throw light into it is to use a snooted light or a mini-spot. This often occurs with a deep casserole dish, for which you may need to throw light into a certain area. Watch out for sprouts or greens and other dark vegetables: these will often benefit from some selective additional lighting. Mirrors are most useful for reflecting light into dark areas and adding a bit of sparkle. The mirrors on extending arms that you can get from your local auto accessories shop are perfect for this. Keep it simple and you can't go wrong.

Technique

I like this photograph of watercress soup. I like the simplicity of the colors and the fresh look. The backlight on the leaves adds so much life to the shot. I wanted the props in the background to be very abstract shapes, so I lit them using a light with silver reflector pointing at them from the right side of the set, and placed a large softbox overhead. The leaves I lit with another light with silver reflector placed to the rear left of the set. It is probably best to position this light first, avoiding lens flare, then place and turn your leaves to catch the light. Shoot a test shot to check your exposure and light balance, keeping your best "hero" leaves for the finished shot. When you are happy, replace the leaves with the heroes and shoot. Tweezers, an essential part of your kit, will help you with this. You won't have long before the leaves start to wilt, so work quickly.

210mm lens ▷ f/8 ▷ 1/250 sec

Equipment

- ▣ Softbox, 100 x 100cm (3¹⁄₄ x 3¹⁄₄ft)
- ▣ Light with silver reflector, 26cm (10¹⁄₄in)
- ▣ Light with reflector, 21cm (8¹⁄₄in)
- ▣ White card reflectors
- ▣ Black flags as required

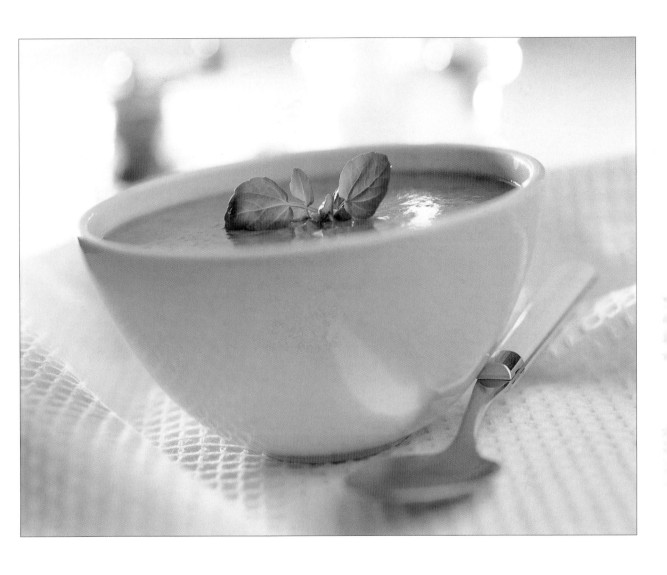

TALKING POINT...
The food stylist

THE PHOTOGRAPHER

I have always had a great love of food. I have also been lucky enough to travel the world, which has enabled me to sample the tremendous gamut of culinary delights we humans prepare and eat. This weird and wonderful variety never ceases to amaze me. Fancy a squirrel or a slice of snake? It probably comes as no surprise that food photography has been a mainstay of my business for many years. The keys to success are meticulous attention to detail in arranging the food, and considered lighting. By this I mean using light to bring the key elements of the food alive. Avoid strong shadows with a subtle use of fill-in lighting. Make sure the food looks very fresh, not dry and wilted. Keeping

the studio and lights cool will help. Keep plenty of Blu-Tack to hand: you can use this to add support to the food where needed. Communicate and work closely with your food stylist. Set up your lighting on a mock dish, and when you are happy with it, replace this with the fresh, finished food.

THE FOOD STYLIST

I often feel like a plumber, arriving at the photo studio with my toolbox of equipment. The correct tools for the job are essential. All professional food photographers will have a fitted kitchen and appliances in their studio, but I always prefer to use my own knives, tweezers, blenders, and other items. I know they are sharp, and I am familiar with using them.

I think the key to a successful food shoot is getting along just fine with the photographer. I discuss the job in hand with them—the food, color, plate size, etc.—and then prepare a mock dish for them so they can set up the lighting. We work in parallel, constantly checking how the other is doing time-wise. Then, in a crescendo, we place the finished dish on the set, carry out some last minute "tweezer work" and oiling, and take the shot. The tricks we use are numerous, but the main one is probably to undercook the food, especially vegetables. To add shine and life to the finished dish, we give it a delicate oiling.

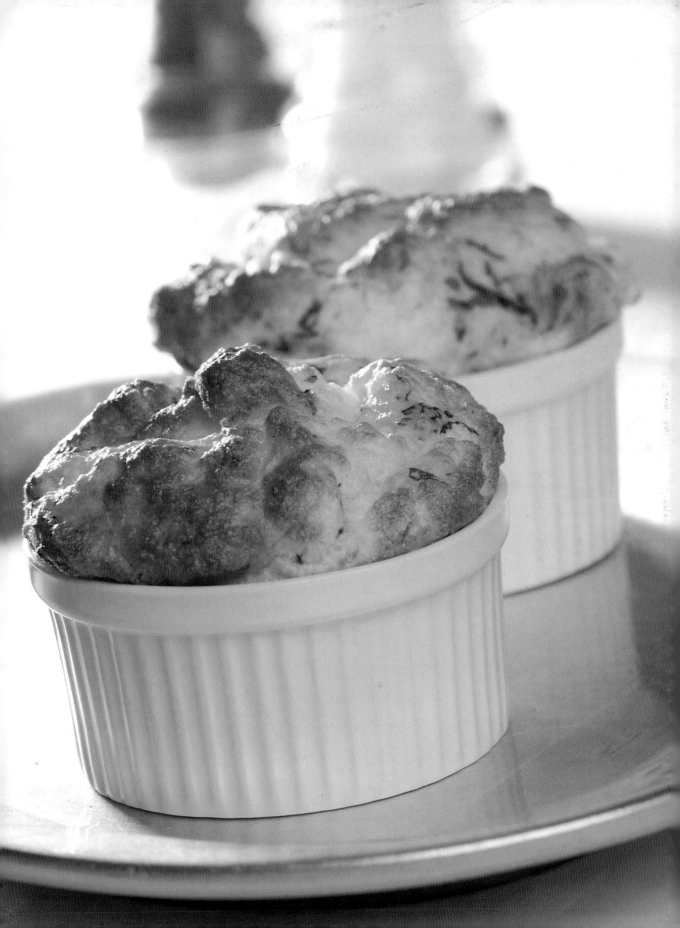

PRODUCTS

"A picture is worth a thousand words." I am always saying that, especially to clients. Of course, I depend on pictures to earn my living, but even so, I do believe this statement to be true. Customers like to see a product before they buy, and it is the job of the photographer to show the product in its best light, quite literally! Take time out to talk to the client. Let them explain their product in depth; let them show you the elements that make their product better than those of their competitors. It is your job to light the product in order to bring out those details to best effect. A "product" can be anything. This is what makes the job of the product photographer so interesting and, at times, demanding. There is no set formula for the lighting setup. Some shots may benefit from added atmosphere to capture the customer's attention; others simply require clean, sharp, well-lit shots to show the product in a more direct way.

Franking Machine

A product could be a plain bottle of pop or a trendy electrical gadget, all flashing lights and display screens. Whatever their form, all products need careful, thoughtful lighting. It is important that the sample given to you is in perfect condition. With digital images, small blemishes can be removed on the computer, though dents in cans are not easy to disguise. Be warned! Most of the time you will be working to a designer's visual and brief, and this may dictate the lighting style to be used. It is always a good idea to see the visual beforehand to check that you have the correct light shapers, backgrounds, and set materials to hand. You may need to hire these in if you haven't. If the required shot is complicated to set up, insist on someone who knows about the product being present.

Technique

I used a sheet of 10mm (c. $^3/_8$in) Perspex on a strong wooden frame to take the machine's weight. For interest, I laid a hole-punched aluminum sheet over this. Behind the set, I placed a large sheet of 5mm ($^1/_4$in) translucent white Perspex, and cast a shadow onto this by shining a light with blue gel through another perforated sheet. I placed a similar light, with reflector and blue gel, under the set. I lit the machine from above, using a large softbox on low power; one light with snoot, barndoors, and red gel on the right; and another with snoot and barndoors to throw light onto the front left of the machine. To take the shot I burnt in the red LED display for a few seconds, with all lights out and the lens open, then exposed the machine with the flash and closed the lens.

150mm lens ▷ f/22 ▷ timed exposure

Equipment

- Softbox, 100 x 100cm (3$^1/_4$ x 3$^1/_4$ft)
- Lights x 2 with silver reflectors and gel holders
- Lights x 2 with reflectors, honeycomb snoots, and barndoors
- Blue and red gels
- White, translucent Perspex, 10mm (c. $^3/_8$in), 2.5 x 1.2m (8 x 4ft)
- White, translucent Perspex, 5mm (c. $^1/_4$in), 2.5 x 1.2m (8 x 4ft)
- Perforated aluminum sheets x 2, 1.8 x 1.2m (6 x 4ft)
- Timber and trestles
- Stands and clamps

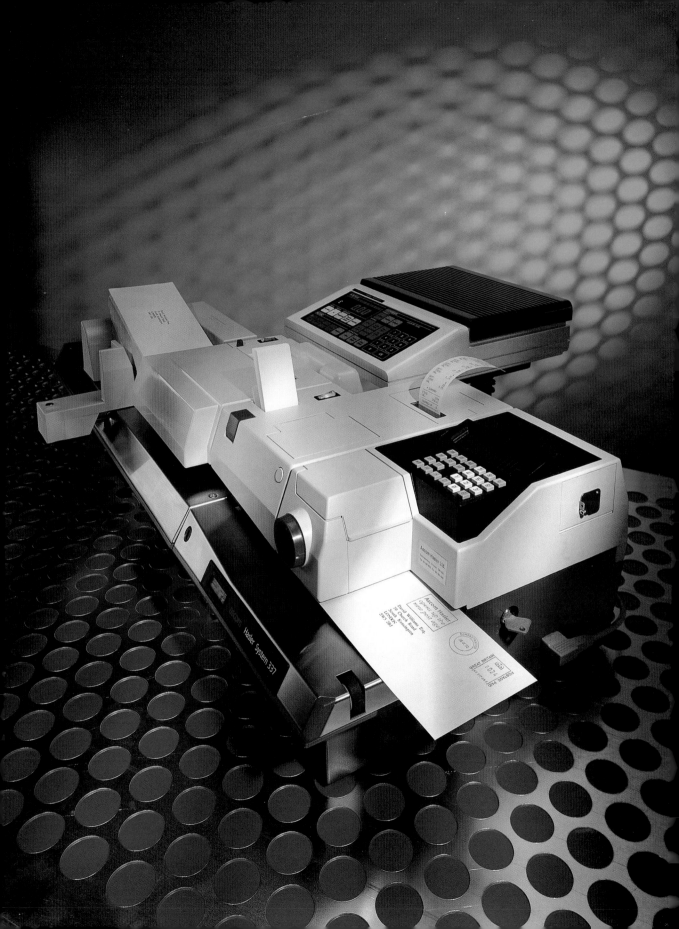

Picnic Hamper

With this hamper you can see what I mean when I say that products can take any form. This shot was to be used in a number of ways: on a show card, on the front cover of a catalog, and in advertising. I worked from a marker-pen visual the designer supplied. The brief was to make the shot busy, warm, and inviting. The idea was to suggest to viewers that if they had this picnic hamper they could be enjoying a nice time in the country, or wherever. I shot the basket, lighting various parts selectively, to bring out the rustic qualities of the wicker. Equally important, I lit the company logo with a strong sidelight to accentuate the embossed leather. The purpose of this shot was to set a mood to entice potential customers.

Technique

I laid out some painted, roughly sawn planks of wood to act as a floor, and placed a mottled canvas background at the rear of the set. With my plate camera in position I placed a Trace, reduced to size, onto its rear screen. To arrange the set, we first placed the props in and around the basket, making sure the logo was at the center of the composition. To give an overall light I used a large, strip-light softbox to the left of the basket. For the main light I used an ellipsoid spot placed to the right, with a gobo to create a mottled effect. I also placed a Straw 1 gel over this light. I then moved the spot around to light the logo in the best way. I used two more lights with narrow snoots to selectively light parts of the foreground. The background canvas I left unlit, but I made sure some light from the spot held the top edge of the basket lid.

5 x 4in camera ▷ 240mm lens ▷ f/32 ▷ 1/125 sec

Equipment

- 📷 Strip-light softbox, 130 x 50cm (4¼ x 1⅔ft)
- 📷 Ellipsoid spotlight
- 📷 Straw 1 gel
- 📷 Gobo
- 📷 Lights x 2 with narrow 12° honeycomb snoots
- 📷 Wooden planks
- 📷 Painted canvas backdrop
- 📷 Blu-Tack

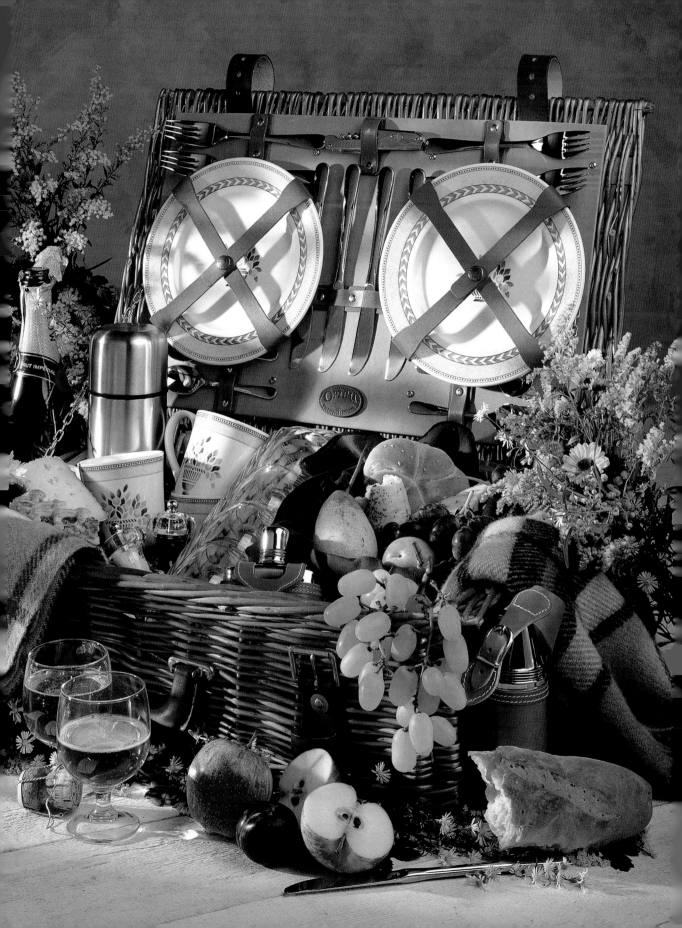

Hair-Care Pots & Tubs

For many years I did work for a world market-leader in hair-care products. Sometimes I was asked to produce complex shots for advertising campaigns, some of them taking a day or more just to complete the lighting setup. To be given a nice budget and three days to produce one shot was just brilliant! Most of the time, working for this client involved shooting product shots to be used as cutouts, but perfectly lit. Each item had to look immaculate. Although jobs like this are still offered, sadly (being a bit of a purist myself), a lot of the photographer's skill has been relegated due to advances in computer imaging. I still like to get things as correct as possible in camera, but all too often I have an art director tell me, "Don't worry. Shoot it on white and we will do it on the system," the "system," more often than not, being Photoshop.

Technique

The technique I used for these shots can be applied to a great variety of tubes, pots, and tubs. The important thing is to pick as near-perfect a product as possible. This will save time in retouching later. I often find only one decent sample out of 20 supplied. Now, the products here all have one thing in common—a gold K—and this had to be lit perfectly each time. I set up a white scoop background, and placed a medium softbox about 60cm (2ft) above the product and slightly forward. I used a strip light at one side—it could be either side—and set a white card reflector on the opposite side. To pick out the K, I placed a white sheet of foamcore in front of the camera, with a hole cut in it for the lens to poke through. This reflected light from the top softbox back into the K. You generally need to fiddle a bit, but it does work well.

150mm lens ▷ f/22 ▷ 1/125 sec

Equipment

- 📷 Softbox, 100 x 100cm (3¹/₄ x 3¹/₄ft)
- 📷 Strip-light softbox, 100 x 30cm (3¹/₄ x 1ft)
- 📷 White card reflector
- 📷 Large white foamcore sheet, 100 x 130cm (3¹/₄ x 4¹/₄ft)
- 📷 White background paper

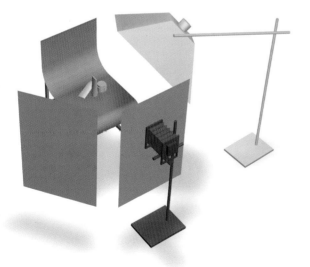

Travel Brochure

This shot of a boxer was an unusual way to promote the release of a travel brochure. I can't actually remember the significance of the boxer, but it's a good shot to illustrate a novel approach to product photography. This image was used on a window poster and on a point-of-sale display containing the new brochures. It worked very well. Such an unexpected image for a travel agent's window certainly got the attention of passersby. We explained the shot to our regular model agency, and they sent us a few bodybuilders. We chose this model as we knew he would look very dramatic oiled and shot against a black background.

Technique

Despite the dramatic effect of the shot, the lighting was actually very simple. It consisted of two lights, one on each side. On the boxer's right was a strip-light softbox; on his left, a light with silver reflector. I placed a couple of sheets of Tough Frost over this second light to diffuse it. Experiment with one layer or two. I set a roll of black background paper about 2.5m (8ft) away from the subject. My assistant oiled up the boxer with baby oil once he was positioned in camera. We then sprayed water over him, being careful to avoid his shorts, gloves, and the brochure, so that nice water droplets formed on his skin. The skill was in placing the two lights either side to create a moody effect and a sheen on the body. Lastly, I placed a white card reflector to throw a subtle light onto the brochure cover. Be careful to avoid any lens flare.

240mm lens ▷ f/32 ▷ 1/250 sec

Equipment

- Strip-light softbox, 140 x 30cm (4²/₃ x 1ft)
- Light with silver reflector, 26cm (10¼in)
- Tough Frost or Trace
- White card reflector
- Black flags as required
- Black background paper
- Baby oil
- Water spray

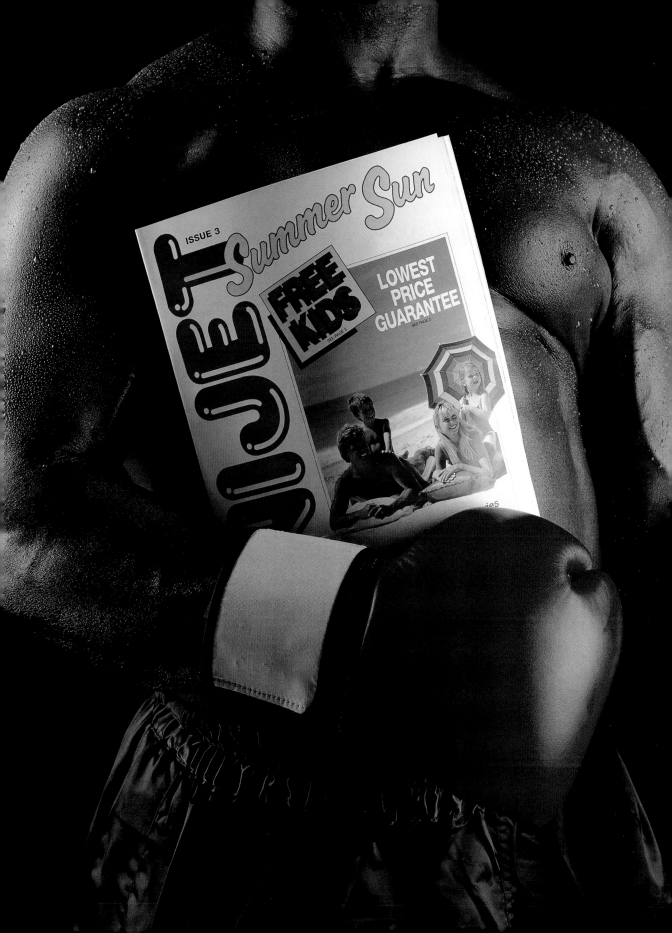

Hair-Styling Collection

Very often a packaging shot requires a hint of drama. In this example, the client had a creative shot featuring a model with big hair as the main photograph in their advert. They needed a product shot showing the complete hair-styling kit to run at the bottom of the page as a squared-up image. Together with the designer, I decided that a low angle, looking up at the products, would introduce drama without adding confusion to the products. We chose blue for the background as it contrasted well with the white of the packs.

Some very useful, practical advice for photographing boxes is this. Remove their contents and carefully apply double-sided tape to the lid and flaps. Seal the bottom first, then add some small gravel or stones to the box for ballast. Finally, seal the lid. The box will look neat and perfect, and the gravel will help it sit properly. I prepare all boxes in this way as a matter of course.

Technique

For the set I covered a small table with blue background paper, which I rolled out carefully over the front of the table and onto the floor. Next I placed a translucent blue sheet of Perspex behind the set. I arranged the group of products in camera, on the blue paper, and used a linear strip light with a Tough Frost diffuser to light the products from front right. To add fill I used white foamcore boards left and right. I used two lights behind the Perspex, one with a background reflector to place a pool of light behind the large bottle, and one with a round snoot to produce a halo effect behind and at the base of the products. You will need to experiment a little with balancing the lights and achieving the correct intensity through the Perspex. If this proves too difficult, you may need to use a two-part exposure, exposing the background on timed exposure and the products on flash.

35mm lens ▷ **f/16** ▷ **1/125 sec**

Equipment

- Linear strip light
- Light with background reflector
- Light with round snoot
- Tough Frost
- Blue background paper
- Translucent blue Perspex, 1.8 x 1.2m (6 x 4ft)
- White foamcore boards

Bodycare Packs 1

Product photography has been an essential part of successful advertising and marketing for many, many years and will continue to be so for many years to come. For most pack shots you don't need an extensive array of lighting. In many cases just one top light will suffice, with white card reflectors to add some fill. Pack shots can be a lucrative form of photography and there are numerous studios set up purely to shoot packaging. Some are actually called "pack shot factories" and practice their craft in conveyor-belt fashion. To get it right you do need some skills—I have seen some very bad examples. Meticulous attention to detail and accurate lighting will set your images apart from the crowd. Make sure your packs are in pristine condition; glue the lids of boxes down and position them with accuracy, make sure labels are aligned and face forward accurately, and you won't go far wrong.

Technique

My client wanted to show off its products in two separate campaigns. One was a Christmas promotion (shown here), and the other for general use throughout the year (see pages 84–85). I set up a white plastic scoop (white paper would also work fine) on a tabletop. Next I placed the products in a suitable arrangement and lit them from above using a softbox. I then placed a strip-light softbox on the left, at 90° to the products. We had found some interesting stick-like plants with small white berries, which suggested Christmas, and I placed these behind the product packs. I lit the branches using one light, with a mid-blue gel over it, from the far left, making sure that no blue light strayed onto the products and foreground. I used a shallow depth of field to throw the branches out of focus. To fill in the right side of the shot, I used a white card reflector.

200mm lens ▷ f/22 ▷ 1/160 sec

Equipment

- Softbox, 100 x 100cm (3¹⁄₄ x 3¹⁄₄ft)
- Strip-light softbox, 100 x 30cm (3¹⁄₄ x 1ft)
- Light with silver reflector, 26cm (10¹⁄₄in)
- Blue gel
- White card relectors
- Black flags as required
- White background scoop, plastic or paper

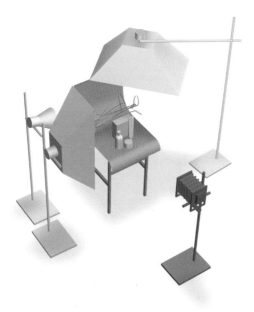

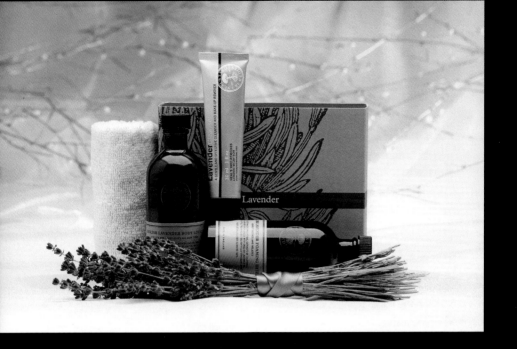

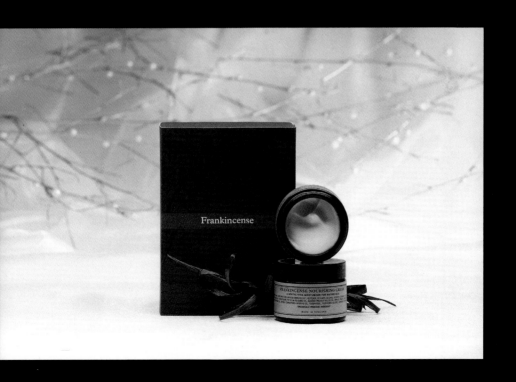

Leather Diary

Because product photography can range from the simple to the artistically complex, it requires an interesting mix of lighting skills and will always keep studio photographers on their toes. You never know what assignment will walk through the door. For me, the more challenging the subject, the better, as I love problem-solving and difficult lighting situations. This is what makes the job so rewarding. Two subjects I always find a little tricky are leather diaries and wallets. Often, these have dark, light-absorbing, or shiny surfaces, and also include white pages, which requires a very critical balance between the highlights and the dark surfaces. It also takes skill to bring out the grain and texture in leather. In many cases keeping the lights at a low angle, skimming across the surfaces, works to good effect.

Technique

This shot of a diary was used as a creative opening shot in a catalog. The lighting and styling helped to identify the product with a particular lifestyle. I produced the maroon background by simply crumpling up background paper, then laid the jacket over this, and placed the diaries on top. To get the position right, a lot of Blu-Tack and padding materials, including small blocks, were called into play; I used both Blu-Tack and superglue to hold the curled pages in place, and lit them with three lights. To bring out the leather's grain I placed a small softbox low on the right side of the shot; to produce the shaft of light across the black diary and throw light onto the left of the brown diary, I positioned a linear strip light at the lower left, with the barndoors nearly closed; and finally, to give a diffused, dappled effect, I placed a snooted reflector top right with clear glass bottles in its path. It takes quite a lot of experimenting to get the desired effect.

150mm lens ▷ f/22 ▷ 1/125 sec

Equipment

- 📷 Strip-light softbox, 100 x 30cm (3¼ x 1ft)
- 📷 Linear strip with barnboors, 30cm (12in)
- 📷 Light with snooted silver reflectors, 21cm (8¼in)
- 📷 Maroon background paper
- 📷 Small blocks

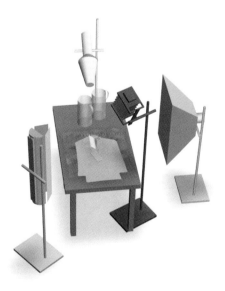

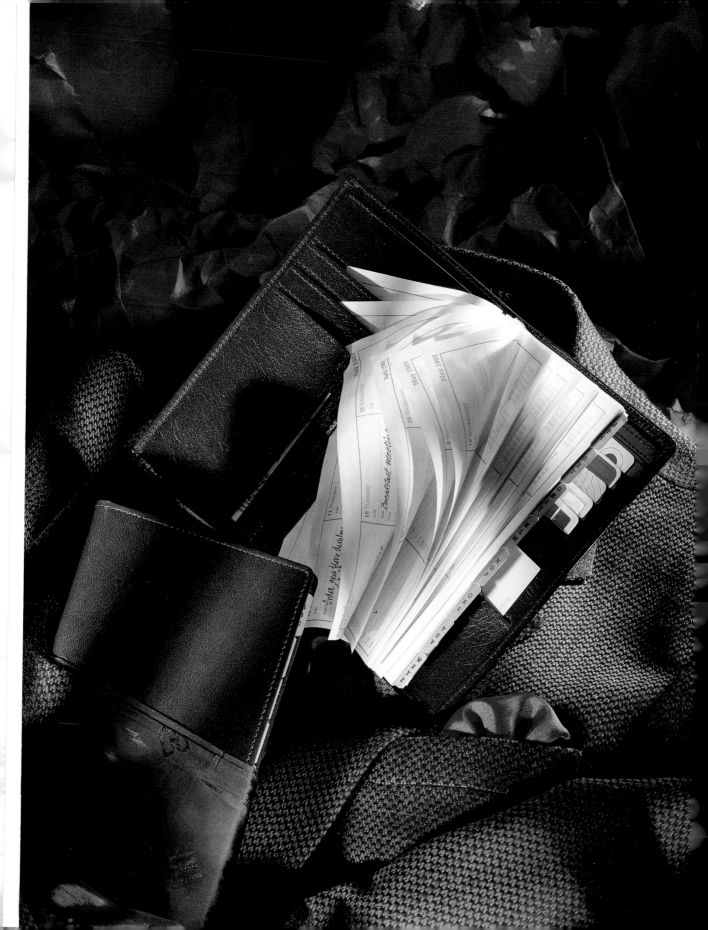

Telecom Control Box

You may have noticed that I often mention lens flare and am always stressing how important it is to avoid it. While there are occasions when lens flare will add a positive effect to a shot, most times it should be avoided at all costs. Technically, lens flare is caused by any stray light reaching the film plane or CCD (charge-coupled device) chip that is non-image-forming. It is most commonly caused by light spill reaching the lens element. The result is a recognizable fogging or pattern, matching the lens aperture shape. Buckled filter gels and too many filter surfaces can also cause flare. The basic, and in many cases, simple cures for flare are:

• use a lens hood;
• use barndoors on lights where applicable; and
• use black flags to block stray light and prevent it from hitting the lens.

A good test for flare is to look at the front of the lens. If there is any flare, you should see it in the elements.

Technique

This shot of a telecom control box was interesting to light, not least because of its shiny metal surfaces. I was asked to show the box with one of the circuit boards revealed. I backlit this board so that light would shine through to give an interesting translucent effect. I used a black Formica base for the table, and black paper for the background. To project a pattern onto this, I used an ellipsoid spot with a gobo and red gel. To throw light onto the right side of the box, I used a light with silver reflector, blue gel, and barndoors, placed to the right and slightly behind it. To illuminate the front and shine light through the printed circuit board, I placed a 30cm (12in) linear strip light on the left. All the lights were masked with flags and barndoors to prevent unwanted light spill. It takes a little time to get the desired effect: you may need to do a timed exposure with the colored lights if their intensity is too low using only flash.

240mm lens ▷ f/32 ▷ 1/60 sec

Equipment

📷 Linear strip light, 30cm (12in), with barndoors
📷 Light with silver reflector, 26cm (10¼in), and barndoors
📷 Ellipsoid spotlight
📷 Gobo
📷 Red and blue gels
📷 Black Formica
📷 Black background paper
📷 Black flags

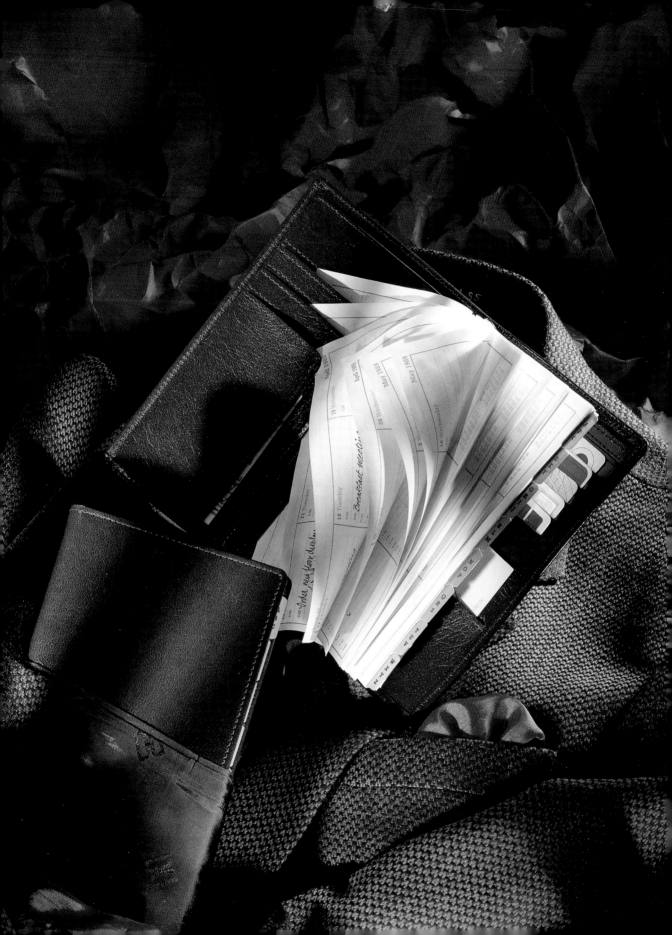

Fridge

Shooting fridges for a catalog requires a lot of studio space, not only for the set and lighting, but also to store the fridges before and after they are photographed: there are often 15 to 20 models in a range. One little tip when carrying out an assignment like this—keep reference shots, or even a video diary, of how the goods were packed. This will save your assistant's skin when he or she can't remember what packing strips went where and the truck is due to collect the goods in half an hour! I always set up the lighting for the largest fridge first: in most cases this will work for them all. As a general rule, catalogs require all the products to look the same, so once you have set up the lighting for the first shot, it is pretty much conveyor-belt stuff. As you work your way through the range, make notes of any details it would be worthwhile shooting, but save all the detail shots until last.

Technique

This shot of a fridge was used on the front cover of a catalog. We laid tiles out on the studio floor and positioned the fridge on these. To create the effect of the glow from within the fridge, we placed a small tungsten strip light inside it before stocking it with food, which hid the light. To hide the cable, we ran it under the fridge and up by the door hinge. Next I placed a linear strip light with red gel to the left of the fridge, with barndoors positioned to produce the red stripe effect. I set another light, with a reflector and blue gel, to the right, about 2.5m (8ft) from the set, to color-wash the fridge. With a setup like this, you must take care to avoid lens flare! To produce this shot I needed a two-part exposure. First, I placed a soft-focus filter on the lens. With studio lights out, I exposed the interior of the fridge first, on a timed exposure. I then turned off the tungsten light, removed the soft filter, and fired the flash lights to complete the exposure. Be careful to avoid any camera movement. You will need complete darkness in the studio for shot like this.

180mm lens ▷ **f/22** ▷ **1/200 sec**

Equipment

- Linear strip light, 30cm (12in), with barndoors
- Light with silver reflector, 26cm (10¼in)
- Tungsten strip light, 60 watt
- Blue and red gels
- Soft-focus filter
- Black flags as required

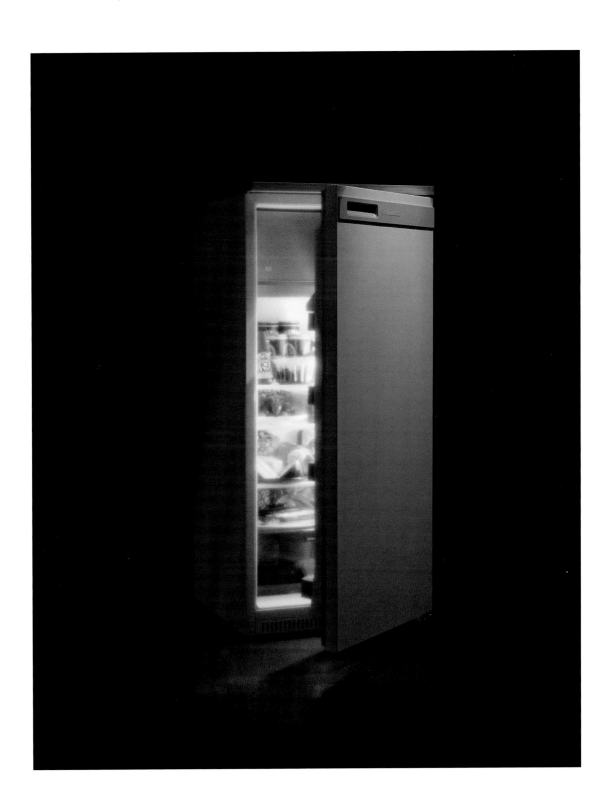

Science Equipment

Using colored gels is an effective way of adding a bit of drama or sparkle to what could otherwise be a pretty mundane shot. Don't overdo it, though. I once had a client who went through a two-year phase of wanting us to shoot everything with colored gels. We still laugh about it today, 10 years later, and refer to it as his "LSD phase." Anyway, the point is, used in a controlled manner, colored gels can work well. You will have noticed that colored gels were used to give many different effects in the shots throughout this book: giving a warm, sunlit feel to a food shot; adding color to a white background; or, as here, subtly lifting the keyboard. Another trick you can use quite effectively is to add food coloring to glass bottles and jars and use them to diffuse light. Doing this will produce a pleasing dappled light, with just a hint of color.

Technique

The shot of the keyboard uses three lights: one softbox from above to add overall light; one light with silver reflector low down, over to the right, with a light blue gel to throw a contrasty light across the keys; and a third light used with a sheet of Tough Frost over it to light the front of the DNA reader. You need to balance these lights carefully to get the desired result. I lit the lab technician in an almost identical way, but with the blue gel on the left and a yellow gel added to the light on the right, which I placed high up, pointing at the technician's arm. The actual DNA readout was shot with no light. For it I used a timed exposure, using the UV light from the machine itself. Most professional photographic or stage lighting suppliers will sell useful starter kits of colored gels.

6 x 6cm camera ▷ 150mm lens ▷ f/16 ▷ 1/125 sec

Equipment

- 📷 Softbox, 100 x 100cm (3¼ x 3¼in)
- 📷 Lights with silver reflectors x 2, 26cm (10¼in)
- 📷 Blue and yellow gels
- 📷 Tough Frost
- 📷 Black flags as required

Telecom Control Box

You may have noticed that I often mention lens flare and am always stressing how important it is to avoid it. While there are occasions when lens flare will add a positive effect to a shot, most times it should be avoided at all costs. Technically, lens flare is caused by any stray light reaching the film plane or CCD (charge-coupled device) chip that is non-image-forming. It is most commonly caused by light spill reaching the lens element. The result is a recognizable fogging or pattern, matching the lens aperture shape. Buckled filter gels and too many filter surfaces can also cause flare. The basic, and in many cases, simple cures for flare are:

- use a lens hood;
- use barndoors on lights where applicable; and
- use black flags to block stray light and prevent it from hitting the lens.

A good test for flare is to look at the front of the lens. If there is any flare, you should see it in the elements.

Technique

This shot of a telecom control box was interesting to light, not least because of its shiny metal surfaces. I was asked to show the box with one of the circuit boards revealed. I backlit this board so that light would shine through to give an interesting translucent effect. I used a black Formica base for the table, and black paper for the background. To project a pattern onto this, I used an ellipsoid spot with a gobo and red gel. To throw light onto the right side of the box, I used a light with silver reflector, blue gel, and barndoors, placed to the right and slightly behind it. To illuminate the front and shine light through the printed circuit board, I placed a 30cm (12in) linear strip light on the left. All the lights were masked with flags and barndoors to prevent unwanted light spill. It takes a little time to get the desired effect: you may need to do a timed exposure with the colored lights if their intensity is too low using only flash.

240mm lens ▷ f/32 ▷ 1/60 sec

Equipment

- 📷 Linear strip light, 30cm (12in), with barndoors
- 📷 Light with silver reflector, 26cm (10¼in), and barndoors
- 📷 Ellipsoid spotlight
- 📷 Gobo
- 📷 Red and blue gels
- 📷 Black Formica
- 📷 Black background paper
- 📷 Black flags

TALKING POINT...
The art director

THE PHOTOGRAPHER

Whether working to a brief or to your own spec, there is a basic procedure you should follow in producing every shot you take. When you *are* working to a brief, add to this the vital first step—make sure you understand exactly what is required.

1. Visualize. How should the shot look?

2. Decide. What kind of lighting should you use to get the desired effect?

3. Select your equipment. This is where experience really counts. Through experience you will develop a thorough understanding of lighting and the effects it will produce, making such decisions quicker, and more reliable.

4. Start the lighting process. Build up your lights one by one. Pay attention to the lowlights and the highlights. Are there any detail points that need lighting?

5. Add the final touches. Will another light enhance the subject? Can you improve anything? Is the setup producing the desired look? Are all the props in place and secure. Is any Blu Tack in shot?

6. Take your light reading. Shoot a test Polaroid or check onscreen. Is there any lens flare?

7. Make your exposure.

THE ART DIRECTOR

I have been working with photographers for nearly 20 years, and I would say the one golden rule of art direction is to get the brief nailed before any photoshoot begins. Give a written copy to the photographer, discuss the mood and feel you are after, and give them some background on the type of subject you need shot. Make sure you are both in agreement about what is required. Your brief should include the number of images to be shot, whether you need a close-up or space left around the subject, what sort of lighting you want (natural, harsh, even), and how you would like the shadows. It should emphasize the mood you want, specify the color and type of background if this is important, and note anything you particularly want them to avoid. All of these things will affect the decisions they make about what equipment to use, and how to set up their lighting.

If you haven't worked with a particular photographer before, ask them about their studio setup and equipment. You need to make sure that they have all the equipment and accessories required, and that the shoot is physically possible in the space they have. Shooting an upright piano is no problem for most photographers, but can they fit one in their studio? Ask them about the backgrounds they have. Do you need to provide them with any, or ask them to buy any, or should you change your plans? They may have an alternative that would suit the job better.

STILL LIFE

Still life is a wonderful field for the photographer—inanimate objects that don't move or answer back. The main market for still-life shots is the art world. Photography is at last recognized as a salable art form and there is a huge market for wall hangings, and also for greetings cards and posters. Still life is studio photography in its purest form. Photographers have free rein in choosing and lighting their subject, without the constraints of a commercial assignment for which they have to work to a visual or creative brief. Generally, aesthetic subjects with an inherent beauty are chosen as still-life subjects. The obvious plants, flowers, and fruits make good subjects, but almost anything the photographer wishes to photograph can be shot in a creative way. Set no limits. Let your imagination run free. Choose a different angle, high-contrast lighting, and even colored gels!

Asparagus

Being a food photographer, I have a natural love of food and have found great pleasure in shooting abstract shots of the subject for my own satisfaction. I hung a few personal shots on my kitchen wall at home, only to find a great market for contemporary, creative food shots as wall hangings. Now, every time we have a dinner party, I am showered with requests for copies for our guests' own homes. Blown up and mounted onto canvas, or even metal, these images look great in today's modern environments. Often the simplest of subjects, propped in a sympathetic way and very simply lit, produce the most rewarding shots. Depth of field, and how you use it, can play just as important a part in the shot as lighting. Remember always to use the freshest of flowers or fruit. And when you are shooting fresh items, keep some in reserve, as they can dry out and shrivel under the studio lights.

Technique

Amazingly—even I was surprised—this very popular shot of mine was taken using only one light. I think it works so well because of the choice and combination of the various colors. The blue plastic beaker does a great job of transmitting the light and transforming this into a translucent glow. The green of the asparagus has an interesting mix and its detail and texture work brilliantly with the purple of the background. So how was it done? I made a scoop background with a sheet of purple paper, positioned the blue beaker, and secured it with Blu-Tack. Next I arranged the asparagus in the beaker and positioned a light with silver reflector and barndoors about 90° to the left. To mask and direct the light, I carefully positioned some black card, and to add detail in the asparagus, I used a small white reflector on the right. Job done.

150mm lens ▷ f/8–11 ▷ 1/125 sec

Equipment

- 📷 Light with silver reflector, 26cm (10¼in)
- 📷 Barndoors
- 📷 Black card
- 📷 White card reflectors
- 📷 Purple background paper
- 📷 Stands and clamps
- 📷 Blu-Tack

Wooden Figures

Creating an eye-catching still-life shot is very much down to choice of subject. As demonstrated once again with this image of handcarved wooden figures, the lighting can be very simple. For this shot I used one light in conjunction with a white card reflector to throw light back into the shadow area. This is almost identical to the asparagus shot shown on page 99, but, as you can see, a very different effect has been achieved. The warm, rustic feel was created through the use of handmade paper for the background, together with the golden color of the wood. Keeping the light very low, almost on the same plane as the background surface, makes for very moody shadows and great depth. With a little work in Photoshop, the warmth and contrast could be enhanced to produce an even more creative shot; it would also look great in monochrome.

Technique

These figures were carved from solid wood by a modelmaker friend of mine. I simply laid down some sheets of handmade paper, being careful to utilize the rough edges in the shot. I raised the right-hand sheet slightly with Blu-Tack to accentuate the shadow. I set up the camera to shoot down vertically onto the wooden figures, then placed a linear strip light low down, level with the table, on the left. A simple light with a narrow-angle reflector would work just as well. To lighten the shadow area a little I clamped a white card reflector in position on the right, and created the halo effect on the head of one of the figures using a mini-spotlight. You will need to move the lights and reflectors around to gain your desired effect.

150mm lens ▷ f/16 ▷ 1/200 sec

Equipment

- 📷 Linear strip light, 30cm (12in)
- 📷 Mini-spotlight
- 📷 Clamps and stands
- 📷 White card reflector
- 📷 Black flags as required
- 📷 Handmade background paper
- 📷 Blu-Tack

White Lily

The freedom that still-life photography allows you is great for practicing lighting skills. Much can be gained from experimenting with different light shapers, reflectors, and positioning. Keep a notebook handy to make sketches of the different schemes, noting the effects each creates. This book will become invaluable when you are confronted with a product or more commercial subject to shoot: you can use it as a reference source for similar subjects. Do not be afraid to try different techniques. This is the only sure way to learn, and it's fun. The great thing about shooting digitally is the "no-cost" factor of shooting images. When I was learning, many years ago, the amount I could shoot was always limited by the cost of film and processing.

Technique

This shot of a white lily was used commercially, on a wedding invitation. It was shot on a white card background to allow for the text that was required. Because the edges of the petals have been held against the white card, it could also be used as a cutout, although I think it would lose some of the depth given by the shadows on the full shot. I set up the lighting on another flower, replacing it with this fresh one when all was ready. I positioned a softbox overhead and to the right, and aimed a light with silver reflector and barndoors from the top left of the shot. This light was low down, on the same plane as the table. The barndoors were used to cast the shadow you see, making the petals hold against the white background and adding depth to the shot. Mask out any stray light to keep it from falling onto the lens.

80mm lens ▷ f/16 ▷ 1/200 sec

Equipment

- 📷 Softbox, 100 × 100cm (3¼ × 3¼ft)
- 📷 Light with silver reflector and barndoors
- 📷 White background paper
- 📷 Black flags as required
- 📷 Clamps and stands

Flamingo Flower

Color plays an enormous part in still-life images. A still-life photographer has the same opportunities as a still-life painter. Choice of subject and colors is unlimited in both disciplines, but where painters are limited in the way their colors are seen—as flat color—photographers have other tricks up their sleeve. Sometimes the most amazing and unexpected colors can be revealed in a subject simply through backlighting. Try this with liquids or plant leaves. Slices of fruit are particularly receptive to this treatment. Don't be afraid to be abstract. Very often you can create a completely different look for your subject simply by being bold and experimenting with light. The range of color relationships and combinations is huge, and what might appear, at first sight, to be awful color mixes, can be brought to life with suitable lighting.

Technique

"Be bold," I said. Well, this bold shot combines two very different colors (in a secondary color scheme that works well together) with a little backlighting. I set up the bright green background several feet behind the subject, and lit it from the right using a softbox strip to produce a rich, fairly even color. I suspended the flower in a clamp and backlit it with one light and silver reflector from the left. You could use a sheet of Tough Frost to diffuse this light if you wanted. Now, with a shot such as this, the difficult part is stopping any stray light from falling onto the lens. Use large black flags, carefully positioned. It may take some time to achieve, but this must be done or your shot will suffer badly from flare and reduced contrast. Lastly, I clamped a white card front right to throw a little light back into the flower.

105mm macro lens ▷ f/16 ▷ 1/200 sec

Equipment

- Softbox strip, 140 x 30cm (4²/₃ x 1ft)
- Light with silver reflector, 26cm (10¼in)
- Green background paper
- Large black flags
- White card reflector
- Clamps and stands

Violin &
Butterfly

Musical instruments make very photogenic subjects for still-life photography. The polished brass and intricacy of a saxophone or trumpet make them a great candidate for an artistic lighting setup. Equally, the exquisite wood grains and delicate shape of the violin or its larger sister the cello are rewarding to light. When shooting the shiny, reflective surfaces of the brass instruments be sure to make your own reflection as unobtrusive as possible. There is nothing worse than seeing the reflection of photographer and camera in the subject. Dulling spray from a photographic supplier can help combat this, although these days I tend to remove unwanted reflections in Photoshop. By the same token, try to avoid bad reflections of light in the polished wood of the string instruments, as this will spoil the depth and color of the wood grain.

Technique

This image of a butterfly sitting on a violin was originally taken as a portfolio shot, but was subsequently purchased by a client for use as a limited-edition poster in a competition. I shot the image with a wide-angle lens to give an exaggerated perspective, laid a timber floor, 1.8 x 2.4m (8 x 6ft), hung a blue paper background to the floor and stapled a length of baseboard to this. I then positioned the violin on top of the sheet music. I curled the pages and made a support for the violin using small blocks and Blu-Tack, and positioned the butterfly on the bridge. I used three lights: a softbox overhead (note the unobtrusive reflection of this in the wood); a linear strip with barndoors that created the shafts of light on the blue background; and a linear strip to the rear left, with clear glass bottles of water placed in front. These created the dappled light streaks on the floor.

5 x 4in camera ▷ 90mm lens ▷ f/32 ▷ 1/125 sec

Equipment

- ▣ Softbox, 140 x 100cm (4^2/$_3$ x 3^1/$_4$ft)
- ▣ Linear strip lights x 2, 30cm (12in)
- ▣ Glass bottles and water
- ▣ Small wooden blocks
- ▣ Blu-Tack

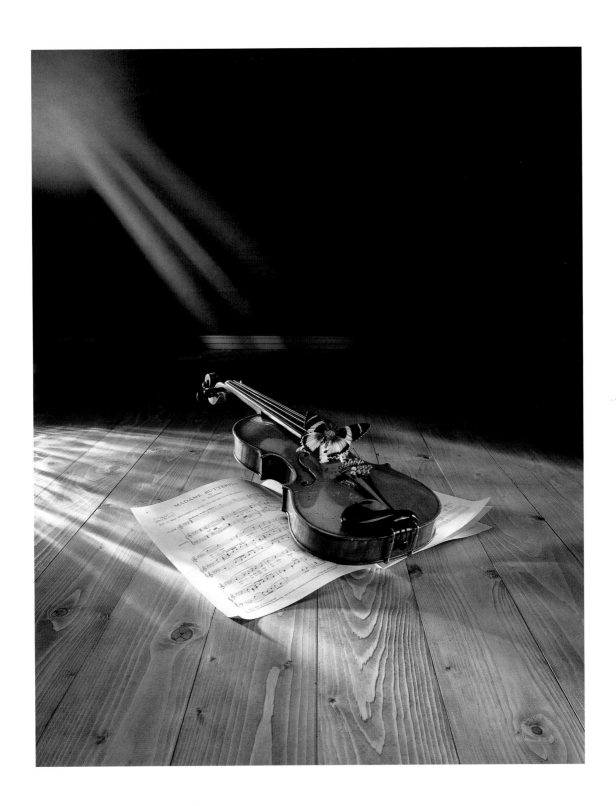

String Quartet

Shooting still-life objects gives photographers great scope in choosing their subject matter, visualizing how they want a shot to look, and experimenting with colors and lighting. If you don't have the "hindrance" of an art director or a brief to work to, feel free to play around and try out different ideas. Photographic lighting can never be learnt by hard-and-fast rules alone, although there are some basic dos and don'ts, and simple setups to start the lighting process. It is possible to learn the basic use of light and shadow through simple experiments. Take an egg or a cube of wood. Dim the ambient lights in the studio to low, and use just one photographic light; move it around the object and observe how this light affects the appearance of the object. You will notice how the light determines the form of the object as seen here, where it subtly defines the outline of the string instruments. Start making mental notes about how shadow and light can work for you.

Technique

Quite a high studio ceiling was required for this shot of a "string quartet," as the camera was set about 3m (10ft) above the instruments. I created a mottled background by sponging paint onto a large roll of brown paper. I positioned the cello first, then placed the other instruments, using wooden blocks to support them at the correct heights. I secured all the instruments with Blu-Tack. When I was happy with the arrangement, I started to set the lighting. I placed a large softbox to the left, pointing at 45° toward the set. I then placed two 30cm (12in) linear strip lights top right, and glass water bottles in front to create the effect of sunlight streaming in. Ordinary silver reflectors could be used to similar effect. Finally, I placed large white polyboards around the perimeter of the set to add some fill light to the shadows. As always, pay particular attention to any lens flare from the two lights top right, using black flags clamped into position.

5 x 4in camera ▷ 150mm lens ▷ f/22 ▷ 1/250 sec

Equipment

- 📷 Large softbox, 140 x 100cm (4²/₃ x 3¹/₄ft)
- 📷 Linear strip lights x 2, 30cm (12in)
- 📷 Brown, painted background
- 📷 White polyboard reflectors
- 📷 Black flags as required
- 📷 Wooden blocks and Blu-Tack
- 📷 Clamps and stands

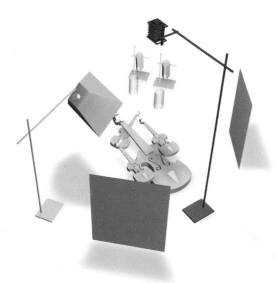

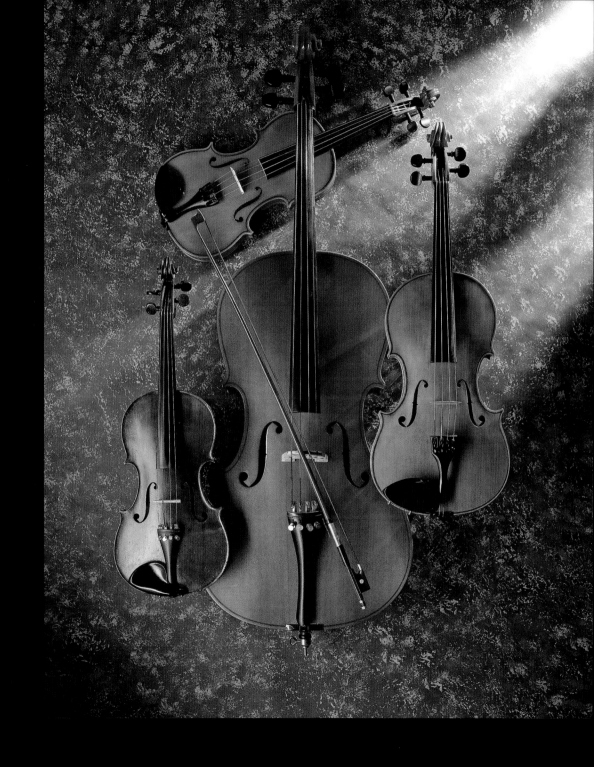

Artists' Paints

If you have spent hours moving a light around an egg (see page 60), you will have noticed that the direction of that light was instrumental in forming the character of the object. The existence of shadow helps to give shape and form. Indeed, the same object can be made to look very different merely by moving the light by a few degrees. It is this control that I find so compelling in photography. The saying goes that "the camera never lies." In fact, it can do, with the considered use of light. Armed with the lighting basics, you will soon be able to visualize your shot and know where to position your lights. With experience, this becomes second nature. All too often I see photographers take the safe road with their lighting; they choose to overlight with a flat, shadowless flooding of the subject, rendering a very characterless shot. Sadly, this seems to have become more prevalent in today's digital age.

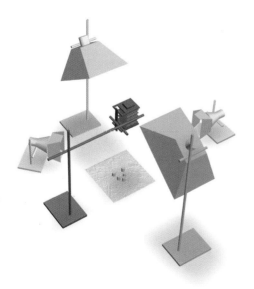

Technique

Artists' materials are always a great subject to shoot, with so many colors, textures, and interesting surfaces. The fun in this shot was laying all the materials out on the background. Once I had arranged everything to my satisfaction, I started the lighting process. I wanted to add some highlight and contrast to the shot, so I positioned one light low down, throwing light across the surface of the paints from the top left of the shot. I set the power of this light so it just started to burn out the white highlights. Don't overdo this, though! I then used two softboxes, one top, and the other bottom, to give an overall light. I used a fourth light with silver reflector and barndoors to add interest from the right of shot. This was also placed low to throw light across the paints. The hardest part of the shoot was clearing up afterward!

150mm lens ▷ **f/22** ▷ **1/200 sec**

Equipment

- 📷 Lights x 2 with silver reflectors and barndoors
- 📷 Softboxes x 2, 100 x 100cm (3¼ x 3¼ft)
- 📷 White card reflectors (optional)
- 📷 Black flags as required
- 📷 Paper or plastic background

Pumpkin Slice

Having chosen the subject matter for your shot, you will then visualize the way you wish the finished image to look. Have you ever noticed the feminine/masculine factor in photographic images? A lot of "masculine" products are shot with bold, contrasty high-key light, whereas more "feminine" subjects are shot with low-key light, with an air of softness and less bite. Once your subject is placed in front of the camera, place your first light; in my case, this is normally a softbox for overall light cover. Next, build up your other lights progressively in a logical manner. Look very carefully at your subject and evaluate what each light is doing. Keep turning your other lights off so you can really see the effect each individual light is giving. If it gives nothing, remove it. There is no point in making things complicated unnecessarily. I think my record for the most lights used in one shot was 14! It was just as well that the subject matter was not perishable, because it was impossible to get to it among all the stands, lights, and clamps. Now, here's the question: is the pumpkin masculine or feminine?

Technique

I love this shot of a slice of pumpkin; it shows just what can be achieved with a little imagination. This technique could be used for all manner of subjects, from fruit and vegetable slices to a printed circuitboard. The best thing is, it's all done with one light. Many people ask how it was done, expecting the process to be very complicated, but it is really simple. (I tell them it was very complicated, though—keep the mystery!) A hole, slightly smaller than the slice, was cut in a piece of Formica sheet. This was placed onto a sheet of glass to add support. The pumpkin slice was placed onto the Formica and was lit from below with continuous light. I shrouded the light in black card to stop any stray light escaping. I then turned off the studio lights, opened the lens, and exposed for a few seconds. It's a good idea to take test shots to determine the correct exposure time. Also be aware of heat buildup and fire risk when shrouding the light.

150mm lens ▷ f/11 ▷ c. 15 secs

Equipment

- 📷 Tungsten light
- 📷 Formica sheet or similar
- 📷 Sheet of ¼in (6mm) plate glass
- 📷 Trestles
- 📷 Black card or velvet as required

Writing Desk

Every lighting scheme must be built up logically. One important aspect of the photographic studio is the opportunity if provides for the photographer to turn the ambient studio lights off or down. Some circumstances, like burning in an LED display on electronic equipment or capturing the glow of a candle, require complete blackout. Without the facility to work in very subdued light, you will not be able to judge what your lighting is doing or adding to the shot. The procedure for lighting a still-life subject demonstrates many disciplines that are common to other genres of photography. By adding or subtracting light, you are refining your image until you finally make the exposure. So remember: visualize your shot, style and arrange the subject, choose your focal length, position the camera, start the lighting process, and finally, make the exposure. These processes are mostly interdependent; if you move a light, it may cast an unwanted shadow, thereby requiring a prop to be moved slightly, and so on. There are occasions when this process may not apply, as in this image. I started the lighting process, then realized that the only light needed was provided by the light in the shot. It worked just fine.

Technique

Things cannot get much simpler than this shot of items from the legendary Orient Express train. Primitive light sources, such as a lighted match, candle, oil lamp, or even that design icon the Anglepoise lamp, are often used to add atmosphere or propping, but in this shot, the only light source was the tungsten bulb in the table lamp. I set the camera up, placed the Orient Express menu and postcard in position, and took my light reading. I kept the camera setting on Daylight to give the warm tungsten color balance. If you are using film, remember to use daylight film to achieve the same result. Obviously, the greater the wattage of bulb used, the shorter the exposure time, but also the greater the heat generated from the bulb, so don't set fire to your lampshade! One final point: the exposure is likely to be several seconds, so avoid any movement in camera or on set.

50mm lens ▷ **f/11** ▷ **4 secs**

Equipment

- Lamp with tungsten bulb
- Tripod

Fish in Newspaper

I have already talked about shadow and its importance in giving a photographic image a sense of depth and dimension. There are two main types of shadow: the cast shadow and the bogus shadow (explained on page 118). The cast shadow is the area in which the light path is obscured, either partially or totally, by an opaque object between the projected light and the background. It is the area of darkness behind this opaque object that is the shadow. In the image here, look at the shadow cast by the newspaper and the glass containers, which are out of shot. In many instances a cast shadow will take the shape of the object, especially if a spotlight is used. The further away this light, the sharper the shadow becomes. This is known as a hard shadow. A softbox, in contrast, will project a very soft shadow. By experimenting with different light shapers you will learn how different types and densities of shadows can be cast.

Technique

This shot of whitebait in newspaper was shot for an advertisement for cooking oil. We cut out a piece of card in the shape of a fish and then glued the tiny whitebait to the card. Next, newspaper was folded to shape and the whitebait placed into the paper. A sheet of white marble was chosen for the background. I used three lights. The first was a softbox, placed overhead and to the top left. Next, I placed a light with a blue gel low down and top right. A milk bottle full of water was placed in front of this to cast a dappled light. On the left, I placed a 30cm (12in) linear strip light, on the same plane as the marble. In front of this I placed a large, clear plastic water jug with fluted sides, filled with water containing green food coloring. This light was aimed to miss the newspaper but cast the shafts of green light over the marble.

10 x 8in camera ▷ 360mm lens ▷ f/32 ▷ 1/125 sec

Equipment

- Softbox, 100 x 100cm (3¼ x 3¼ft)
- Light with silver reflector, 26cm (10¼in)
- Linear strip light, 30cm (12in)
- Blue gel
- Clear glass bottle
- Large plastic water jug with fluted sides
- Sheet of marble
- Black flags as required

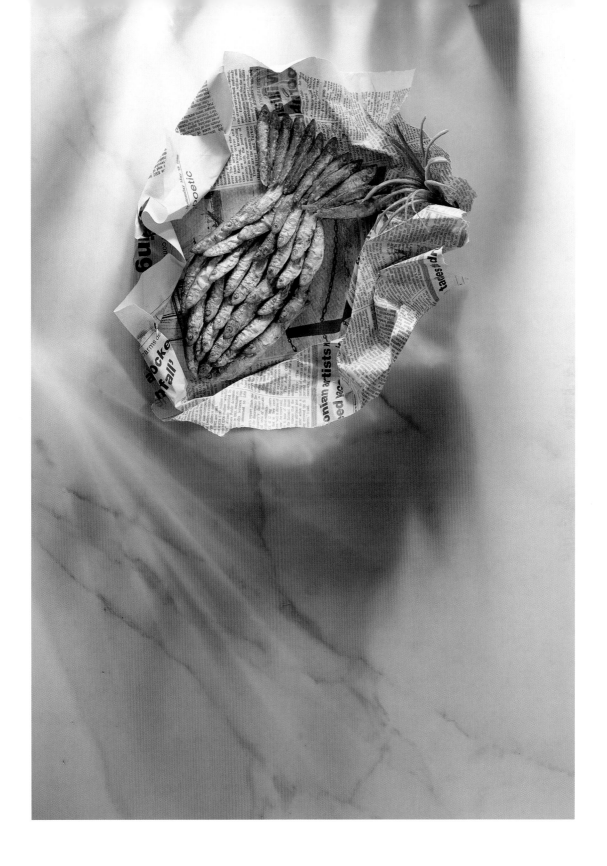

Torso

"Shadow definition" refers to how hard or soft the shadow is or, to put it bluntly, whether the edges of the shadow are sharp or fuzzy. The bogus shadow is shadow or tonal shading that is present on the subject's surface—the part where light does not fall—and naturally causes the tone to fade away, as on the muscle tone of the torso shown here. Without this bogus shadow, the contours and definition in the shot would be lost and the muscle would appear flat. For example, if you shine a light onto the side of a person's face, the shadow cast by the nose would be a true shadow. The shadow area on the cheek, beyond the shadow of the nose, is a bogus shadow. Another example of a bogus shadow is the shadow on the unilluminated part of a sphere—the shadow cast onto the background is the cast shadow. Using these shadow techniques will bring your subject to life.

Technique

The shots here of a male torso are a good example of how shadow can be used to emphasize toned muscles. If I had lit the model evenly with a softbox the contours of the muscle would have been lost. This shot used a simple lighting setup. Two lights, with 21cm (8¼in) silver reflectors, were used to illuminate the background, one on each side. The man was lit using one soft light (sometimes called a beauty light); this is a large white reflector 50cm (20in) or larger in diameter that has a central diffuser to slightly soften the light quality. This was placed about 1.8m (6ft) high, on the far right pointing down toward the model. His skin had been lightly oiled to give it some sheen. I also used a large white polyboard to add some fill light on the model's left side. The background lights were about ½ stop brighter than the main light to keep it bright and clean.

6 x 6cm camera ▷ 150mm lens ▷ f/16 ▷ 1/250 sec

Equipment

- Beauty light, 50cm (20in) or larger
- Lights x 2 with silver reflectors, 21cm (8¼in)
- White background paper
- White polyboard reflector
- Black flags as required
- Baby oil

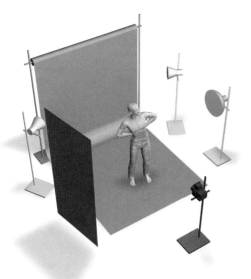

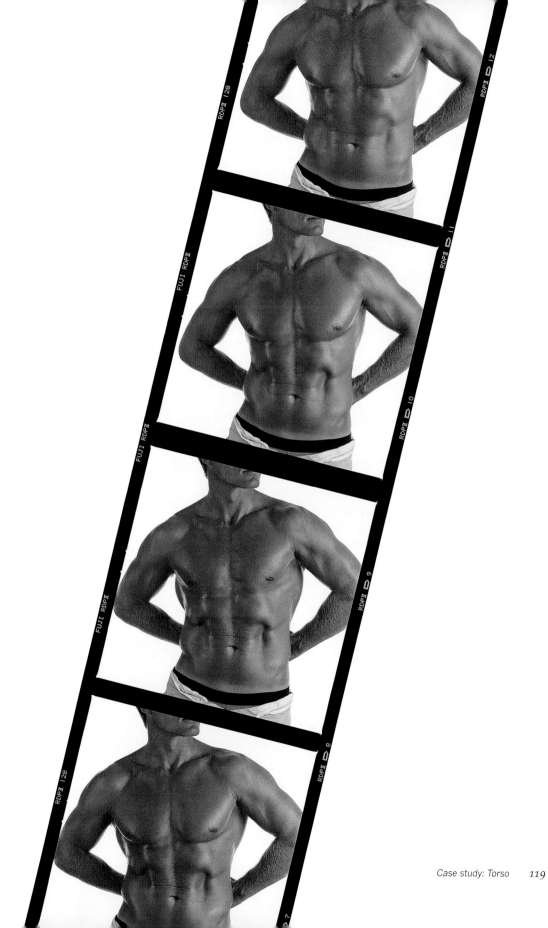

Panpipes

Another type of shadow is the isolated shadow. This is a shadow cast from an object that is some distance away from the background or subject. A good use of cast shadow is the mottled light used in the shot of the leather diary on page 87. Often I throw shapes and shadow effects onto a subject or background with the use of gobos in an ellipsoid spotlight. These shapes are often called "cookies" in the movie world. You frequently see a slatted-blind effect projected onto a background to suggest the presence of a window, and so on. Don't be afraid to experiment with these techniques. I have even cast shadows into a shot by shining a light through a beer crate. You can make your own cookies from sheets of black card. Just cut random shapes and place them in front of your light. Such shapes can provide a subtle, dappled light, casting soft shadows that add mood to a shot. I used this technique for the shot of the panpipes opposite.

Technique

This shot of panpipes formed part of the same series as the string instruments illustrated on page 109. Again, I created a background by sponging paint onto a blue paper background. I wanted to create a South American feel to the shot, so placed a poncho on the painted background. Next I placed the panpipes into position. I wanted a semi-hard key light, so I used a silver reflector with Tough Frost placed low and to the right. I placed a homemade black card cookie in front of this to add a bit of shadow. I placed a large white polyboard on the top right to add fill to the left side. Finally, a softbox strip light was placed low on the opposite side to the silver key light to add a little highlight along the left side of the panpipes. Again, this was very simple but very effective.

5 x 4in camera ▷ 150mm lens ▷ f/22 ▷ 1/250 sec

Equipment

- Light with silver reflector, 21cm (8¼in)
- Strip-light softbox
- Tough Frost or Trace
- Black card cookie
- Black flags as required
- White polyboard reflectors
- Background material

TALKING POINT...
The prop maker

THE PHOTOGRAPHER

Still-life photography gives photographers
a great opportunity to choose their subject matter
according to their own personal choice and interest,
and to visualize their shot without any external
constraints. There is no set of rigid rules or lighting
schemes to adhere to. You have a blank canvas,
light at your disposal, and many, many ways of
using it. Experiment with different light shapers,
shadows, texture, and color, and you will learn a
great deal. Don't forget to keep notes and lighting
diagrams—they will become an invaluable
reference tool and give you the bare bones upon
which to build future lighting setups. Remember
that how you use your lights has an enormous
influence over how the finished image will look.
With an awareness of how the subtle qualities of
light can work, you will be able to create powerful
images with buckets of atmosphere.

THE PROP MAKER

My work as a modelmaker for the movie and
photographic industries enables me to live in a
childhood fantasy world of balsa wood and glue.
Well, it's more like composite plastics and resin
these days, but just as much fun. I would say that
prop makers need to be flexible, versatile, and have
an abundance of creative, problem-solving skills.
Nowadays we have many materials at our disposal.
I work in everything from fiberglass, latex, foam,
polystyrene, and metals, to good old wood. I have
to be "jack-of-all-trades," and this includes having
a basic knowledge of photographic and movie

lighting. Before a shoot I always discuss with the
photographer what he or she has in mind, and
go through, in detail, how he or she will light
and shoot the set. Having a basic knowledge helps
me enormously in understanding what is required.
I have gathered various tips and techniques from
attending shoots. To some extent, computer
retouching has made the modelmaker's task easier,
but I always like to do as perfect a job as possible
in the first place. It gives me pride.

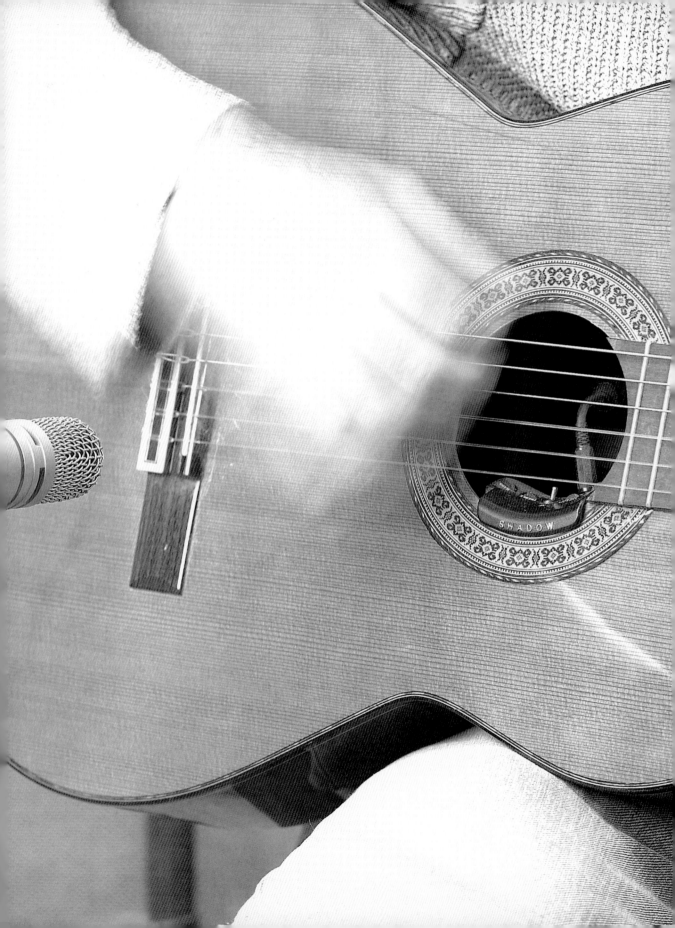

KEY
CONSIDERATIONS

GLASS &
REFLECTIVE
SURFACES

Photographing glass and reflective surfaces brings the photographer a whole new series of problems to overcome. I have spent many hours painstakingly moving an object a tiny amount one way and a tiny amount the other way in a quest to rid the shot of unwanted reflections. Moving the lights as well as the subject is often required, as well as a large helping of patience. There are certain useful techniques that you can employ, such as using dulling spray, dabbing the reflective surface with a substance such as plasticine, or using a polarizing filter—I discuss these techniques later in the chapter. However, even the most experienced photographer will face challenges and surprises when photographing shiny objects. Having mastered the basic skills, it is mostly trial and error. Often you can use the reflections to your benefit, as I did for the image of stainless-steel hoppers on page 135. Sometimes they can be a real nuisance. Today's photographers, of course, have the advantage of being able to eliminate unwanted reflections using a digital workstation, although this is not always a straightforward process.

Leather & Metals

Reflective surfaces can be so troublesome as to cause the studio photographer to contemplate a change of career. However, as you gain experience, the set of problems associated with reflections will become easier to deal with. Positioning and choice of light will be a key factor, but do not be surprised if you start reorganizing your entire set to make a reflection disappear or become unobtrusive and acceptable. In product photography, cellophane packaging can be particularly difficult, as the client wants to see their product beneath the cellophane in all its glory. Where possible, it is best to remove this shiny packaging carefully with a scalpel. If you are careful with your lighting, no one will notice that the packaging has been removed. I have also been known to remove the offending shiny surface when shooting watches and spectacles. Just be careful that your choice of shooting angle and lighting doesn't make it obvious that you have done this.

Technique

This handbag and cosmetics set was quite a challenge to photograph because of the shiny surfaces on the eyeliner pencils. The client also wanted the zips on the handbag and the logo on the cosmetics bag to stand out. The lighting setup for the smaller image consisted of two lights—one wide softbox strip on the left, and a slightly narrower one on the right. I used Blu-Tack to hold the zip tabs and cosmetics in place. The larger image was shot on shiny gold card with a thin sheet of nonreflective glass on top. I lit this from above with a square softbox positioned to produce the dark shadow. I then placed a softbox strip light above the camera at the front, and used white card reflectors to mask reflections. Finally, I retouched the images digitally to clean up the black lines and reflections in the gold.

150mm lens ▷ f/22 ▷ 1/160 sec

Equipment

- Strip-light softbox, 140 x 30cm (4^2/$_3$ x 1ft)
- Strip-light softbox, 100 x 150cm (3^1/$_4$ x 5ft)
- Large white card reflectors
- Softbox, 100 x 100cm (3^1/$_4$ x 3^1/$_4$ft)
- Gold mirror card
- Nonreflective glass sheet

Mixed Finishes

There are many different types of reflective surface. Simple flat surfaces, like a mirror, give directional light and will reflect only a limited area of their surroundings. Other surfaces, such as those of a brass fruit bowl or a stainless-steel saucepan, are convex. Convex and concave objects will reflect large areas of their surroundings; in the studio this will most probably include the camera, together with the lighting and other equipment. Such unwanted reflections need to be controlled. Glassware and liquids cause their own set of problems—they not only *reflect* light, they also *transmit* it. Fill a glass with water and notice the exaggerated image as you look through that glass. It acts like a fisheye lens. You will probably see an almost 360° view of the room. All these different types of reflections can be controlled; it just takes a little lighting magic.

Technique

The hairdressing tools shown here were all shot to be used as cutouts. Some of the surfaces were chrome, others had a satin finish. I used only two lights: one large softbox and one strip-light softbox, with white card reflectors and strips of black card to reflect black lines into the surface. To light the upright clippers, I placed one softbox on the left and the strip light on the right. Keep such lights quite close to the subject: this helps to block out the studio surroundings. Place white card to fill any spaces so that you just have white reflected. Then place strips of black card in front of the white to reflect some black "modeling" lines back into the surfaces. I shot the curling tongs in a similar way, but placed the softbox overhead and the strip light at table level. Again, I used strips of black card to add dark lines and give the subject definition.

200mm lens ▷ f/32 ▷ 1/160 sec

Equipment

- Softbox, 100 x 100cm (3¹/₄ x 3¹/₄ft)
- Strip-light softbox, 100 x 30cm (3¹/₄ x 1ft)
- White card reflectors
- Black card strips
- Sticky tape and Blu-Tack
- Clamps and stands

Glass Bottles

There are many different disciplines involved with photographing reflective objects. Glass can look very pleasing—I would go so far as to say dramatic—if lit well. Backlighting is always a good starting point. Placing a large, translucent Perspex sheet behind the set and lighting it from behind to form a large lightbox, or simply reflecting light off a white paper background, will give the desired effect. Providing the glass and the liquid it contains are both fairly transparent, you will find that the reflections on the front surface of the glass are cancelled out. If you look at this photograph of classic olive oil bottles you will notice that the dark green "extra virgin" olive oil retains some front reflection, but this has gone from the thinner oil. Backlighting, when applied correctly, will also help to emphasize the shape of a bottle. Try graduating the backlight to see what a difference this makes.

Technique

I love olive oil and am always amazed at the different types available, and how different and varied the tastes can be from region to region. The shot you see here was used in a book about healthy living. Sourcing the props wasn't difficult, as there is a vast array of bottle designs available. I set up my backlit Perspex background and used two diffused, wide-angle reflectors to light this from low down. You can see the slight fade toward the top of shot. You can easily vary this by moving the lights. I wanted some highlight in the glass, so I used a light diffused with a square-cut piece of Tough Frost on the right, and a light diffused with a round-cut Tough Frost on the left. I kept both these lights well back from the set to keep their reflections in the glass small. With such a setup, you can also add white reflector cards where necessary.

180mm lens ▷ f/22 ▷ 1/200 sec

Equipment

- 📷 Lights x 2 with wide-angle reflectors, 21cm (8¼in)
- 📷 Lights x 2 with reflectors, 26cm (10¼in)
- 📷 Tough Frost or Trace
- 📷 White Perspex sheet
- 📷 White card reflectors
- 📷 Black flags as required

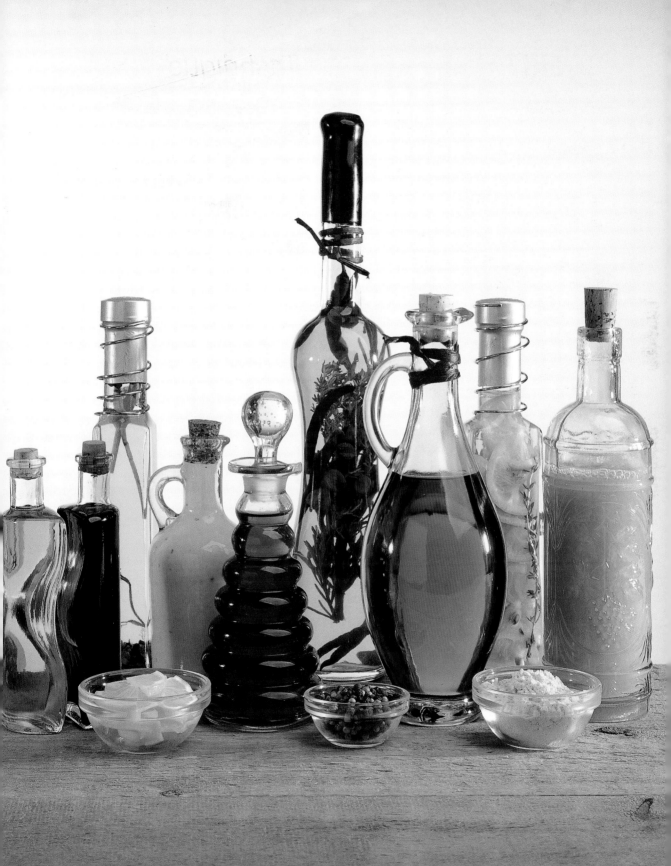

Stainless Steel

The best attitude to take when photographing shiny objects is a determination to rise to the challenge. Just as you would take time to bring out the detail in a textured object, with shiny surfaces you need to put effort into making those reflections work for you and look pleasing to the eye. With a little effort, miracles can be performed. Take these stainless-steel hoppers used in a pill factory—cleaned up and with the correct lighting, they look fantastic. There are many ways to set your lights up when shooting shiny objects. Many of these will involve trial and error, but that is the beauty of studio photography—you control the light. One useful technique is to keep your lights well back from the set and well disguised. This, combined with the careful use of reflectors and some black velvet to mask the studio environment, can work very well.

Technique

This shot was taken for a client who produces steel fabrications. It took some time to construct the set and polish the stainless steel, but it was well worth the effort. I hung a painted, graduated background behind the set. Next, I placed the subject on a white background, raising the front hopper up on hidden wooden bricks to add interest. The back hopper I clamped to hold it upright. I then used a large softbox overhead, placing large polyboard reflectors from this light down the left and right sides. I placed a softbox strip next to the camera, which was set behind some black velvet with a hole cut out for the lens. I also placed a large white polyboard to the left of camera. You can see both of these clearly in the front reflection. All this effectively produced a "light tent" around the subject, cutting reflections from the surrounding studio.

240mm lens ▷ f/32 ▷ 1/125 sec

Equipment

- Softbox, 145 x 145cm (4³/₄ x 4³/₄ft)
- Strip-light softbox, 140 x 30cm (4²/₃ x 1ft)
- White polyboard reflectors
- Black card and velvet
- Wooden blocks
- Painted, graduated background

Silk

The careful positioning of your lights is a key skill with photographing glass. Many people find this difficult at first, but you will soon be able to read what effect a light will have before you place it. This shot was quite complicated to set up. The products are sitting on a sheet of glass positioned 30cm (12in) above the bottom layer of silk. You will notice that, despite this sheet of glass, there are no reflections to be seen. I achieved that by placing the lights well away from the glass and using a relatively long lens to keep the camera as far away as possible as well. By lighting the first layer of silk with direct and indirect light, I created a backlit effect. Although the product is sitting above the silk, to the viewer the setup looks as if it is on one plane.

Technique

This shot was quite complex. I arranged the first layer of silk on a baseboard on the floor. Next I supported a clean sheet of glass about 30cm (12in) above this silk, making sure the supports were covered in black to stop them causing reflections anywhere. I then arranged the products roughly in place so I could position the camera at the correct height. I used a long lens to make the camera-to-product distance as far as possible, thus minimizing any reflection of the camera. I then positioned the products properly, and added more silk on this second level. I used two softboxes, one top right and the strip on the far left. I used two lights with silver reflectors to light the lower layer of silk. With careful adjustment of these lights, it was possible to avoid all reflections in the glass. In similar situations, be sure to flag any lights and make sure the studio is blacked out.

240mm lens ▷ f/32 ▷ 1/250 sec

Equipment

- Lights x 2 with silver reflectors
- Softbox, 100 x 100cm (3¹/₄ x 3¹/₄ft)
- Strip-light softbox, 100 x 30cm (3¹/₄ x 1ft)
- Sheet of plate glass, 5mm (¹/₄in)
- Timber supports
- White card reflectors
- Black flags as required
- Black gaffer (duct) tape
- Clamps and Blu-Tack

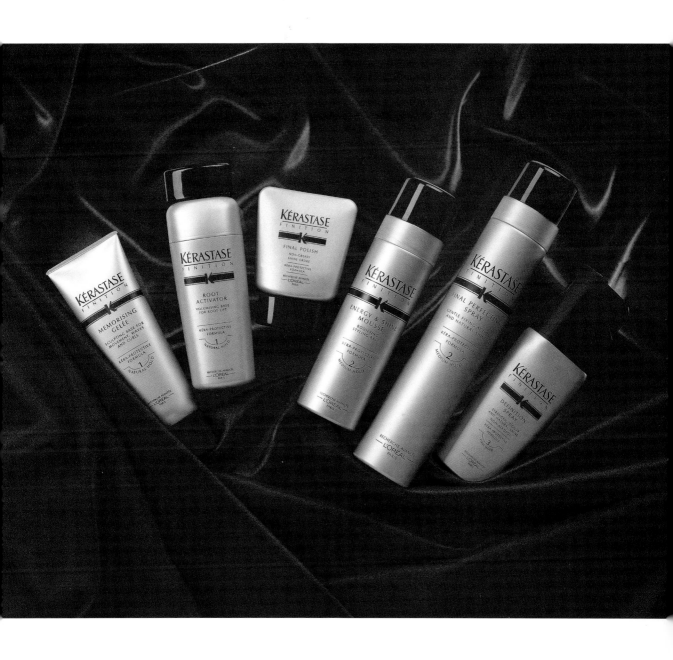

Brushed Metal

By far the safest and easiest light to use when shooting highly reflective surfaces is a large white softbox. This is mainly due to the uniform and clean shape that is reflected. Avoid using photographic umbrellas at any cost! They look dreadful, in my opinion, when reflected in shiny objects. Generally, the more opaque the diffusing material, the more even the light. You don't have to keep to a square reflection, either. Try cutting a circle out of a sheet of black card. The size you need will depend on the size of your softbox. Place the card over the front of your softbox to obtain an evenly diffused, circular light. This technique also works well for portraiture, because you achieve an attractive round light that is reflected in the subject's eyes. And don't limit yourself to squares and circles; cut out a triangle or any other shape that appeals to you.

Technique

These corkscrews were shot using just one softbox together with some white card reflectors. The darkness of the surrounding studio was sufficient to hold the edges, but you could use black card strips, if necessary, to put some dark lines back in. I placed the objects on a white background and positioned the softbox so it was reflected in the surface of the corkscrews. Notice how well this brings out the "brushed" surface of the metal. The colored reflection in the shot of the pair of corkscrews was achieved by placing some small strips of colored gel over the diffused surface of the softbox. This gave a little lift to the picture. This image was used as a more creative shot, whereas the other two, overhead photographs were used as cutouts. In similar situations, make sure you expose correctly to avoid any loss of detail.

50mm lens ▷ f/8 ▷ 1/125 sec

Equipment

- Softbox, 100 x 100cm (3¼ x 3¼ft) or larger
- White card reflectors
- Black card strips as required
- Colored gels as required

Polished Aluminum

So far I have discussed how to avoid unwanted reflections, but, of course, you can also deliberately introduce reflections. You could, for example, cut out a window-effect mask from black card and place this over a softbox so that it reflects back into, say, a polished stainless-steel kettle. You could also place objects relevant to the subject matter close to the object and include their reflections. Make sure this does not look messy and complicated, however. It's also not good form to have the camera and photographer in the reflection! Another quick and simple method that I have used to light a collection of reflective objects, such as a pile of stainless-steel saucepans and cookware, was to bounce light off a white studio ceiling. This worked well because of the distance the light had to travel. I disguised the lights and their stands with black velvet and pieces of card. These days it is also possible to do any final cleaning up on computer.

Technique

This mountain bike was made of polished aluminum and the client wanted to show that detail. I placed a 4.2 x 2.1m (8 x 4ft) white-painted background at a 45° angle, raised at the back, and placed the bike on the back edge of this. I hung a gray paper background to the rear of the set, and placed a double bank of softboxes on boom-arm stands above the bike. This light bank measured 200 x 100cm (6½ x 3¼ft). In front of the bike I placed a 140cm (4²/₃ft) strip light horizontally at floor level. These two light sources produced the highlights visible in the top and bottom of the frame. At each end of the set I placed large white polyboard reflectors. To shine light into the crank and gears I used two snooted lights. The "shaft of sunlight" effect was produced by shining a 30cm (12in) linear strip, with barndoors closed, onto the background.

200mm lens ▷ f/22 ▷ 1/125 sec

Equipment

- Softboxes x 2, 100 x 100cm (3¼ x 3¼ft)
- Strip-light softbox, 140 x 30cm (4²/₃ x 1ft)
- Lights x 2 with silver reflectors and snoots
- Linear strip light, 30cm (12in)
- White reflectors x 2, 2.4 x 1.2m (8 x 4ft)
- Gray background paper
- Boom arms and various stands
- White timber, 2.4 x 1.2m (8 x 4ft)

Stainless Steel & Cheese

Using a light tent is a popular technique for avoiding unsightly reflections. As the name suggests, a light tent is a "canopy" constructed from a diffusion material. The object to be shot is placed inside this tent. There is a small hole for the camera lens to poke through, and the lights are placed around the outside of the tent. You can purchase commercially made light tents, but they are simple enough to construct yourself, as I did for the shot of the fondu set here. I usually make a large-diameter upright tube with Tough Frost and tape a lid made of the same material to this. I then suspend my tent from a boom arm or the ceiling. It is easy to lift up in order to gain access to the interior. Then you just need to cut a very small hole for the lens on one side. The only drawback is the loss of edge definition due to the lack of any shadow, but you can redress this by introducing black card strips.

Technique

This shot of a bubbling cheese fondue was taken for a cookery book. I liked the contrast of the pure, clean lines of the fondue set with the food. The key to this image was to surround the table setting with as much white as possible. I hung wide white background paper to the rear of the set, placed a large white softbox overhead, and reflected two lights off the white background. Using Tough Frost, I diffused a light with a silver reflector and placed this to the rear right of set. This was about ¾ stop brighter than the softbox. I placed an ellipsoid spot, aimed at the food on the skewer, at 90° on the left. Finally, I placed large white card reflectors as close to the set as possible without being in shot, to block any unwanted reflections in the fondue set. If you try this yourself, remember to stop any lens flare.

180mm lens ▷ f/11 ▷ 1/200 sec

Equipment

- Softbox, 140 x 100cm (4²/₃ x 3¹/₄ft)
- Lights x 2 with silver reflectors, 21cm (8¹/₄in)
- Tough Frost
- Ellipsoid spot light or similar
- White background paper
- Large white reflectors
- Black flags as required

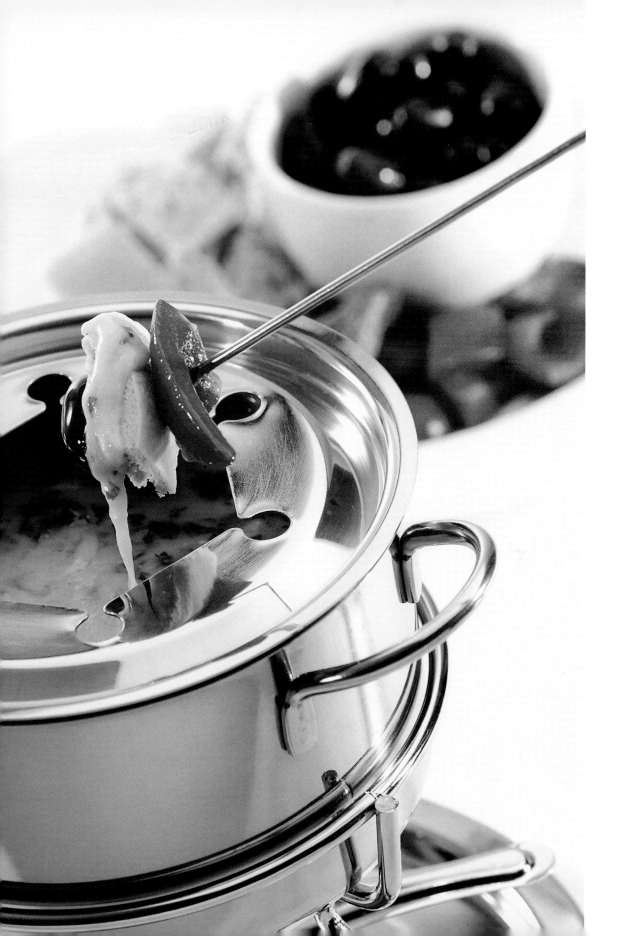

Polished Aluminum

So far I have discussed how to avoid unwanted reflections, but, of course, you can also deliberately introduce reflections. You could, for example, cut out a window-effect mask from black card and place this over a softbox so that it reflects back into, say, a polished stainless-steel kettle. You could also place objects relevant to the subject matter close to the object and include their reflections. Make sure this does not look messy and complicated, however. It's also not good form to have the camera and photographer in the reflection! Another quick and simple method that I have used to light a collection of reflective objects, such as a pile of stainless-steel saucepans and cookware, was to bounce light off a white studio ceiling. This worked well because of the distance the light had to travel. I disguised the lights and their stands with black velvet and pieces of card. These days it is also possible to do any final cleaning up on computer.

Technique

This mountain bike was made of polished aluminum and the client wanted to show that detail. I placed a 4.2 x 2.1m (8 x 4ft) white-painted background at a 45° angle, raised at the back, and placed the bike on the back edge of this. I hung a gray paper background to the rear of the set, and placed a double bank of softboxes on boom-arm stands above the bike. This light bank measured 200 x 100cm (6½ x 3¼ft). In front of the bike I placed a 140cm (4²⁄₃ft) strip light horizontally at floor level. These two light sources produced the highlights visible in the top and bottom of the frame. At each end of the set I placed large white polyboard reflectors. To shine light into the crank and gears I used two snooted lights. The "shaft of sunlight" effect was produced by shining a 30cm (12in) linear strip, with barndoors closed, onto the background.

200mm lens ▷ f/22 ▷ 1/125 sec

Equipment

- 📷 Softboxes x 2, 100 x 100cm (3¼ x 3¼ft)
- 📷 Strip-light softbox, 140 x 30cm (4²⁄₃ x 1ft)
- 📷 Lights x 2 with silver reflectors and snoots
- 📷 Linear strip light, 30cm (12in)
- 📷 White reflectors x 2, 2.4 x 1.2m (8 x 4ft)
- 📷 Gray background paper
- 📷 Boom arms and various stands
- 📷 White timber, 2.4 x 1.2m (8 x 4ft)

Glass Phials

By producing good lighting, photographers can bring out the best qualities in the material they are shooting. Photographing glass requires capturing the transparency of the glass, the smoothness of its surface, its crystal-like sparkle, and the shape and form of the object. Backlighting is one of the best ways to bring out these attributes, although backlighting alone will not be sufficient. Using a front light as well will bring out the reflective qualities. You may also need to enhance the subject's shape and form. Try using black card to throw shadow into the subject's surface, or introducing shadows via backlighting. The shot of medical phials opposite was achieved using this technique, which I feel gives depth and 3-D qualities to the image. Don't be afraid to introduce color into your photograph. You can capture attractive images by filling glass bottles with colored liquids.

Technique

A packaging company arrived at my studio one day with a box of small glass phials and corrugated-card packing materials. They wanted me to produce shots for use on exhibition display panels. First, I set up a table using a sheet of wired security glass that I had in my props store, about 60cm (2ft) above a sheet of large white card. I set up the camera above this, shooting vertically down. I then experimented with the position of the phials until I was satisfied with the design. At each side, left and right, I placed a strip-light softbox. Next, I positioned three lights with barndoors to throw shafts of light onto the white background. The white card packaging looked a little dull, so I added some color by using a mini-spot and blue gel. Finally, I balanced the lights to obtain the correct exposure.

105mm macro lens ▷ f/11 ▷ 1/125 sec

Equipment

- 📷 Strip-light softboxes x 2, 100 x 25cm (3¹⁄₄ft x 9³⁄₄in)
- 📷 Lights with silver reflectors and barndoors x 3
- 📷 Mini-spotlight
- 📷 Blue gel
- 📷 Sheet of wired security glass
- 📷 White background paper
- 📷 Clamps and supports

Gold Plate

At the beginning of this chapter I mentioned a few of the tricks that can be helpful when dealing with unwanted reflections. One of those was dulling spray. This is a commercially made product widely available from photographic suppliers. In the old days it consisted of beeswax in aerosol form. These days it has different ingredients, and comes in semi-matte and full-matte varieties. (Another useful tip is that hairspray produces a similar result.) Dulling spray is effective for some jobs, but should be used with caution, as it can give a very false look to shiny objects and alters the metallic appearance of the finish. It is always best to experiment first. I have always found dulling spray an essential part of my studio equipment, and it has got me out of trouble many times. It can easily be cleaned off afterward with a cloth and a little solvent.

Technique

This shot of ice cream in a gold-plated bowl (plated especially for the shoot) is an interesting one. The client wanted the bowl to be a pure gold to show off their "king" of ice creams. Normally the temperature of the ice cream would have caused condensation once it came into contact with the bowl, thereby marring the gold effect. To overcome this problem I had to keep the ice cream and the bowl separate. First I filled the bowl with polystyrene chippings. Next I cut out a small circle of polystyrene and sat this on the chippings in the bowl. This disc provided a base for the ice cream scoops to sit on, and kept them from the surface of the bowl. The bowl and the ice cream were now effectively insulated, with no condensation the result.

240mm lens ▷ f/32 ▷ 1/160 sec

Equipment

- Softbox, 100 x 100cm (3¼ x 3¼ft)
- Strip-light softbox, 100 x 25cm (3¼ft x 9¾in)
- Metal bowl
- Black velvet
- Black silk
- White card reflectors
- Polystyrene chippings
- Polystyrene sheet

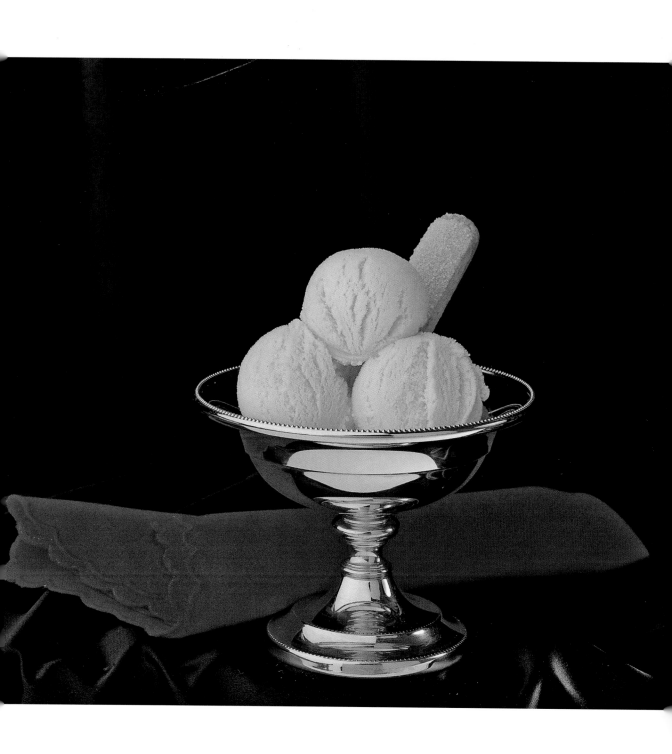

Liquid in Glass

A polarizing filter is another useful piece of kit for dealing with unwanted reflections. These filters work only with nonmetallic surfaces, so they are most effective when employed for glass and plastic packaging. A polarizer is neutral in color, but cuts down on the light entering the lens, so an increase in exposure will be required. As well as attaching a polarizing filter to the lens, you can obtain sheets of polarizing material to put over your lights. In tricky situations a combination of the two can provide a solution. There are two types of lens filter: linear and circular. They do the same job, but linear filters can sometimes interfere with the camera's exposure control, so check with your camera manufacturer which one you should use. Using polarizing filters is really a matter of trial and error, but you will be able to judge the results instantly and gauge whether the filter will be effective in that situation.

Technique

The two shots shown here, taken for a world-renowned cosmetics company, both contain a glass perfume bottle. I lit the shot so as to produce a pleasing result in the reflections on the lipsticks. You will note that I kept the lid of the eyeshadow palette partly closed so that its mirror reflected the color patches. When all this was done the little perfume bottle looked dull; it needed some life and sparkle. The trick I used will work with all manner of liquids and drinks in glasses. Get some gold or silver mirror card (which one to use will depend on the subject), cut out some tiny reflectors, and place these behind the bottle to shine light through the glass. You will probably spend hours fiddling to get the effect right, but it will be worth the effort. Sometimes the top- or sidelights will produce enough reflection, but if they don't, shine a mini-spot at your little reflector to increase the intensity of the highlights in the glass.

360mm lens ▷ f/45 ▷ 1/200 sec

Equipment

- Softbox, 100 x 100cm (3¼ x 3¼ft)
- Softbox, 100 x 20cm (3¼ft x 7¾in)
- White card reflectors
- Grey-to-white graduated background
- Sheet of silver or gold mirror card
- Blu-Tack or plasticine
- Mini-spot or snooted light if required

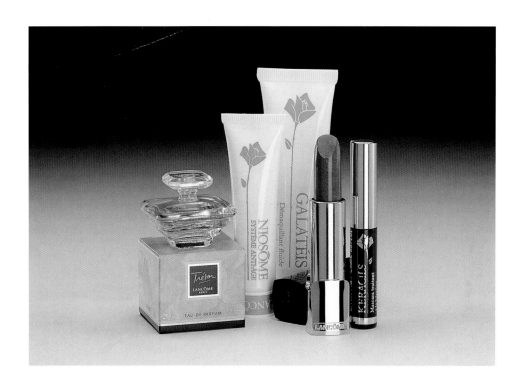

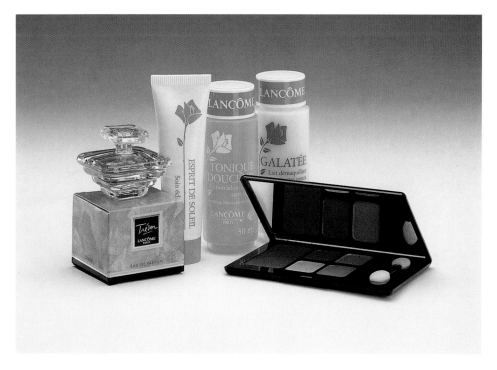

TALKING POINT...
Lighting for exhibitions

THE LIGHTING DESIGNER

My specialist area of lighting design is exhibition
and retail lighting. Lighting is crucial to an exhibition
or display. The ambience it creates plays a major
part in attracting customers into that space. My role
is to light the area, which is, effectively, a small,
defined presentation area within a much larger
space, in such a way that once entered, the space
is lively and interesting. My job as a lighting
technician has many parallels with that of a studio
photographer. We both have the task of lighting
to highlight the best attributes of the product or
subject, although I may light things in a more
dramatic way to give immediate visual impact.
The differences are that my lighting is usually
temporary, with an active life of just a few days,
and I have to be very aware of the heat my lights
generate. I prefer using metal halide and compact
fluorescent sources, as they require less cooling.
An exhibition space that is too hot is not a pleasant
environment in which to be, and prospective
customers will not hang around. Lamps of a cooler
color balance, around 4,000 K, tend to render better
color quality although, in the main, we tend to use
slightly warmer lamps of around 3,000 K. For some
reason, visitors find the warmer balance inviting,

LOOK AT

- The use of color temperature and accent lighting
 to manipulate mood
- The use of natural vs artificial light
- Considerations of heat generated by equipment

CREATIVE TECHNIQUES

In this chapter I have included examples of photography that don't really fit into a specific genre, but that illustrate how a little ingenuity and thought can add something extra to an otherwise unexciting subject. There are many factors that determine the success or failure of a photographic image. Subject and composition are, of course, important, but by far the most crucial aspect of the image-making process is the lighting. When you shoot outside using the sun as your sole light source, the position of the sun in relationship to your subject can change the mood of the shot dramatically. From sunrise to sunset, the quality of light alters and subtle changes in color occur. In overcast conditions the light softens in much the same way as that achieved with a studio softbox. You can position your subject to use backlighting, and at midday, when the sun is highest, you can toplight. Watch and learn how the sunlight illuminates our world, then transfer this knowledge to the studio where you will have the added advantage of being in control of the light. In this chapter, not only will you see how lighting can work for you, but you will learn how you can combine this with a little creative set-building to produce powerful and atmospheric images.

Bubbles

For me, problem-solving is by far the most enjoyable part of my job. We photographers are incredibly lucky in having a career that combines freedom of creativity (to a degree dependent upon the art director!), technical skill, physics, and mechanics; if you have a few construction skills as well, the job becomes even more interesting. I am blessed in that I can turn my hand to most set-construction techniques, mainly due to the skills my father taught me when I was a boy. Together we were always building things, mending cars, rewiring this, replumbing that. All this proved to be invaluable training, enabling me to fulfill photographic briefs with ease. Whether a complete room set was required, or an intricate paper model, I have been able to make them all in-house.

Technique

The shot seen here may seem strange taken out of context. My brief was to illustrate a new contact lens called Calendar. It is a slightly tangential concept, but I thought the bubbles that kids blow using dish soap looked rather like contact lenses. The "calendar" part comes from the pages of a diary falling to the ground. I used a dark-painted background so that the bubbles would show up clearly. I glued the calendar pages to some fishing line and suspended that from the ceiling. The woman is lying on a bench that I had constructed and covered with black velvet. I used one large softbox overhead and white reflectors at each side of the set. I needed the bubbles to rise, so I made a curved card scoop and placed this on the floor between the background and the model. I set up a fan heater to blow hot air gently into this; hot air rises, and so did the bubbles. Simple lighting—moody effect.

150mm lens ▷ f/16 ▷ 1/250 sec

Equipment

- Softbox, 140 x 100cm (4²/₃ x 3¹/₄ft)
- Large white polyboard reflectors
- Painted background
- White card
- Electric fan heater
- Fishing line and glue

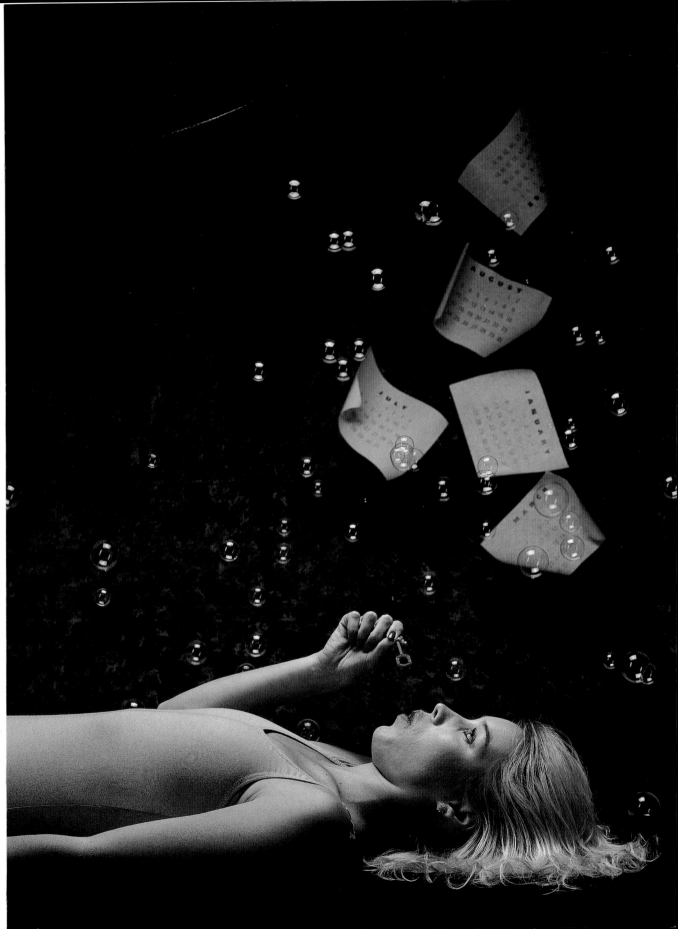

Staggered Exposure & Flash

To continue with my room-set reminiscence just a little longer—it is an important financial issue for a studio photographer—room sets are made up of timber "flats." I had devised a series of these flats that I could store when not needed and simply bolt together in different configurations. I would then construct custom flats only to accommodate doors, windows, or other features. This saved a lot of time. After the first couple of jobs the flats had paid for themselves, and they became a valuable revenue stream as I charged the clients for set construction on future jobs. The construction process normally took around two days. Where possible we used quick-drying paints and materials. We used double-sided tape to apply features such as baseboards and dado rails. Durability was not an issue as the set only had to last a day before it was broken down.

Technique

This is a shot of a classic British Christmas pudding complete with flaming brandy. I had to use black for the background so as to show up the flames. I used two lights. On the left I placed an ellipsoid spot with warm-up gel, set around 1 stop brighter than the front light. This not only lit the pudding, but also highlighted the holly on top. The second light was a strip-light softbox, used front right. Once everything was in place I poured brandy over the pudding, turned out the studio and photographic lights, opened the lens, then lit the brandy. I exposed the pudding for a few seconds before firing the flash lighting, then closed the lens. When trying this for yourself, you will need to take several shots at varying exposure times until you find the correct interval. Avoid camera or set movement at all costs.

150mm lens ▷ f/16 ▷ timed exposure plus flash

Equipment

- Strip-light softbox
- Ellipsoid spot or similar
- Warm-up gel
- Black velvet
- White card reflectors
- Fire extinguisher!

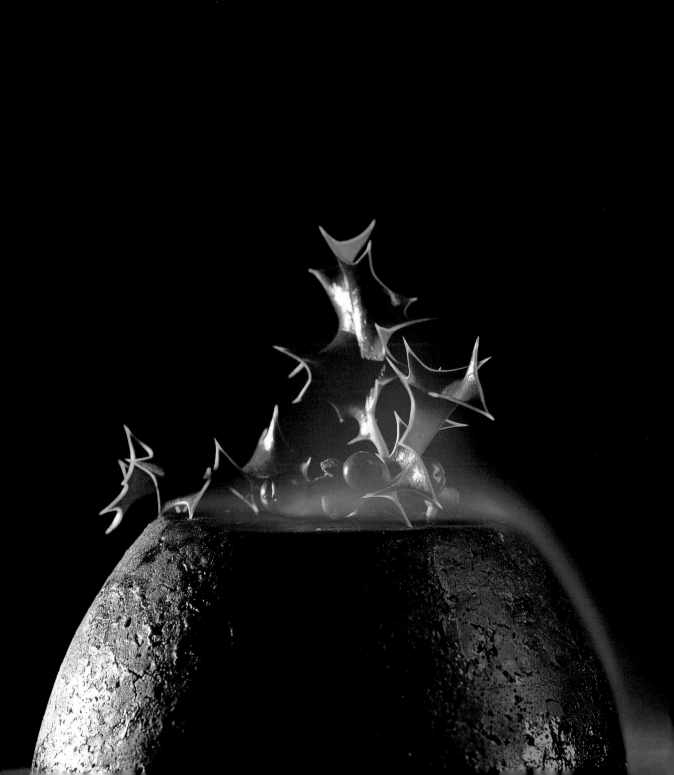

Water Shot 1

For me, lighting room sets and creative displays such as this water shot is always a joy. Some photographers like to use tungsten light because of the amount of light needed to illuminate a set. It takes thousands of joules and many flash packs. However, times have changed. More powerful flash is available at less cost these days and, with the use of high-resolution digital SLR cameras, we are shooting with wider apertures and thus require less light. Lighting a room set really depends on the atmosphere required. Usually there is a window to light. I find the easiest way of dealing with this is to backlight by bouncing light off a suitable backdrop, such as a sky blue. I might also put a plant in front of it. I then overexpose or flare this light by two stops, to give the appearance of a bright light through the window. For the room itself, soft lighting is the order of the day.

Technique

Suspending this fruit in water was fairly simple, and I positioned the product in the same way. I filled a 90 x 60cm (3 x 2ft) aquarium with water, then set up a blue background and lit that with an ellipsoid spot and gobo to project the ripple effect. Next I set up an air pump (the type used in fish tanks) and placed the tubes and air bricks out of shot. Using "suckers," again available from an aquarium shop, I attached slices of fruit to three different sheets of glass and the shampoo bottle to a fourth. These sheets I lowered carefully into the tank, with spaces between them. I had to adjust the position of the fruit to obtain the desired effect. Two softboxes provided the frontlighting. When all was in place I switched the air on, the bubbles flowed, and the exposure was made. With shots such as this, it is well worth spending some time balancing the light until the effect looks good.

240mm lens ▷ f/32 ▷ 1/125 sec

Equipment

- Softboxes x 2, 100 x 100cm (3¼ x 3¼ft)
- Ellipsoid spot with gobo
- Glass aquarium
- Clear glass sheets x 4
- Air pump, tubing, and aerator bricks
- Blue background paper
- White card reflectors
- Clamps and fixing suckers

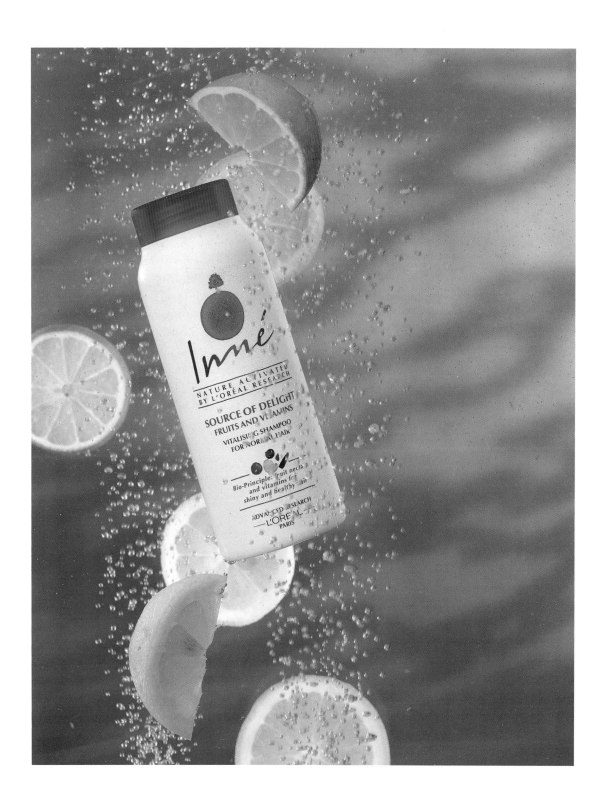

Water Shot 2

To create a softer light for this shot, I stretched Soft Frost (a more flexible form of Tough Frost) over a 4.2 x 2.1m (8 x 4ft) wooden frame. This was supported upright. I then put two, or even three lights behind this to create a very large softbox-type light. I could move the lights closer or further away from the screen to change the diffusion and intensity until I achieved the result I desired. I added more localized light using snooted lights, often combining this with the tungsten light of table lamps or wall lights built into the set. Another method, but one with no directional control, is to bounce light off a white ceiling. This is a technique I often use when photographing rooms on location. It is very much a case of playing with the lights—turning some up, turning some down—shooting test Polaroids, or looking on the computer screen until you achieve a lighting balance you are satisfied with.

Technique

This water shot was photographed from above. I had a very strong water tank made with a 10mm (³/₈in) glass base. This was supported on a wooden frame. There is a tremendous amount of weight to support, so if you try this out be very careful and over-engineer your set. I lit the blue background paper, which I had placed on the floor, using a light with a 26cm (10¼in) silver reflector. Be very careful of heat, as it could crack the glass. I then filled the tank with water and used beer glasses to support the products on its surface. For the green products I used the glass-domed top of a cheeseboard as the support. This gave the impression of a round "ripple." To light the products I used softboxes and reflectors, and made a few exposure tests. When we were happy, my assistant made small waves and ripples with a stick and I took a series of shots. The ripples disguised the supporting glasses; to this day, the client doesn't know how the shot was achieved.

150mm lens ▷ f/11 ▷ 1/60 sec

Equipment

- Softboxes x 2, 100 x 100cm (3¼ x 3¼ft)
- Light with silver reflector, 26cm (10¼in)
- Glass tank and support
- Blue background paper
- Glass supports
- White card reflectors
- Black flags as required

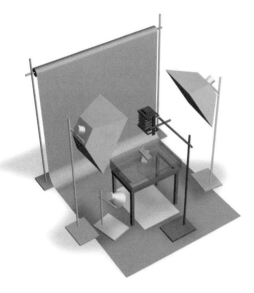

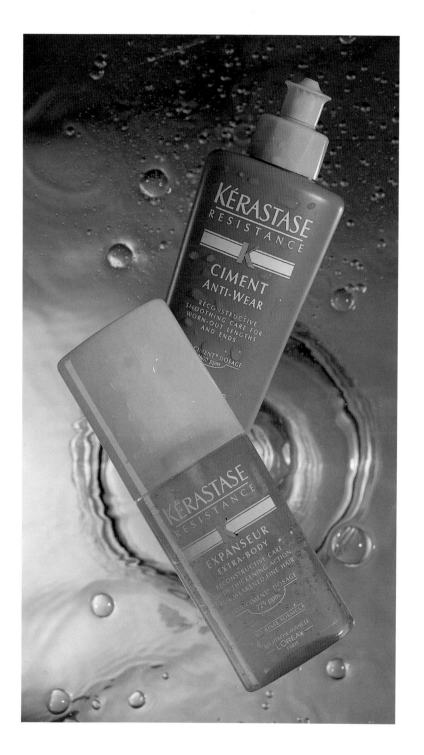

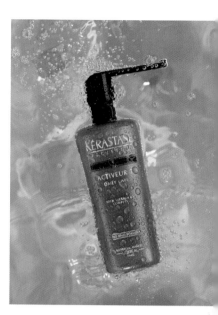

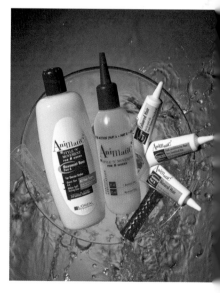

Customizing Backgrounds

Your choice of background colors, setting, and the way you present your subject are very important. It is these elements, mixed with good lighting technique, that make a shot successful. The two go hand in hand, and when constructing a set you should always think about your lighting at the same time. In the shot on page 165, the circuitboard appears to be playing tricks with gravity. You can produce many interesting images in which your subject appears to defy gravity or fly through the air, like the shot of the woman blowing bubbles shown on page 155. You can also suspend objects using strong monofilament fishing line to achieve this effect. The clever use of rigid rods, clamps, and stands will allow all manner of items to be suspended. With the computer now in the photographers' armory it is very simple to remove all trace of your trickery. If you want to go even further, try tilting the camera or shooting from an extreme angle.

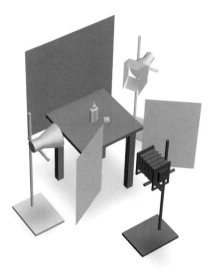

Technique

The client in this case was producing a show card to promote a new sunscreen for hair. He wanted to convey heat and sun in the image and catch the customer's attention. I decided to combine a strong visual background with shallow depth of field. For the foreground I used red wax crayon and chalks to color up a piece of canvas. This gave me texture and a mottled effect. For the far background I used a selectively crumpled sheet of red background paper. With the product in position I placed a light with a silver reflector rear right, and used barndoors to narrow the beam. I chose backlighting because the bottle was transparent. I also used a light with a Tough Frost diffuser on the left, at 90°. To direct or shade the light I positioned black card flags. To complete the effect I used a shallow depth of field, and overexposed the lights slightly to achieve some intensity in the shot.

200mm lens ▷ f/8 ▷ 1/200 sec

Equipment

- 📷 Light with silver reflector and barndoors
- 📷 Light with reflector, 26cm (10¼in)
- 📷 Tough Frost
- 📷 Black card flags and masks
- 📷 Canvas background
- 📷 Wax crayons and chalks
- 📷 Red background paper

Customizing Reflectors

You will find, with a lot of practice, experimentation, and a will to try new things, that the technical aspect of making good photographs will come naturally to you. You will automatically and instinctively learn which light shaper to try first. You will have a database in your head that will tell you what is possible and what is not. Then again, I am a great believer in saying "anything is possible if you put your mind to it." Even on the most mundane of photographic assignments, great results can be achieved just by injecting a bit of original thought, unconventional lighting, or color and texture.

A trip around my local building supplies store or lumberyard always fires me up with inspiration and new ideas. A good artists' materials store will do the same. There is always a wealth of new materials coming into the marketplace for you to exploit.

Technique

A local brewery asked me to shoot a catalog of the beers they sold. This shoot became quite an experience as we collected the beer for the shot in three-gallon buckets from the local bar! The shots you see here have not been retouched. I hung a black background roll and lit it with a background reflector, then set up a mock bartop and put the beers in place on it. Essentially the same lighting was used for all: one softbox to the left, and one softbox strip on the right. The tricky part was using gold mirror card to throw light through the beer. This I placed behind the glass, out of shot (see also pages 148–149). I spent hours cutting these reflectors to the correct shape. I used Blu-Tack to hold them at the correct angle so as to reflect light from the softboxes. Incidentally, the head on the beer was spooned on at the last minute, just before the exposure was made.

240mm lens ▷ f/32 ▷ 1/250 sec

Equipment

- Softbox, 100 x 100cm (3¼ x 3¼ft)
- Softbox strip, 100 x 30cm (3¼ x 1ft)
- Background reflector
- Black background paper
- Wooden bartop
- Gold mirror card
- Blu-Tack

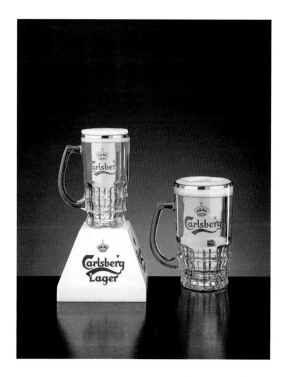

Lighting for theater

THE LIGHTING DESIGNER

I have been a lighting designer for the theater for 18 years. My work encompasses not only theater, but also lighting design for opera, dance, and musicals. Most lighting methods used in the theater are loosely based on a basic two-step formula: first light the actor for visibility, then light the scenery and background to create atmosphere and interest. We get to use many more lights than stills photographers. It is not unusual to use 12–20 in a small production, 48–200 in a professional production, and 500 or more in a major musical! So, at times my job gets quite interesting, but it's great fun. From my experience, there is some crossover between lighting for theater and for the studio stills photographer, but there is probably more that the studio photographer can adapt from our approach. In lighting a stage, I am involved in creating atmosphere in a moving scene. The light show flows from one scene to the next, with the viewer's focus constantly changing, and their eyes compensating for light and dark, contrast, and the like. Stills photographers cannot rely on this; they have to achieve correct lighting balance in their photographs. As viewers of photographs have time to take all the detail of an image in, stills photographers have very little margin for error; they have to get their shadows looking great, and light every minute detail to produce the effect they want

LOOK AT

- The use of light to direct the audience's attention to, or away from a specific area
- The use of shadow to alter the audience's perception of form
- The use of color and gobos to suggest a particular time and/or space

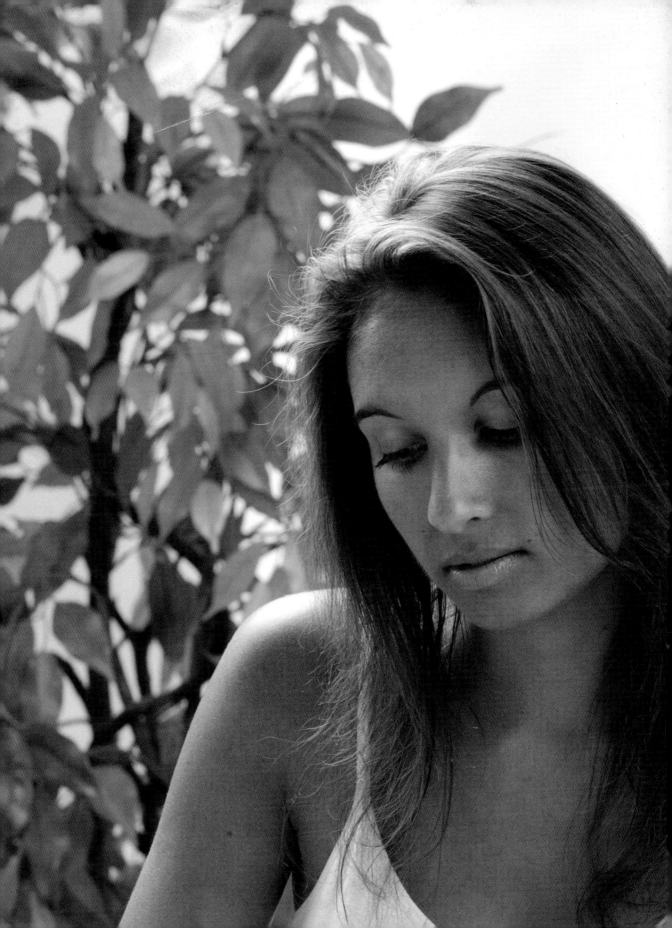

LIGHT
SURFACES

Photography has always followed fashions. In the 1970s and 1980s the fashion was to be very precise and technically perfect. This was the era of my training and it taught me to be meticulous, to take time to attend to detail, and to be technically accurate. There was a period in the 1990s when anything seemed to do; in fact, the more out of focus and technically imperfect your shot, the more awards you won. Needless to say, I never won any awards! It may have been the dawning of the digital era that caused this momentary blip. Perhaps the digital scene exposed certain photographers' inexperience, and their poor grasp of lighting, composition, and exposure produced some shameful results. The computer, with its newly loaded software Photoshop, was used to try to rescue the mess. But many photographers didn't know how to use Photoshop, either. Thankfully, the shallow depth of field, overlit technique has now matured. And I rather like it.

Still Water

In the introduction to this chapter, I said that I like the shallow depth of field and brightly-lit approach that is widely used today. I have found that my ability to be fairly technically accurate with lighting (a skill learned in the 1970s) makes easy work of my photography today. I was always conscious of depth of field and intricate lighting. Now I shoot everything on an SLR, use f/5.6, and if the lighting is not quite right, then I don't worry too much. Actually, this is not strictly true. To get it right you do need skill, and correct composition is a must. The changes in the profession during the past few years have amazed me. We used to shoot on large format at tiny apertures such as f/45, which required huge amounts of light. Now we use comparatively low-powered lights, because we often shoot at f/5.6 or f/11—maybe f/22 at the most.

Technique

This shot of mineral water was used on posters throughout a large chain of retail outlets. The lighting was pretty simple. The bright white background and subtle gray tones, together with the shallow depth of field, make for a refreshing image. I hung up a white paper background and covered a tabletop in a semi-matte plastic sheet to give a slight sheen to the base. I used three lights. The first two—a softbox for the toplight and a softbox strip light placed front right of shot—were set for correct exposure. The third light, with a silver reflector and used back left, I set around 1½ stops brighter than the front lights. I placed bottles in the background, and used a shallow depth of field to throw them out of focus. I have included a shot that was taken with the camera on a slight angle to illustrate how effective this can be. As always, watch out for lens flare from the backlight.

200mm lens ▷ f/8 ▷ 1/125 sec

Equipment

- 📷 Softbox, 100 x 100cm (3¼ x 3¼ft)
- 📷 Strip-light softbox, 100 x 25cm (3¼ft x 9¾in)
- 📷 Light with silver reflector, 26cm (10¼in)
- 📷 Black flags as required
- 📷 White background paper
- 📷 Semi-matte plastic

Candle Flame

When I shot mainly on large format, I had at my disposal six flash generators, 14 flash heads, two monobloc flashlights, and numerous light shapers. All this produced a huge 24,000 joules of light, a joule being a unit output from an electronic flash equal to one watt-second. Whatever that means, it equates to a big flash. I needed this amount of light because I was working mainly at very small apertures such as f/32 or f/45. This enabled me to achieve the required depth of field. All this lighting has now been bypassed, and my entire lighting setup today consists of four 500-joule monobloc lights (a total of only 2,000 joules) and a carefully chosen collection of light shapers. This is because I now shoot mainly on a digital SLR, which requires far less light output. I can also control my entire lighting setup via my laptop computer if I so wish, without even leaving my chair. How times change.

Technique

This is a very simple shot, lit with only one light plus the candle itself. If you want to try this yourself, you will need to be able to black out your studio. You will also need absolute stillness, with no drafts, or the candlelight will flicker. First, I set up a white paper background scoop on a table. I wanted the candlelight to reflect into the metal lid, so I set the candle up using a spare candle, supporting the lid with Blu-Tack. When I had adjusted the reflection to my liking I replaced the candle with a fresh one, without moving the lid. I illuminated the candle and lid with one overhead softbox, which I positioned to bring out maximum definition in the "K." I then turned all the lights out so we had complete darkness. We lit the candle, I opened the lens, and after around 5 seconds I fired the flash to expose the tin, then closed the lens. I made a series of exposures and chose the best one.

150mm lens ▷ f/11 ▷ timed exposure plus flash

Equipment

- Softbox, 100 x 100cm (3¼ x 3¼ft)
- White background paper
- Spare candles
- Matches

Corrugated Card

The point I want to emphasize in this chapter is that you do not need a vast array of expensive lights in order to produce strong photographic imagery. You will have noticed throughout this book that many shots have been lit with just two, or maybe three lights, some with only one. The key aspect is how you control this light. I have previously talked about the sun and how this single light source can make the same subject look very different, depending on its position. When you have your lights and light shapers, set up a subject—a textured vase of flowers, for example. Try all of your light shapers individually, noting the different looks you can achieve. Some will make subtle changes; others quite dramatic. In addition, set up a white background and repeat the process, shining the lights at the blank paper from around 2m (6ft) away. Again, note how each light shaper produces a different effect. You will soon learn the endless lighting possibilities that are available.

Technique

This packaging, known as Dividella, is designed to protect the glass phials used by the medical profession. It is nothing more than folded cardboard, but lit in this way, with a hard sidelight, it starts to come to life. I left some of the little glass bottles in the shot so that viewers could see what the product did. I had an attractive piece of marble in the studio and used that for the background. I shot vertically down onto the set, which was about 30cm (12in) off the floor, in order to set the lights at table height. I used two lights, both from the top of shot, with barndoors to control the light spill. Because the lights were at product level, they produced pleasing shadows and highlights across the packaging. I placed white card reflectors opposite the lights to soften the shadows, clamped black flags in place, and took the shot.

150mm lens ▷ f/16 ▷ 1/160 sec

Equipment

- Lights x 2 with silver reflectors and barndoors
- White card reflectors, 100 x 60cm (3¼ x 2ft)
- White marble or other suitable background
- Clamps and stands
- Black flags

Silver Steel

Now you have gathered a vast knowledge of lighting, the behavior of light, and how to use it (and hopefully some of this knowledge has been gained from this book), you should be able to visualize your shot before you move a single light. That's the idea, anyway. Only after you have planned the atmosphere of a shot can you decide which lights to use and how to employ them.

I hope that you take the route of logical thought and creative experimentation rather than the simple, safe route of flat, soft lighting, avoiding dangerous shadows. Don't get me wrong. As you have seen, the softbox does have a huge role to play, but you should always try to give your lighting a lift by introducing a strong sidelight or backlight. It will make so much difference to the finished shot, and give it dynamism and bite. There are exceptions, however, as seen on the opposite page.

Technique

This image was taken for a mountain-bike catalog. After shooting all the studio shots, the fun started and we shot the location images north of San Francisco. The shot here was used to convey the handbuilt quality of the bikes. I wanted it to be a little moody so I deliberately kept the edges dark, to produce a traditional workshop feel. The silver steel of the bare frame gave the shot its lift. I used only one light—a large softbox overhead. I took out the internal diffusers to make the light a little harder. The careful choice of props was the key to getting this shot right. The welding torch and goggles helped convey the "handmade" concept; the rusty, aged piece of steel I used for the background also helped. The calculator brought in a hint of modern times.

50mm lens ▷ f/11 ▷ 1/125 sec

Equipment

- Softbox, 140 x 100cm ($4^2/_3$ x $3^1/_4$ft)
- Steel background
- Props

Clear Glass & Liquid

Photographers use various terms to describe certain basic kinds of lighting. These terms are based on the position of the light source in relation to the subject being lit. The first is frontlighting—the effect produced when the light source is placed in front of the subject. Next, if the light source is moved horizontally to the left or right, we obtain side-lighting. We continue this movement through to rimlighting and, finally, moving all the way to the rear, backlighting. Starting from the front again, but moving the light vertically, we obtain toplighting; moving it down down, underlighting. If we carry on, we eventually produce rim- or backlighting again. If the light is moved diagonally upward, we produce crosslighting. To try out these positions yourself, set up one light and, using a suitable model or subject, see the different effects the light has on the various contours.

Technique

This glass bottle of hair serum was very small—only 4cm (1½in) high. With its clear glass and liquid, and white label and lid, it looked a little insignificant. The bottle needed lighting that would give it form and substance. I set up a mirror on the table and placed a sheet of nonreflective glass on top of it. This combination gave me a good reflective surface. I set the camera low, on the same plane as the table, and positioned the product. I put up a white background, cut out 15cm (6in) squares of black paper, and maneuvered them into position on the background, securing them with Blu-Tack once I was happy with their position. I used two lights: a 30cm (12in) linear strip on the left, and a light with a silver reflector and Tough Frost on the right. I placed these lights well to the side to spill onto the background, and used a shallow depth of field to throw the black squares out of focus. The high-key lighting helped to bring the bottle alive.

200mm lens ▷ f/8 ▷ 1/200 sec

Equipment

- Light with silver reflector
- Linear strip light, 30cm (12in)
- Tough Frost
- Mirror sheet
- Nonreflective glass
- Black background paper
- Black flags as required

Paper, Card & Canvas

The position of our lighting has a direct bearing on the way we can render textures. Texture in a photograph is very important. It adds interest and, more importantly, gives the viewer a sense of form and realism. The rendering of texture depends on the position of the lights. Cross- and sidelighting, in which the light is at an oblique angle to the surface being lit, are two useful techniques for rendering texture. The harder the light, the stronger the shadow and thus the more texture is revealed. You can control this hardness of light through your choice of light shaper, or by using a diffuser such as Trace or Tough Frost. You can, of course, do quite the opposite. Maybe you don't want to show texture on, say, a bad casting. By using a soft frontlight you can obscure the texture. So, the shallower the textural "bumps," the more oblique the lighting should be. The harder the light, the more pronounced the surface texture will be.

Technique

This shot of a selection of paper, card, and canvas is a good example of using oblique sidelighting to bring out the texture in different surfaces. If it had been lit from above with a softbox, all the depth and texture would have been lost. I set up the camera above a large baseboard, about 30cm (12in) above floor level, and used one large softbox next to the camera to give an overall light. I then worked on the collage until I was happy with the composition. To bring out the texture I placed one light with a silver reflector top left of the shot. This was on the same level as the baseboard and shone across the papers to reveal and highlight the textures. I placed a white reflector board at the opposite end to throw light back in so as to very slightly soften the shadows. The sidelight was about $1\frac{1}{2}$ stops brighter than the toplight.

105mm macro lens ▷ f/11 ▷ 1/125 sec

Equipment

- 📷 Softbox, 140 x 100cm ($4\frac{2}{3}$ x $3\frac{1}{4}$ft)
- 📷 Light with silver reflector, 26cm ($10\frac{1}{4}$in)
- 📷 White card reflector
- 📷 Black flags as required
- 📷 Stands and clamps

Mixed Materials & Finishes

Whether the surfaces within the subject to be shot are smooth and shiny or rough and irregular (as shown in the shots opposite), you will notice that the lighting helps to convey their form to the viewer; it helps to express how the surface would feel if you were to touch the object. The marbles shown here give a sense of smoothness, hardness, and roundness; the shells give a sense of texture. In the marbles it is the reflection of light that conveys this information to the viewer. On the other surfaces it is the shadows. Despite the photograph being two-dimensional, lighting is fundamental to the visual representation of form. Start with your base lighting and gradually add to this, bringing out the all-important attributes that your subject holds in order to bring your photograph to life.

Technique

The six images on the opposite page were all lit with the same single light, set in the same position. They were all used in a book illustrating different materials and finishes. I had many shots to take in a limited time and needed a lighting setup that would work for the vast majority of subjects. This setup also helped keep a sense of visual continuity throughout the book. The items were shot from above, so I set up a tabletop about 30cm (12in) off the studio floor. I used a large softbox, placed at the top left of the shot, and white card reflectors to throw light back into the subject. I used two sheets taped together to form a hinge: this enabled them to support themselves when opened to 90°. I was able to move this reflector in and out with ease, depending on the amount of fill light I required.

105mm macro lens ▷ f/22 ▷ 1/125 sec

Equipment

- Softbox, 100 x 100cm (3¼ x 3¼ft)
- White card reflectors
- Low tabletop
- White or black background as required
- Gaffer (duct) tape

TALKING POINT...
Lighting for film

THE LIGHTING DESIGNER

The job of a lighting director in film has a strong
parallel with that of the stills photographer and the
way he or she lights their studio sets. Producing
a proper lighting plan is a creative endeavor. At the
risk of being shouted down by the cameraman and
director, I would say that lighting is probably the
most artistic part of movie-making! It is my job to
work with the director and interpret the creative
vision and mood he or she has for the movie. It is
my responsibility to choose and set the lighting that
best tells the story. I am constantly watching light in
day-to-day life; it has become second nature to me.
I am able to use the information gathered through
observation in my movie work. From one hour to
the next, light constantly changes the atmosphere
of the world around us. The best lighting directors
and cinematographers embed this information in
their memory, ready for recall at any time. This same
discipline applies equally to a stills photographer in
the way they light their subjects within the studio.

LOOK AT

- The use of lighting as a visual cue to suggest
 character, danger, etc
- The use of lighting to give a sense of space
- The characteristic lighting associated with
 different film genres (high key lighting in
 comedies, low key lighting in mysteries,
 balanced lighting to suggest glamor)

MOTION

There are two basic ways of recording motion in the camera: you can create a "motion blur" of your subject by using a prolonged exposure, or you can do step photography, making a series of short exposures that record your subject's path as it moves. (There are a number of variations on these themes, explained later in this chapter.) Motion blur is also fairly easy to achieve with image-editing software. Photoshop offers some quite sophisticated motion-blur tools, and the effect can enhance your shots considerably, if applied with skill. This also saves considerable time in the studio. Using software-based movement techniques in conjunction with an in-camera technique can be very effective. I would recommend that you experiment with the digital route—there are many books available to help you master the necessary skills. For the purists among you, turn the page and we will examine the old-fashioned way!

Motion Blur 1

Whether you prefer the shot of the static globe (shown in the lower picture) or the moving globe is purely subjective. The most important element in the image is the literature; the globe, although related to the main subject matter, was used primarily to add interest to the shot. Introducing the motion effect makes the globe a more abstract part of the image, bringing the viewer's attention to the static literature. This shot was taken using continuous light rather than flash. By spinning the globe and then exposing the shot, I captured the movement of the globe as a blur. If you try this yourself, you will need to run a few test shots to determine how fast to spin your globe to achieve the level of blur you want. Make sure your table is very solid: if the globe creates vibration on the table, the literature could appear soft in the final photograph. Also, set your camera, if digital, to the correct color balance for the light source, or use the correct film for your light source.

Technique

I set up a solid table, placed the globe in the center of this with the client's literature displayed in front, and hung up a graduated black-to-white background. Overhead I placed a large softbox, with tungsten halogen modeling light, to illuminate the subject evenly. Next, I positioned an ellipsoid spot with gobo to the left of the set to project a mottled pattern onto the background. This also illuminated the spines of the brochures, giving them more depth and shape. I took an exposure reading and then made a few test shots with the globe spinning at different speeds until I achieved the result I wanted. You will find that the globe need spin only very slowly to produce a motion effect. You could also achieve this shot with flash lighting, using a similar technique to that explained on page 196. Make sure no movement occurs in the brochures, or they will look soft.

150mm lens ▷ f/16 ▷ around 1/4 sec

Equipment

🔲 Softbox, 100 × 140cm (3^{1}/$_{4}$ × 4^{2}/$_{3}$ft)
🔲 Ellipsoid spotlight
🔲 Gobo
🔲 Graduated black-to-white background
🔲 Sturdy table

Step Photography

A useful technique for depicting movement is step photography. This involves taking a series of exposures tracing the path of a subject as it is moved into different positions, or as it moves continuously in some way. A dark background generally works best, as lighter backgrounds tend to wash out the effect. This is why I chose a navy-blue background for the shot opposite. Step photography requires some experimentation and test shots, as no two subjects or lighting setups are the same. The principle is to make multiple exposures. Because you are using a very dark background, effectively this area remains unexposed, so each time you move your subject and make another exposure it will record well in the previously unexposed areas. You will need complete blackout in your studio.

Technique

To achieve this shot I first set up a dark-blue background scoop. I placed the computer in position and lit it with one snooted light from the front. The background I lit with an ellipsoid spot and gobo. I also used a smoke machine to produce atmosphere in the lower part of the shot. I glued one CD onto a thin black wooden pole and clamped this in the correct position; by releasing the clamp I could move the CD in various increments. I lit the CD with another snooted light. With the CD out of shot and the lights out, I exposed the computer on a timed exposure to burn in the LCD display. During this time I fired the flash. I then placed black velvet over the computer to stop further exposure, and moved the CD gradually toward the computer, stopping at various stages to fire the flash, lighting the CD to make the nine exposures you see here. If you try this yourself, remember that all this must be done in complete darkness, as the lens remains open throughout the process.

150mm lens ▷ f/22 ▷ various exposures

Equipment

- 📷 Lights × 2 with reflectors and snoots
- 📷 Ellipsoid spot
- 📷 Gobo
- 📷 Dark-blue background
- 📷 Black velvet
- 📷 Black pole
- 📷 Glue or double-sided sticky tape
- 📷 Clamps and stands as required
- 📷 Smoke machine if required

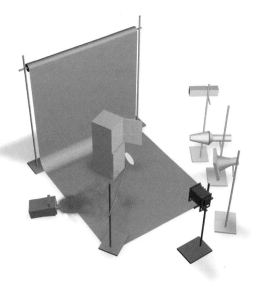

Slow Shutter & Flash

There are many situations in which introducing an element of motion will not only enhance the visual interest of a shot, but also help to tell your subject matter's story. Here, a soluble powder is being poured into a glass, telling the viewer that using this medicine is quick, convenient, and easy. I needed to make sure that the model's hand remained still, as the only movement was to be in the falling powder. This required skill from the hand model, who had to keep her movement to an absolute minimum. I helped her to some degree by providing her with an arm rest, which is just out of shot. The movement was produced by using a slow shutter speed, which blurred the falling powder. The flash froze what little movement there was in the hand.

Technique

In this shot, I wanted to produce movement in the fast-falling powder. I had to use a slow shutter speed to produce the blurring of the powder. I could not use available light, as any movement of the model's hand would have caused it to look soft in the resulting image. Instead I used flash, because it would arrest this slight movement. As the powder was moving very quickly, I could still record blur in it. I also provided a support for the model to help her keep her hand still. I set up a black table and put the glass in place. Behind the table I hung a gray-to-black background, which I lit with a background reflector. This light also threw an attractive highlight on the underside of the hand. Next, I placed a softbox above the set to add some downlighting. Lastly, I used a light with a silver reflector and snoot to highlight the top of the hand. I made a series of test shots using slow exposures until I was happy with the blurring of the powder, each time using fresh water and a new sachet.

150mm lens ▷ f/16 ▷ around 1/2 sec

Equipment

📷 Softbox, 100 × 100cm (3¼ × 3¼ft)
📷 Light with background reflector
📷 Light with silver reflector and snoot
📷 Black tabletop
📷 Gray-to-black graduated background
📷 Black flags as required
📷 Clamps and stands

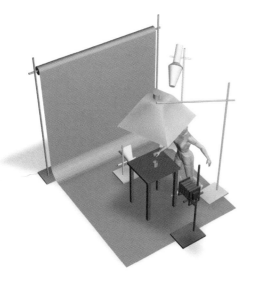

Timed Movement

You can decide for yourself whether or not the movement of the guitarist's hand in the upper shot enhances the image. I believe it adds interest to the shot. The photograph was taken to illustrate the positioning of a microphone when making a studio recording. Giving the viewer the impression that the guitarist is producing a sound strengthens the message of the text. As with the image on the previous page, I needed to keep the model's body movement to a minimum; he had to sit extremely still, moving his hand up and down very slowly, only as the shutter was opened. The flash-unit modeling lights provided the ambient lighting required to capture the movement. The flash froze the very slight movement that occurred naturally in the guitarist's body. In such situations, it is necessary to do test shots to establish your optimum exposure/shutter speed combination. You may get a slightly warmer color balance in your shot due to the tungsten modeling lights.

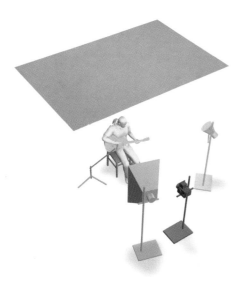

Technique

I sat the guitarist on a high-backed chair to give him support and help him keep still, placed the microphone in the correct position, with a few props placed strategically in the background, then framed up the image in the camera. I placed a large softbox about 1.2m (4ft) off the ground and to the left of camera. Next I placed a light with a silver reflector just out of shot on the right, pointing up at the white ceiling to bounce light into the background area. I took an exposure reading with the shutter speed set at around $1/2$ sec at f/8. As I pressed the shutter-release button, I asked the guitarist to move his hand up and down very slowly. As I was shooting digitally, I could check the images on screen. I varied the shutter speed and the guitarist's speed of movement until I achieved the desired effect. Because of the slow shutter speed, the modeling lights caused a slight warm color cast, which I removed using image-editing software.

70mm lens ▷ f/8 ▷ around 1/2 sec

Equipment

▢ Softbox, 100 × 140cm (3$1/4$ × 4$2/3$ft)
▢ Light with silver reflector, 26cm (10$1/4$in)

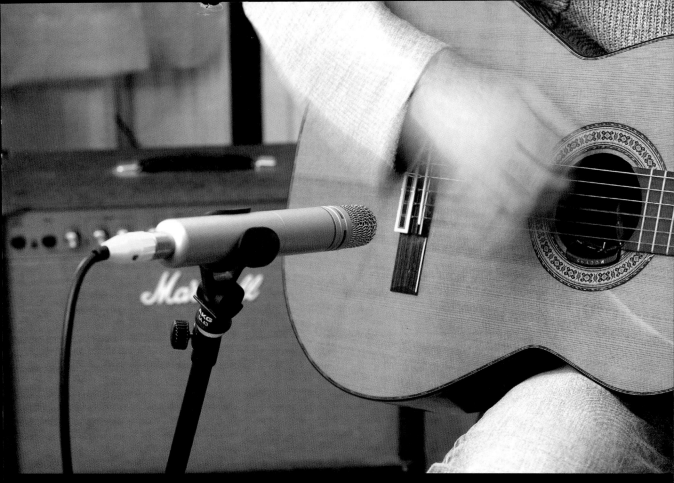

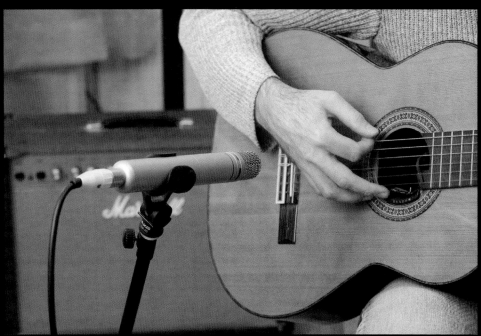

Motion Blur 2

Here is another instance for which movement, this time in the bubblers, was an essential element in the photograph. I tried to use the actual bath-bubble products, but they didn't look good when they bubbled. I ended up casting plaster-of-Paris models of the product, sticking these to a sheet of glass, and submerging them in water. I needed to create the illusion of bubbles radiating from the plaster balls as if they were the real product. If the bubbles were frozen with a fast shutter speed, they would have looked like spots in the water. The illusion of them rising upward was created by using a slow shutter speed of around ½ sec to blur them slightly. If you try this yourself, you need to get the blur just right so they still look like bubbles and not long white streaks. Do a series of test shots, varying your shutter speed.

Technique

I glued suction pads to the back of my plaster models and stuck them to a sheet of glass, ready to be immersed in the tank. I set up my tank of water, covering the base and back with blue paper, placed aquarium aerators on the bottom of the tank, and connected them to an air pump. With the bubblers immersed, I adjusted the aerators until I found the correct position. The lighting was very simple: just one softbox strip placed close to the tank on the right, and one white card reflector on the left. I checked my exposure reading and took the shot at ½ sec. You will notice that the bubbles below the product were removed at artwork stage (see inset shot) to give the impression that all the bubbles were coming from the dissolving bubblers.

150mm lens ▷ f/16 ▷ 1/4–1/2 sec

Equipment

- Strip-light softbox, 100 × 30cm (3¼ × 1ft)
- White card reflector
- Glass tank filled with water
- Aquarium aerators, tube, and pump
- Blue background paper

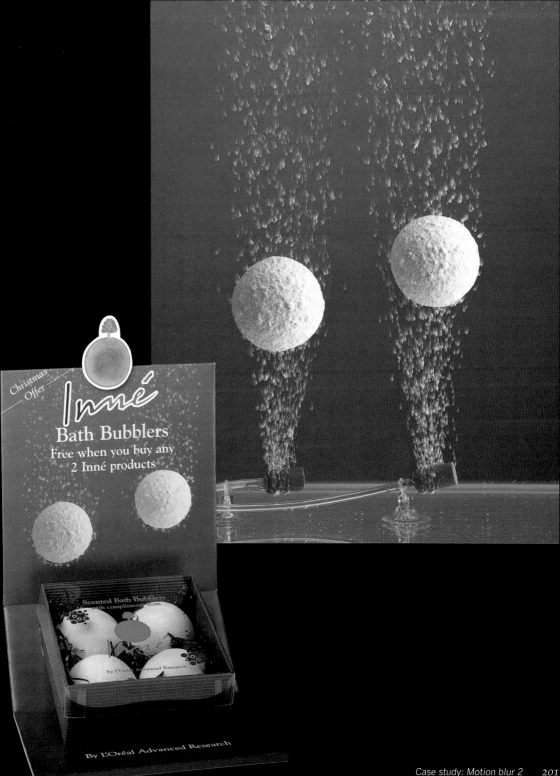

Staged Movement

Most subjects with distinct areas of color and tone and an easily recognizable outline will work well with the addition of motion blur. As long as you are careful not to lose the object's identity, you should find that you can add considerable atmosphere and action to your photographs, as has been achieved in the shots shown here. To freeze this motion I would have needed a shutter speed of 1/250 sec. Shutter speeds of between ¼ and 1 sec should produce some attractive motion blur. Your results will be somewhat unpredictable, so you will need to experiment with color, tone, and exposure. How you light your subject is pretty much up to you. As long as you have some contrast between subject and background, and keep things fairly simple, you should achieve satisfactory results. You will, of course, require a fairly bright source of continuous light.

Technique

I was commissioned to illustrate a book on vegetarian cookery. As well as images of the main dishes, we needed shots depicting food preparation to use as fillers. These did not need to be instructional, so I chose to add some interest by featuring motion blur. I chose to use clean white backgrounds with pastel-colored clothing: the choice of props was an important aspect in producing contemporary-looking shots. I hung up white background paper and set up a table with a white melamine surface. I bounced two lights off the white studio ceiling to illuminate the background, and set a large softbox high and to the left of camera. I kept all the modeling lights full and used them as a continuous light source. Finally, I set my digital camera to tungsten color balance. The key to success lay in directing the model's movements.

85mm lens ▷ f/8 ▷ 1/4 sec

Equipment

- 📷 Softbox, 140 × 100cm (4²/₃ × 3¹/₄ft)
- 📷 Lights × 2 with silver reflectors, 26cm (10¹/₄in)
- 📷 White background
- 📷 Table

Lighting for concerts

THE LIGHTING DESIGNER

As a lighting designer specializing in concerts, I have a truly great job. Unsocial though the hours may be, it is very exciting and has the added bonus of a lot of travel thrown in. The basic principles of stage and theater lighting also apply to lighting concerts, but the equipment we have at our disposal is bigger, more expensive, and comes with a huge array of special-effects lights. More "toys" I suppose! The industry uses automated lighting rigs almost exclusively now, and all this is controlled by computers, so, following much the same path as stills photographers in their transition from film to digital, we have become computer programmers as well. Computers allow us to control the lights with repetitive precision, and in time with the music. Our lighting armory consists of many different lighting fixtures such as color changers, image and background projection, motion effects, and strobe through to pyrotechnics and video. We call in specialists for pyrotechnic and video effects, much the same as a studio photographer would use a stylist or make-up artist. The main constraint on our creativity is the financial budget.

LOOK AT

- The use of strong color to create impact and energy
- The use of black backgrounds to create a specific, clear focus
- The use of lighting to create background patterns and textures

CLOSE-UP

This chapter looks at the area of close-up photography. "Close-up" is a fairly general term, ranging from images taken at life-size (1:1 reproduction) through to images such as head-and-shoulders portraits. Photographs of subjects at very close distances (larger than life, in other words) fall into the category of "macro" photography. Photographing subjects in extreme close-up, usually through a microscope, is termed "photomicrography." This is a very specialized area that has little scope for complex lighting, so is not included in this book.

Photographing in close-up can give a fascinating perspective to everyday objects, often producing colors and textures that we might not normally notice. Most of the time you will be able to use or adapt your normal studio lighting, but you will usually need a specialist macro lens. Macro lenses are specially corrected for close-up work and will produce very sharp images. You will also need a tripod or other camera support.

Contrasting Colors

Close-up photography, although somewhat specialized, involves the same disciplines as other areas of photography, with one difference—you are photographing a mini still-life set. This is a great method of showing things in a different way, as in this shot of a rubber plant. You can produce an eye-catching image with a careful choice of angle and a striking background color. Most ordinary lenses have a limit on how close you can focus (usually down to about 60cm [2ft]), so you will need to use a macro lens. Such lenses have specially designed glass elements to cope with extremely close focusing distances, and will produce very sharp results. There are other ways of focusing at close distances, such as using a bellows or a supplementary lens attachment. Large-format plate cameras also lend themselves well to close-up work, due to their extendable bellows movement.

Technique

This shot of a rubber plant was taken for my personal work (as were a lot of the images in this chapter). It was an extremely simple shot to create, and I think it is the contrast between the vibrant purple background and the greens of the plant that makes the image successful. I placed a 90 x 60cm (3 x 2ft) sheet of purple paper on the wall about 90cm (3ft) away from the plant. I lit this using one light with a silver reflector, set a few feet away. I placed another, similar light on the left, near the background. This shone at the back and side of the rubber plant. The intensity of the light gave the leaves a lovely translucent look. If you try this yourself, be very careful to stop any lens flare by using black flags. Your exposure will need to be determined precisely so that detail is not lost due to overexposure. A little trial and error will be necessary.

105mm macro lens ▷ f/8 ▷ 1/160 sec

Equipment

- 📷 Lights with silver reflectors x 2, 21cm (8¼in)
- 📷 Black flags as required
- 📷 Purple background paper

Isolating Detail

Close-up photography will often be required in conjunction with your day-to-day photography of products. It is often necessary to shoot details in equipment, such as the microchip on the circuitboard shown opposite. You will notice that the depth of field becomes very shallow with close-up photography. Often you will be shooting at apertures as small as f/32 and f/45. This requires considerable lighting power, but as you are working close to your subject, this should not be a problem. However, because of this close working, be mindful of any heat generated by your lights. Glass can crack and molten plastic creates a mess, not to mention a fire hazard. Remember to use your depth-of-field preview button; it will be invaluable in determining if you have the correct detail in focus.

Technique

Because of the small areas you are illuminating, your lighting setups will nearly always be very simple, with only one or two lights. I used two lights with reflectors for this shot of the circuitboard. I put a blue gel over one to give an overall cast to the subject, and a narrow snoot over the other light to illuminate just the center of the circuitboard. Because this light was set at about half a stop brighter (the correct exposure) than the blue light, it rendered the detail I wished to show in normal, neutral light. I used the blue on the periphery of the board to bring this area to the viewer's attention. You could, of course, use a reverse tactic and render the center blue and the surrounding area neutral, simply by moving the blue gel to the other light. Use any colors you wish—don't be afraid to experiment.

105mm lens ▷ f/11 ▷ 1/60 sec

Equipment

- 📷 Light with silver reflector, 21cm (8¼in), and narrow snoot
- 📷 Light with silver reflector, 21cm (8¼in)
- 📷 Blue gel
- 📷 Black flags as required

Backlighting 1

Close-up photography is not only useful for showing detail or photographing very small subjects. You can also photograph objects in close-up to great creative effect. This will enable you to show things from a different, and often fun perspective. Backlighting often works very well with close-up. This shot of candy was created using backlighting, as was the shot of the cabbage leaf on page 223. Backlighting the candy enabled me to bring out its translucency and vibrant color. The candy is sitting on a piece of dimpled, translucent Lexan sheet that I found at my local timber yard— a great place to source backgrounds. This added enormously to the overall abstract effect of the shot. Using a shallow depth of field enhances its mystery.

Technique

This shot was taken for my personal work. I set up a clear, glass-topped table and placed my dimpled sheet of Lexan on top of it. Behind this I set up white background paper, which I lit from one side using a light with a silver reflector. I placed another light with silver reflector and medium honeycombed snoot under the table so that it shone up at the Lexan sheet. By using a snoot on the light below, you can cut down any stray light and direct the light with more precision. Don't be afraid to try different-sized snoots; you can also introduce colored lighting gels if you wish. Finally, I used a small white card reflector front left to throw some fill into the shot. As always, some experimentation is necessary to obtain the desired result.

105mm macro lens ▷ f/16 ▷ 1/125 sec

Equipment

- Light with silver reflector, 26cm (10¼in)
- Light with silver reflector, 26cm (10¼in), and honeycomb snoot
- Clear, plate-glass sheet, 5mm (¼in)
- Dimpled Lexan sheet
- White background paper
- White card reflector

Spot Sidelighting

Most close-up work can be treated as a mini set, employing the same lighting techniques as you would for larger items. Generally, the lighting techniques explained in other chapters of this book can all be used in close-up photography. Look at your chosen subject, decide on your lighting plan, and start shooting. Using small mirrors to reflect light into specific parts of your shot is also a useful way to light, due to the small scale of your set. I have found the mirrors that automobile engineers use ideal for this, as they come on small arms and can be clamped into position easily. When you are shooting small subjects you will usually need to use snoots or spotlights, and to mask the lights down with barndoors and black card. I used a spotlight for the shot of fungi on the opposite page. Their color and texture were superb, and sidelighting seemed the ideal way to bring out this detail.

Technique

I shot this photograph using a 5 × 4in plate camera. Such cameras have an extendable bellows, so they focus very close and produce very high-quality results. The only drawback is the large amount of light required because of the bellows extension—light intensity diminishes because of the distance the light has to travel from lens to film plane. This, together with a small lens aperture, means that you will need plenty of light. For this shot I first selected the fungi I wished to shoot, then chose a suitable background—some handmade clay roof tiles that I had lying around. I used just one light, an ellipsoid spot, which I placed to the left, level with the roof tiles. Positioning this on the same plane as the fungi helped bring out their delicate textures. I also used a warm-up filter on the lens and a white card reflector clamped on the right.

5 x 4in plate camera ▷ 240mm lens ▷ f/32 ▷ 1/60 sec

Equipment

- 📷 Ellipsoid spotlight
- 📷 White card reflectors
- 📷 Warm-up filter

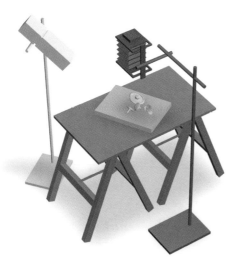

Diffused Light

Many items you shoot in close-up will be small, such as pieces of jewelry. Jewelry is often difficult to photograph, not only because of its small size, but also because of its shiny, reflective surfaces. The gold rings shown here were photographed in a similar way to the stainless-steel hoppers on pages 134–135. I built a light tent for this shot too, but on a slightly smaller scale. I introduced black into the reflective areas via the selective use of black card—exactly like the hopper shot. One of the trickiest tasks when photographing jewelry is moving your subjects into place without getting fingermarks on them. To avoid this, white cotton gloves are a must, but they don't prevent the introduction of tiny dust particles. I use a blower brush (available from any good photographic supplier) to tackle this problem.

Technique

These shots of rings were two out of 150 taken for a catalog. I had to keep the angle of the rings the same, as far as possible. I molded a "cradle" out of Blu-Tack, covered this with a piece of fine silk, and sat each ring in its cradle, in the same position. Next, I set my camera in position. I used a 105mm macro lens, as this gave me a 1:1 magnification. I placed a softbox overhead and white polyboard reflectors at the back and left, leaning them on the side of the softbox for support. On the right I hung a sheet of Tough Frost from the softbox. I shone a light with a silver reflector through this to give some sidelight. I also hung a sheet of black velvet fabric, with a hole cut from it for the lens, from the front edge of the softbox. Velvet is useful in such situations as it produces a very black effect, is flexible, and disguises the lens well.

105mm macro lens ▷ f/32 ▷ 1/200 sec

Equipment

- 📷 Softbox, 100 x 100cm (3¼ x 3¼ft)
- 📷 Light with silver reflector, 26cm (10¼in)
- 📷 White silk
- 📷 White reflector boards
- 📷 Tough Frost
- 📷 Blu-Tack
- 📷 Black velvet

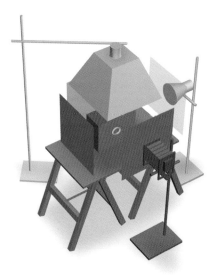

Highlights & Shadows

Close-up photography provides a wonderful opportunity to illustrate everyday objects in spectacular and unusual ways. Most of the photographs in this chapter have been shot using fairly simple lighting techniques, but they grab the viewer's attention because of their unusual angle of view, or because they reveal detail that cannot normally be seen. This shot of a Venus flytrap is crying out for the addition of a fly. Today this could easily be done using digital imaging. You could even use the blurring techniques explained in the previous chapter to make the fly appear to be moving at speed. When time allows, I will use Photoshop to complete the image by adding this fly. The creative freedom photographers have is extraordinary; it is up to you how far you take this.

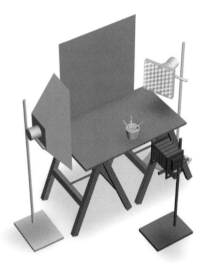

Technique

As a boy I was fascinated by the Venus flytrap and its ability to capture and eat flies. I thought this was just brilliant—a meat-eating plant! For this shot I used two lights to accentuate the jaws of the plant. I chose a strong blue background to hang about 1.2m (4ft) behind the plant, and lit this from the left with a softbox strip. You can see the graduated light-to-dark effect this has created in the blue. I then placed a light with a reflector and snoot on the right, positioned to light the mouth of the plant while keeping the front edge in shadow. I placed a second plant a few inches behind and kept this out of focus using a shallow depth of field. Making the blue background darker on the right increases the visual impact of the out-of-focus rear plant.

55mm macro lens ▷ f/11 ▷ 1/200 sec

Equipment

- Strip-light softbox, 100 x 30cm (3¼ x 1ft)
- Light with silver reflector, 21cm (8¼in), and 12° snoot
- Blue background paper
- Clamps and stands

Toplighting

Continuing the theme of photographing jewelry, I have included these two shots to show you how to light jewelry from above. Although, strictly speaking, these two setups were not what I would call close-up (each display was around 30cm [12in] across), the same techniques would apply if you were to shoot just one of the keyrings. The camera needed to be positioned overhead, so I made a hole in a large sheet of white polyboard for the lens to poke through. I used softboxes to form the light-tent ends, and white polyboards to form the top and bottom of the "box." A good tip for putting some sparkle and form into gold items is to place gold mirrorboard reflectors inside the tent along with some black (you can use silver mirrorboard reflectors with silver items). The effect is to enhance the gold or silver surfaces and produce a richer tone.

Technique

I am showing two nearly identical shots here. Each setup included mirrorboard reflectors placed inside the light tent to reflect color and tone back into the jewelry. I find that if you use softboxes alone, the richness of the jewelry can sometimes be lost. Having set up my camera above the jewelry and correctly focused and framed the shots, I clamped a large sheet of white polyboard in place, with a hole cut in it for the lens. I then placed one softbox on the right and another on the left; these lights should be kept soft to minimize the double shadow. Both lights were angled down onto the jewelry at 45°. Next, I placed two white reflector boards top and bottom, effectively joining the two softboxes, the baseboard, and the top reflector (where the camera was), to make a box. I then placed my gold mirrorboard reflectors to gain maximum effect. In such situations, you must be very accurate with your exposure to prevent your highlights burning out.

105mm macro lens ▷ f/32 ▷ 1/200 sec

Equipment

- Softboxes x 2, 100 x 100cm (3¹⁄₄ x 3¹⁄₄ft)
- Large white polyboard reflectors
- Reflective gold mirrorboard
- Black flags as required
- Clamps and stands
- Gaffer (duct) tape

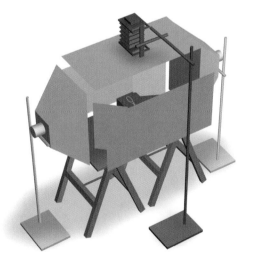

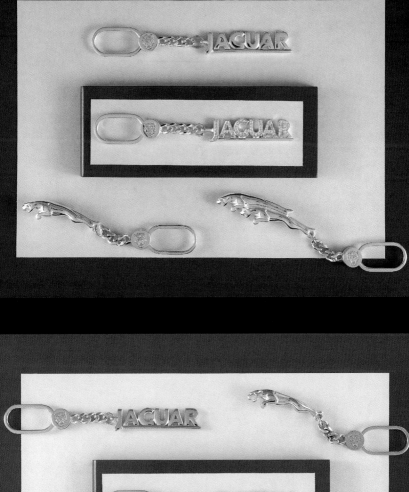
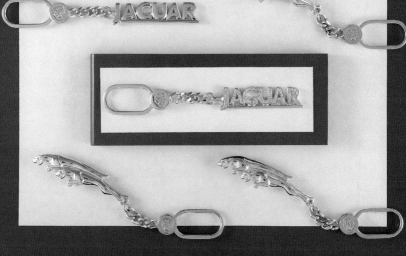

Highlights & Shadows

Close-up photography provides a wonderful opportunity to illustrate everyday objects in spectacular and unusual ways. Most of the photographs in this chapter have been shot using fairly simple lighting techniques, but they grab the viewer's attention because of their unusual angle of view, or because they reveal detail that cannot normally be seen. This shot of a Venus flytrap is crying out for the addition of a fly. Today this could easily be done using digital imaging. You could even use the blurring techniques explained in the previous chapter to make the fly appear to be moving at speed. When time allows, I will use Photoshop to complete the image by adding this fly. The creative freedom photographers have is extraordinary; it is up to you how far you take this.

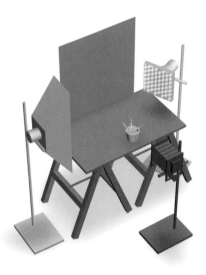

Technique

As a boy I was fascinated by the Venus flytrap and its ability to capture and eat flies. I thought this was just brilliant—a meat-eating plant! For this shot I used two lights to accentuate the jaws of the plant. I chose a strong blue background to hang about 1.2m (4ft) behind the plant, and lit this from the left with a softbox strip. You can see the graduated light-to-dark effect this has created in the blue. I then placed a light with a reflector and snoot on the right, positioned to light the mouth of the plant while keeping the front edge in shadow. I placed a second plant a few inches behind and kept this out of focus using a shallow depth of field. Making the blue background darker on the right increases the visual impact of the out-of-focus rear plant.

55mm macro lens ▷ f/11 ▷ 1/200 sec

Equipment

- Strip-light softbox, 100 x 30cm (3¼ x 1ft)
- Light with silver reflector, 21cm (8¼in), and 12° snoot
- Blue background paper
- Clamps and stands

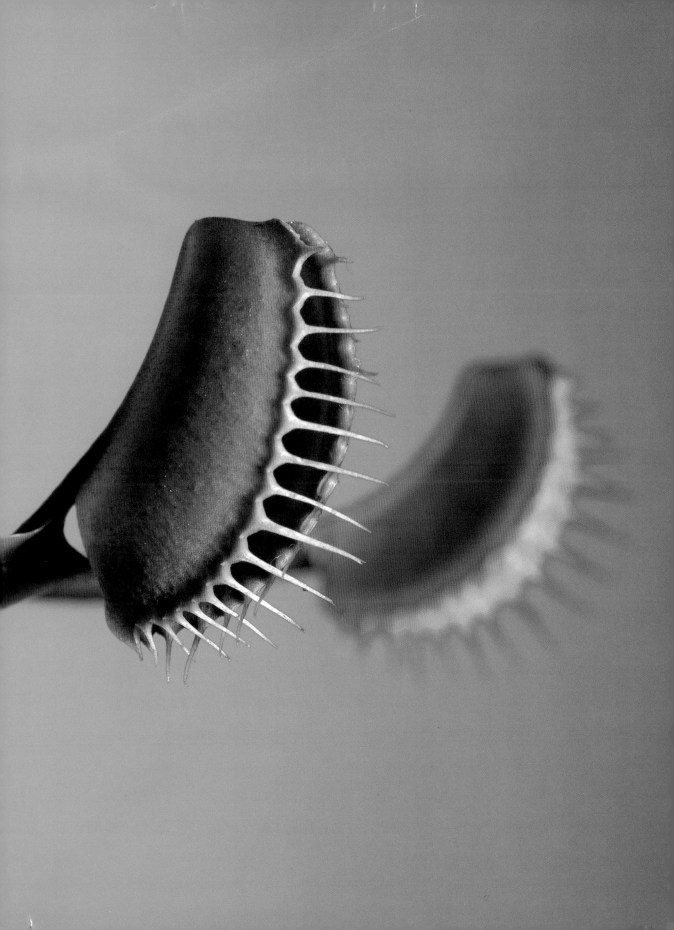

Backlighting 2

Getting your lighting right in close-up photography is, of course, just as important as in any other genre. Composition is also very important. You may find it is best to choose your angle of view and get the camera into position before working on your lighting (although the shot of the cabbage leaf opposite was an exception to this rule). Remember that you are lighting much smaller areas than usual. This means that the minutest movement of your light will have a dramatic effect on your subject. Likewise, the smallest movement in your camera will have a marked effect, so make sure it is fixed firmly in position using a sturdy tripod or camera support. Finally—at the risk of repeating myself— do consider the heat of your lights and the damage it could do due to the close proximity of all your image-making elements.

Technique

One of my most memorable images, and one that always prompts debate with viewers, is the photograph of the pumpkin on page 113. This was a very simple shot, both in composition and execution, but it is a perfect example of producing an image of an everyday item from an unusual and dramatic viewpoint. The cabbage leaf on this page was shot in a similar way, and has a similar effect. This image probably used the simplest lighting in the whole of this book. I used a sheet of translucent Perspex supported on trestles, and placed a light with a silver reflector and 12° snoot underneath this, pointing upward. I placed the cabbage leaf on top of the Perspex and framed it up in the camera, which was positioned to shoot vertically down onto the leaf. I took an incident light reading, pointing at the Perspex rather than the cabbage leaf. In similar cases, you will need to make a few test exposures to obtain optimum detail in the leaf.

105mm macro lens ▷ f/22 ▷ 1/60 sec

Equipment

- 📷 Light with reflector, 21cm (8¼in), and narrow-angled snoot
- 📷 Translucent Perspex, 10mm (½in)
- 📷 Trestle supports

Lighting for TV & video

LIGHTING DESIGNER

The methods I use as a lighting designer for
TV and video were obviously born from the stage
and theater. While the techniques are very similar
in principle, when you work with video cameras
there are certain technical issues that need to be
addressed in planning any lighting scheme. I am
concerned with color balance and the quality of
light, as is a stills photographer, but I do have one
important concern—that of contrast and specific
differences in the dark and light areas throughout
the picture. The human eye and brain can adjust
contrast in the field of vision almost 100,000:1;
the typical contrast range of the TV camera is only
around 100:1, although technology is constantly
improving on this. A typical lighting plan consists
of a strong directional key light trained on the
performer from one side, a softer fill light at around
90° to this, and a backlight to visually separate the
performer from the background, with all these
lights balanced to achieve the correct contrast for
TV. The final element, called the base light, is to
light the background and scenery to create
atmosphere and visual balance.

LOOK AT

- The use of light to separate the subject from
 the background
- The careful control of contrast and color balance

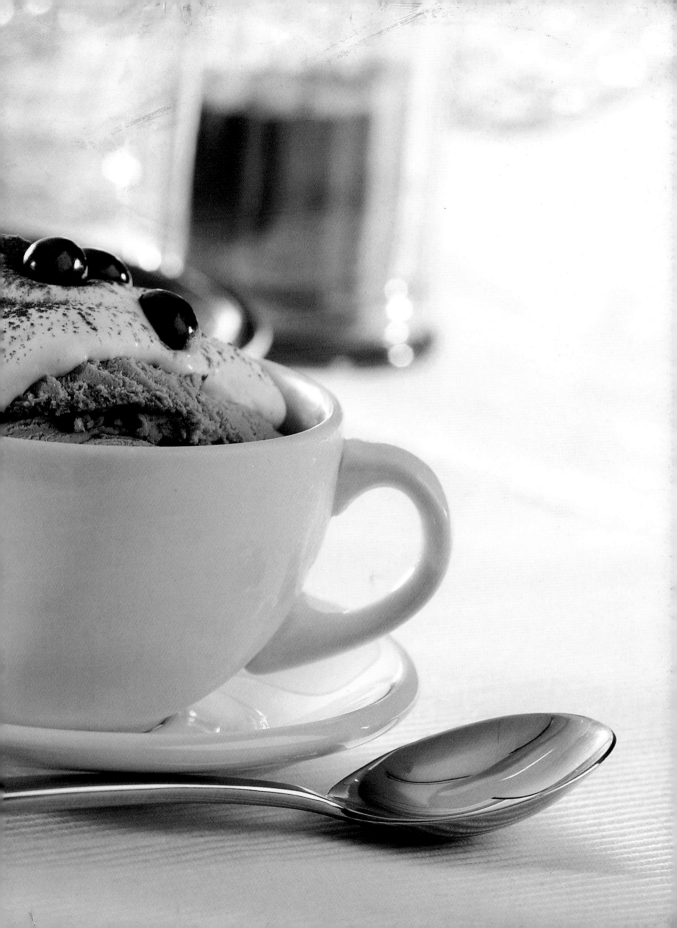

BEST PRACTICE & RESOURCES

Choosing & Designing a Studio

During my 30-odd years as an advertising and still-life photographer I have moved in, and moved out, of four studios. Even in my first three years as a studio assistant, I moved the photographer I was working with out of his old studio and into a new space. I still get a buzz just remembering the hunt for new space, finding it, then planning the studio. I have friends who have remained in one studio for the whole of their careers. I don't think this is healthy for the creative mind. A change of environment gives you renewed impetus and fresh ideas. After working in the same studio for seven years I felt the need for a minor redesign and a new paint job. This process gave me a sense of new beginnings and reinvigorated creativity.

You need to make some crucial decisions before starting your own real-estate hunt. Making the wrong choice about your space requirements can be very costly, so spend time evaluating your needs. Most photographers have some idea (although they may be somewhat vague when starting out) about where their photographic interests lie, and about their strengths and weaknesses. You may love the hustle and bustle of the fashion world, you may have a love of food, or you may be a master of all genres. Your specific interests will have an important bearing both on the type of studio space you choose, and on its location. To help you prioritize your criteria, consider the following options, and remember—big is not always better, but it is always costly!

• Will the items and objects you shoot be large or small? A car photographer will require a studio the size of a football pitch; a food photographer requires a more modest space.

• Will the items be heavy or light? Will you require a ground floor, or will an upper floor be okay? Will you need an elevator, or are the stairs wide enough? Do you need direct off-street access, large loading doors, and so on? A car photographer will need good access; a fashion photographer could make do with a first-floor studio with access only by stairs.

• Consider the studio location. Do you need to be near good stores? Do you need to be near a railway station or good access roads? A food photographer will need to be near a source of food, fresh produce, and props. A fashion photographer will need to be near good public transport systems, as this is how most models travel.

• Will you be doing any set building? Will you require additional workshop space? If your specialty is food and drink, you will require comprehensive kitchen facilities and storage for props.

• Will you be doing any fashion or beauty work? If so, you will need dressing rooms, makeup facilities, and clothes rails—and the extra space these will take up. You may also need to be near a good shopping mall to buy those last-minute emergency props.

• Are you intending to employ full-time staff, or to use freelance staff when you need them? Again, local transport will be a factor, along with restrooms and catering facilities.

• Do you intend to work on more than one job at a time, or to share your studio with another photographer? If so, can the studio space be split easily into different areas?

• Will the success of your studio depend on its location? Do you need to be in a fashionable art district, industrial estate, or central (high-rent) area?

• Do you plan to live and work in your studio?

• How secure is your chosen area? Will you require a security system?

• Do you require daylight? How many windows are there? Blackout blinds can be very costly.

• Are the floors of the space you are considering stable or of the sprung wooden type? Are there noisy neighbors? Is there a loud highway, or a vibrating railway or subway line nearby?

The above is by no means a complete list, but it gives you some insight into the process of developing a successful studio. A useful way of determining the suitability of a space is to make a pros and cons list. So get ticking those boxes…

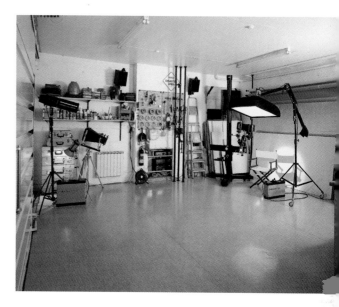

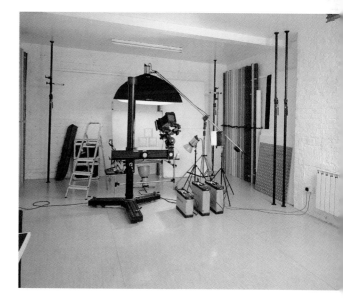

Having worked through the list above, and probably thought of a number of extra criteria, you should be in a position to work out what space you need, and your preferred location. You should also have a good idea of your budget. You can now start engaging realtors to help you hunt for suitable studio space. You should also have decided whether you are going to buy your studio outright or to rent one. Purchasing the studio is probably the best option, with its long-term investment potential. However, money is usually tight when you are setting up a new venture, or you may just like to test the water, in which case renting will be the best option.

Soon you will have a number of properties to consider and it will be time to make full use of your pros and cons list. When leasing a property, always check out your liability regarding the structure of the building. If you have a long lease with a full buildings-repair obligation, you may find yourself with large bills for a new roof, and so on. These costs can be very high and will mean that you are refurbishing your landlord's property at your expense. Always seek good legal advice and enlist the services of a building surveyor. If you purchase your studio outright and you need to spend money on costly structural repairs, it is your investment that you are adding value to and not someone else's! Try not to tie yourself into long leases. Once again, always seek legal advice.

When you have found your studio space, you need to check out the hidden costs. Are there any taxes or local council rates? Look closely at your electrical requirements. A studio needs a lot of electricity and power outlets. Is the wiring in a safe and reliable state? You may need to carry out a complete rewire.

I have had to do this in all my studios: sockets are rarely in the right place, and the ambient lighting usually needs redesigning to produce a more tasteful atmosphere.

You will probably need to invest in burglar alarms and high-security locks. Check what your insurance company requires you to install. Telephones and Internet access are another cost to consider. And always go to see the property at different times of the day and night. Check out the noise levels and what is going on in the area at different times. Once I was about to sign a lease on a property when I decided to visit the studio one evening, only to discover that a dance studio used the space upstairs and the noise from the music and the creaking of the floor rendered the studio unusable at these times. Needless to say, I declined the lease.

Having found the studio space of your dreams, you need to plan the interior and fit it out. If you tend to shoot under ambient daylight conditions, you will probably choose a studio with large windows and skylights. Your shooting stage would obviously be positioned near to these windows. Bear in mind the direction the windows face, as this will directly affect the type, intensity, and quality of light, as well as the times of day you can shoot. Many people consider a good north light to be the best solution, as it has no directional light and maintains an even, soft illumination. Also bear in mind the heat buildup if you have lots of windows facing direct sunlight. Personally, I cannot work at the mercy of the sun and its position; I find it too restricting. I have always worked mostly with controllable studio flash, choosing to shoot on location if available sunlight is a prerequisite of the shoot.

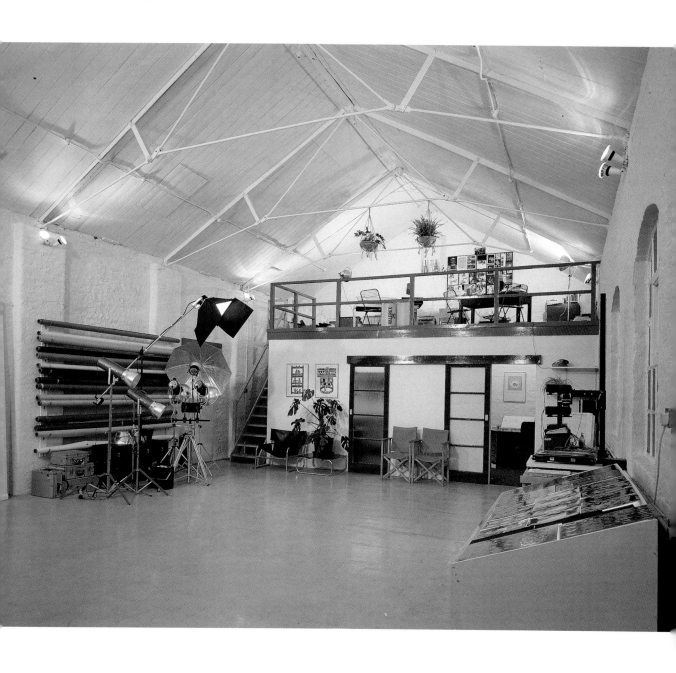

The color of the studio walls, floors, and ceiling is another factor to consider. Avoid brightly colored walls and ceilings: the color cast this will introduce into your shots due to bounced light will be a major problem. My advice is to stick to pure white walls and ceilings, with a neutral gray floor covering. I have had two studios with a gray-painted concrete floor finish, and two with a gray, industrial vinyl floor covering. The latter, without doubt, is the best option. It may appear more expensive at first, but it works out cheaper in the long term—a painted floor will wear out, so you will need to prepare and recoat it a few times.

Some photographers paint their entire studio black to stop stray light reflection, but I think this makes a very oppressive working environment. A black ceiling might be useful for stopping reflections, but it does mean you won't have the option of bouncing light from this surface. My current studio has polished pine floorboards, and I am amazed at how warm the color balance of my shots has become because of the stray ambient reflection from this floor. I often use black velvet sheets to cover the boards in order to stop this color cast.

If you have a large enough space, there are four areas that you need to consider: the reception area, the admin office, the meeting room, and the kitchen. (You may also need other areas, depending on your chosen field.) The reception area is important: it gives clients a first impression of your business. It is best to have an area separate from the main shooting stage; you don't want visitors walking straight into the studio, especially if you have clients attending, or you are photographing items of a sensitive nature. The reception can also act as a gallery for your work. Clients often spend a few minutes in your reception area, and this will offer

a good opportunity to show off your latest work. Change your display at least every six months to keep it fresh. A separate reception area has a security advantage, too—it stops the casual visitor or delivery person from seeing all your expensive equipment on display. You can't be too careful.

The administration office is another important part of a busy studio. You don't want clients viewing potentially sensitive information such as bills and invoices; it does not look professional. Also, it is good to have a separate area where you can make calls in private, away from clients. I have often been in a panic because a model has not arrived and I needed to chase them up. It does not do the clients' confidence any good if you are chasing the agency in front of them. It is best to maintain an air of calm, even if things are going pear-shaped!

For food photographers the kitchen area is a must, and for any studio it is invaluable for preparing refreshments, and for washing brushes and other items used in set-building. Hot and cold water will be necessary, as will a reliable refrigerator. Professional film needs to be kept refrigerated prior to use to keep it at its optimum color consistency. Food photographers will need much more than the basic sink and cupboard unit. Your requirements will probably include a full-sized, well-equipped kitchen, with ample work surfaces; a large freezer; a large refrigerator; a microwave; preferably two cookers, one gas and one electric (gas and electric cookers have different characteristics, especially for baking); and lots of storage space. You will need pots, pans, bowls, spoons, food mixers, blenders, and knives to meet every eventuality. Also, remember that the kitchen needs to be adjacent to your shooting area. It is no good having the kitchen one floor up if you are a busy food photographer. I have always

had my kitchens situated in the studio area. Make sure you have good air extraction to take the cooking fumes away from the shooting stage.

The last of the four required areas is a meeting room. This is often a luxury, but it is very useful for the client to relax in and to make telephone calls. It will also enable you or your assistant to take a brief on a new job. If space is at a premium, look at the possibility of combining your reception area with a meeting area. This has worked well for me in a couple of studio premises. Always have a decent-sized lightbox and a color-corrected computer monitor available for your clients to view work on.

Having planned your studio and the four essential work areas, there are one or two other areas that you may need to incorporate, depending on your specialty. Food photographers, for example, may need an area for storing props and background surfaces and fabrics, though you can always hire your props and any extra electrical appliances as you need them. You may also need additional refrigerator and freezer space. A fashion and beauty photographer will require a changing room, complete with clothes rails and full-length mirrors. If you have lots of space, a separate makeup area could be useful, although the changing room could double up for this. Make sure you have suitable mirrors with adequate lighting. Ask a few makeup artists for advice with setting up this area. The room-set photographer is another specialist case. For this you may require a workshop for set construction, and huge areas to hold furniture and room-set flats.

I have not mentioned darkroom space; sadly, this is a diminishing area of mainstream photography. However, I do know some digital photographers who have dedicated rooms for post-production.

Final considerations in planning your studio space include equipment storage needs, such as access to background paper rolls and other useful items such as tools and gaffer (duct) tape. Many of my clients have talked about other studios they have used, complaining about their chaos, mess, and mayhem! I always run my studio like an operating theater: everything has a place and is returned to that place after it is used. This way, if you need the gaffer tape you know where it is, every time. Clients pay good money for our services; they don't expect to pay for us while we spend hours looking for the light meter or a roll of tape. I have kept my clients, and gained a fair few from the competition, because of my neat and tidy studio and the efficient way I run it. A well-run, clean, and orderly studio (especially one that is warm in the winter) gives a client confidence.

A great studio does not guarantee great photographs, but it certainly helps—and it will also help you enjoy your working day.

Good Working Practice

Being a professional photographer can make for a great career. It is a creative, sometimes lucrative, always interesting, varied, and very satisfying way to spend your working life. There is a popular myth that being a photographer is also glamorous, although I have never quite found this side of the business! Being a professional photographer does not merely mean earning a living from your "snaps." There is a duty of care and a code of ethics that the professional photographer should maintain at all times. Clients are investing their trust, time, and money in you, and as a professional you must produce results for them at all times, often despite difficult working conditions. Failing to produce the desired picture not only means not collecting your fee, but also letting your client down, perhaps irretrievably, and probably a whole string of other people too. A worst-case scenario might involve lost money in model fees and location or prop hire, an important publication deadline missed, and an unrepeatable event undocumented.

In my long career I have been very fortunate to be commissioned not only for my skills with the camera and lights, but also for my watertight planning, reliability, and attention to detail. It always pays to plan your shoot in every detail. Do not take anything for granted, and never rely on the client doing what he or she says they will do. On numerous occasions I have found it has been the client who has failed to get things ready for a shoot. It will always pay to keep a dialogue going with your client and involve them in the planning. After all, you are the professional, and you know the requirements for the shoot. I feel that many clients just do not understand the mechanics of photography and look on us photographers as magicians—which I quite often have to be!

Make sure that you cost your jobs accurately. Work needs to be produced efficiently and with adequate speed to remain economical. As your experience grows you will be able to judge fairly accurately how much time you should allocate each job. Do not be told by your client how long the job should take! If your client does not agree with your time estimate, make sure he or she attends the shoot and agree a run-on time if the job takes longer than he or she thinks it should. I find this agreement works very well; nine times out of ten, the client is proved inaccurate in their estimate.

I do not have the space here to fully explore the financial aspects of running a photographic studio. There are many more specialized books available on this subject, or you could seek the advice of your bank or accountant on these matters. All I will say is, you will not survive long in this business if you do not get your calculations right. Photographers' fees vary, not only from region to region, but also from genre to genre. You may well have to be guided by the going rate of rival photographers in your area, so a little research is required. Your fee and how you arrive at this figure should not only encompass your experience, skills, and creativity, but also take into account the tools of your trade and their costs. These will include the capital cost of equipment, cameras, lights, and computers, and your studio overheads. Do not forget to factor in your rent or mortgage costs, light, heat, telephones,

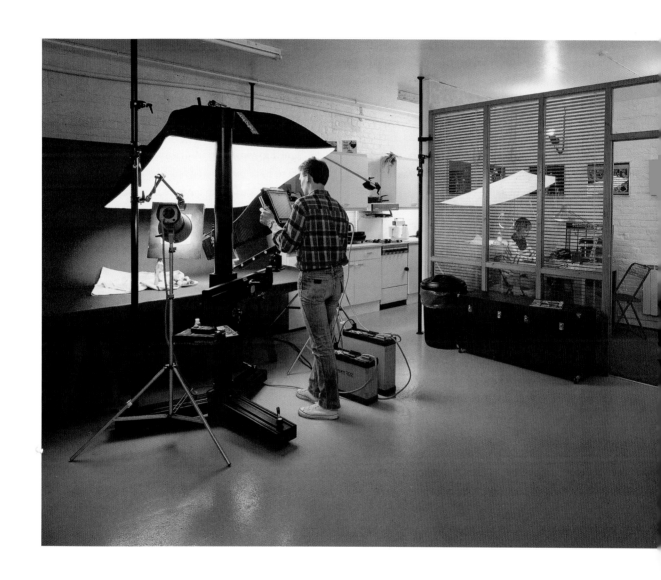

The Future of Photography

I have mixed emotions about the direction in which photography, in its digital form, is heading. We seem to be losing a great set of core skills to the power of the computer. When I was six I had an unforgettable, even magical, experience—one that would change my life forever. With my father's help, I saw a silver halide print emerging before my eyes while I carefully swished tart-smelling developer in a plastic tray, from end to end. Together, we watched the image magically appear in the dim red light of the darkroom. And all this after the mystical experience of standing in complete darkness, unable to see a thing, with only the rustling of the film backing paper, the clicking of the film spiral, and the running commentary my father gave me while he loaded the film I had shot earlier that day into the Paterson tank. The mixing of the magic chemicals, the temperature control, and the timer are things unknown to most photographers today.

I now have a young son myself. Recently we made a pinhole camera together, with an old shoebox, a piece of tracing paper, some glue, and a pin. This is the original camera, one that so simply and elegantly demonstrates the law of optics. My son was highly bemused at this, but listened intently to my stories of the darkroom and how we used to make prints with chemicals and enlargers. He commented on how fun it must have been, so much better than the instant capture of images on digital cameras, which can be printed out at will.

Because of the advances in digital technology, photography is much more accessible now. And, while this is mainly a positive development, I feel it has diluted the perceived skills of the professional photographer. There is a perception that "anybody" can be a photographer. I also feel that the advent of digital has produced a lot of mediocre photographers who use the computer to rescue their poor imagery, and thus dilute the core skills even more—the basic skills of composition and lighting.

Before the dawning of the digital age, if you failed to correctly expose your image or failed to capture your subject's smile, you were done for—there was no computer to dig you out of a hole! Let us not forget, there is no difference between the film camera and the digital equivalent. They do exactly the same job and need the same operating skills; they simply record the image in a different format. The CCD chip is no different from a piece of conventional film. They both need light, lens, and a photographer's eye. You still need to get the lighting and the composition right in the first place. Despite my nostalgia for the darkroom days, I have come to regard my digital camera as a friend, and the software I use on my digital workstation as another tool in the professional photographer's armory—a tool to use alongside my lighting skills to add an extra dimension to my images. Having embraced this transition from old school to new school I am at peace with all those pixels and RAM chips—although I could do without the mountain of CDs and DVDs I am amassing.

The Future of Photography

I have mixed emotions about the direction in which photography, in its digital form, is heading. We seem to be losing a great set of core skills to the power of the computer. When I was six I had an unforgettable, even magical, experience—one that would change my life forever. With my father's help, I saw a silver halide print emerging before my eyes while I carefully swished tart-smelling developer in a plastic tray, from end to end. Together, we watched the image magically appear in the dim red light of the darkroom. And all this after the mystical experience of standing in complete darkness, unable to see a thing, with only the rustling of the film backing paper, the clicking of the film spiral, and the running commentary my father gave me while he loaded the film I had shot earlier that day into the Paterson tank. The mixing of the magic chemicals, the temperature control, and the timer are things unknown to most photographers today.

I now have a young son myself. Recently we made a pinhole camera together, with an old shoebox, a piece of tracing paper, some glue, and a pin. This is the original camera, one that so simply and elegantly demonstrates the law of optics. My son was highly bemused at this, but listened intently to my stories of the darkroom and how we used to make prints with chemicals and enlargers. He commented on how fun it must have been, so much better than the instant capture of images on digital cameras, which can be printed out at will.

Because of the advances in digital technology, photography is much more accessible now. And, while this is mainly a positive development, I feel it has diluted the perceived skills of the professional photographer. There is a perception that "anybody" can be a photographer. I also feel that the advent of digital has produced a lot of mediocre photographers who use the computer to rescue their poor imagery, and thus dilute the core skills even more—the basic skills of composition and lighting.

Before the dawning of the digital age, if you failed to correctly expose your image or failed to capture your subject's smile, you were done for—there was no computer to dig you out of a hole! Let us not forget, there is no difference between the film camera and the digital equivalent. They do exactly the same job and need the same operating skills; they simply record the image in a different format. The CCD chip is no different from a piece of conventional film. They both need light, lens, and a photographer's eye. You still need to get the lighting and the composition right in the first place. Despite my nostalgia for the darkroom days, I have come to regard my digital camera as a friend, and the software I use on my digital workstation as another tool in the professional photographer's armory—a tool to use alongside my lighting skills to add an extra dimension to my images. Having embraced this transition from old school to new school I am at peace with all those pixels and RAM chips—although I could do without the mountain of CDs and DVDs I am amassing.

So where does this leave the future of photography? I think there will be a die-hard core of enthusiasts who will keep the good old days of film and chemicals alive, especially in the fine-art market. I think digital will surpass the quality of film—in fact, it already has by a large margin at the top end of the digital camera market. Cameras will become cheaper and the handling and archiving of large image files will become easier.

Increasingly, we will view our photographs on computers, TV screens, and cell phones. I also think the use of digital moving images will become more mainstream, coupled with our own home-produced soundtracks. Photography is, and will always be, about recording a moment in time and space, and how that exposure is made is largely immaterial. I leave it to you to decide how you wish to do your photography in the future. Happy snapping.

Materials & Equipment

LIGHTING EQUIPMENT

Australia

Bowens
C. R. Kennedy & Co. Pty Ltd.
P.O. Box 440
663–669 Chapel Street
South Yarra
Victoria 3141
Tel: +61 (0)3 9823 1555
drulach@crkennedy.com.au
www.crkennedy.com.au

Multiblitz
Alderson Camera Stores Pty. Ltd.
364 Kent Street
P.O. Box Q 97
QVB Postshop
Sydney
NSW 2000
Tel: +61 (0)2 9299 6745
mark@fotoriesel.com
www.fotoriesel.com

Elinchrom
Kayell Australia Pty. Ltd.
1/9 Hotham Parade
Artarmon, Sydney
NSW 2064
Tel: +61 (0)2 94399377
kayellaustralia@kayell.com.au
www.kayellaustralia.com.au

Austria

Multiblitz
Wiener Neudorf Sagafoto
Bürocenter B17/2
Brown Boverl-Straße 8/1/18
2351 Wiener Neudorf
Tel: +43 (0)2236 865 271
office@sagafoto.at
www.sagafoto.at

Canada

ARRI Canada Ltd.
415 Horner Avenue, Unit 11
Etobicoke, Toronto
Ontario M8W 4W3
Tel: +1 (416) 255 3335
email@arrican.com
www.arrican.com

Bowens
Headshots
290 Shutter Street
Toronto
Ontario M5A 1W7
Tel: +1 (416) 466 9600
mail@headshotsrentals.com

Elinchrom
Vistek Ltd.
496 Queen Street East
Toronto
Ontario M5A 4G8
Tel: +1 (416) 365 1777
sales@vistek.ca
www.vistek.ca

China

Elinchrom
PSC C° Ltd.
20/F.I. Jinsui Building
96–110 Guanzhou Da Dao, North
510020 Guanzhou
Tel: +86 (0)20 3886 6382
pscltd@21cn.net
www.elinchrom.net

Croatia

Multiblitz and Bowens
Prizma d.o.o., Drage Gervaisa 2
10147 Zagreb
Tel: +385 (0)1389 5127
prizma@prizma-foto.hr
www.prizma-foto.hr

Czech Republic

Bowens
Ades Nad Zameckem 50
150 00 Praha 5
Tel: +42 (0)2 5721 1991
ades@terminal.cz
www.ades.cz

Elinchrom
Flash Centrum.CZ
Dipl. Ing. Vladimir Cech.
Dolnomecholpska 209/17
Prague 10 Hostivar
102 00 Prague
Tel: +420 737 243 922
cech@flashcentrum.cz
www.flashcentrum.cz

Estonia

Bowens
Maksifoto
Tartu tn.3
71004 Vijandi
Tel: +372 4333 089
www.maksifoto.ee

Elinchrom
Olympus Estonia OÜ
Järvevana tee 9
11314 Tallinn
Tel: +372 6549 543
romet.roosalu@olympus.ee
www.olympus.ee

Multiblitz
AS Fotex
Öismäe Tee 115 A
EE 13515 Tallinn
Tel: +372 50 31213
lonu@fotex.ee
www.fotex.ee

France

Bowens
Technicinephot
Division Photo PRO
135 Rue du Fosse Blanc
92622 Gennevilliers Cedex
Paris
Tel: +33 (0)1 40 10 55 55
commandes@technicinephot.com
www.technicinephot.fr

Elinchrom
DB Photo
124/132 Rue des Poissonniers
75018 Paris
Tel: +33 (0)14 6272 900
info@dbphoto.fr
www.dbphoto.fr

Multiblitz
Mc Donald – Multiblitz France
(MMF-Pro)
24 Rue Davoust
F 93698 Pantin Cedex (Paris)
Tel: +33 (0)1 48 91 20 66
contact@mmf-pro.com
www.mmf-pro.com

Germany

ARRI Lighting Solutions GmbH
Ernst-Augustin-Straße 12
Gebäude R1
12489 Berlin
Tel: +49 (0)30 67 82 33 0
arri-solutions@arri.de
www.arri.com/sub/de/li_
solutions/about.htm

Bowens
Calumet Photographic
Bahrenfelder Straße 260
22765 Hamburg
Tel: +49 (0)40 423 1600
mail@calumetphoto.de
www.calumetphoto.de

Elinchrom
Profot GmbH
Oskar-Jäger-Straße 160
D-50825 Cologne
Tel: +49 (0)221 987 498 8
info@profot.com
www.profot.com

Multiblitz
Ferdinand-Porsche Straße 19
51149 Cologne
Tel: +49 (0)2203 9396 31
info@multiblitz.de
www.multiblitz.com

Greece

Bowens
N. Cofinas-H. Alexandrou
9 Orminou Street
Athens 115-28
Tel: +30 210 723 6847

Elinchrom
Salcofot S.A.
19 Sarantaporou Street
54640 Thessaloniki
Tel: +30 2312 78 600
skounio@the.forthnet.gr

Multiblitz
D. & J. Damkalidis S.A.
44 Zefyrou Street
17564 Paleo Faliro
Tel: +30 210 9410 888
jdamkalidis@damkalidis.gr

Hong Kong

Elinchrom
Radiant Co.
RM. 101 1/F, Thomson Center
76 Thomson Road
Wanchai SAR
Tel: +852 2575 7859
kwancheechoy@yahoo.com.hk

Hungary

Bowens

Studio Line Fototechnika Kft.

Gizella út 30

1143 Budapest

Tel: +36 1222 4200

studioline@nika.hu

www.nika.hu

Elinchrom

Tripont Kft

Menesi út 39

1118 Budapest

Tel: +36 1 279 1822

info@tripont.hu

Multiblitz

Studio Line Fototechnika Kft

Gizella út 32

1143 Budapest

Tel: +36 1 222 4200

studioline@nika.hu

www.nika.hu

Italy

Bowens

Gruppo BP

Via C. Tacito 6

20137 Milan

Tel: +39 (0)2 550 15489

info@gruppobp.it

www.gruppobp.it

Elinchrom

Aproma SRL

Via De Lemene 37

20151 Milan

Tel: +39 (0)2 3801 1138

info@aproma.it

www.apromastore.it

Multiblitz

Infoto S.P.A.

Via Corinto 12

I 00148 Rome

Tel: +39 (0)6 5432332

Infoto.Bari@pangeanet.it

www.infoto.it

Ireland

Elinchrom

Barker Photographic Ltd.

Unit 18m South Link Park

Frankfield

Cork

Tel: +353 21 4319 766

info@barkerphotographic.ie

www.barkerphotographic.ie

Japan

Bowens

Take, Inc.

2-14-2 Ginza, Chyuo-Ku

104-0061 Tokyo

Tel: +81 (0)3 3543 5961

import@takeinc.co.jp

www.takcinc.co.jp

Elinchrom

Take Inc.

2-14-2 Ginza, Chou-Ku

104-0061 Tokyo

Tel: +81 (0)3 3543 5961

import@takeinc.co.jp

www.takeinc.co.jp

Lithuania

Multiblitz

Fototechnika

Paménkalnio 15/6

01114 Vilnius

Tel: +370 5 2791545

info@fototechnika.lt

www.fototechnika.lt

The Netherlands

Bowens

Calumet Netherlands

Keienbergweg 13–15

1101 EZ Amsterdam ZO

Tel: +31 (0)20 697 7171

info@calumetphoto.nl

www.calumetphoto.nl

Elinchrom

Foto & Flitstechniek

Kerkstraat 43

1511 EA Oostzaan

Tel: +31 (0)75 684 1742

info@fotoflits.com

www.fotoflits.com

Multiblitz

GE Nieuw-Vennep

Transcontinenta B.V.

Tarwestraat 29

2153 GE Nieuw-Vennep

Tel: +31 (0)252 687 555

info@transcontinenta.nl

www.transcontinenta.nl

Poland

Bowens
Foto 7 sc
ul. Dworcowa 62
44-100 Giwice
Tel: +48 (0)32 238 2514
foto7@foto7.com.pl

Elinchrom
PPHU "Milso"
Wlodzimierz Mildner
ul. Zwyciezcow 46
03-938 Warszawa
Tel: +48 (0)22 6170 243
milso@milso.com.pl
www.milso.com.pl

Multiblitz
Ostrów Wielkopolski
Multiblitz w Polsce s.c.
ul. Kolejowa 30
63-400 Ostrów Wielkopolski
Tel: +48 (0)62 5918855
biuro@multiblitz.com.pl
www.multiblitz.com.pl

Portugal

Multiblitz
Canelas (Rechousa)
Ibermagem e som LDA.
Rua dos Abracos 38
P 4405-261 Canelas (Rechousa)
Tel: +351 22 7150800
Ibermagem@ibermagem.pt
www.Ibermagem.pt

Russia

Bowens
Photo-Frame
119285 Russia Moscow
Mosfilmovskaya Street 1
Tel: +7 095 234 99 15(16)
info@bowens.ru
www.bowens.ru

Elinchrom
Marco Professional
125167 Russia Moscow
Leningradsky Prospect 47
NIKFI off. 145
Tel: +7 495 2255068
info@marco-pro.ru
www.marco-pro.ru

Slovakia

Multiblitz
Moonlight Spol. S.R.O.
Nové Záhrady I/13
82105 Bratislava
Tel: +421 (0)2 4823 5345
moonlight@moonlight.sk
www.moonlight.sk

Spain

Bowens
Bach Import S.A.
Gran Via Carlos III 58-60D
08028 Barcelona
Tel: +34 93 330 9408
info@bachimport.com
www.bachimport.com

Elinchrom
Cromalite S.L.
Vinyals 29 Bajos

08041 Barcelona
Tel: +34 93 436 0561
info@cromalite.com
www.cromalite.com

Multiblitz
Cimat Foto, S.A.
Francisco Navacerrada 57
E 28028 Madrid
Tel: +34 91 3610515
cimatfoto@cimatfoto.com
www.cimatfoto.com

Sweden

Elinchrom
Aifo AB
Tappvägen 36 B
168 65 Bromma
Tel: +46 (0)8 7200 645
aifo@aifo.se
www.aifo.se

Profoto
Box 2023
S-128 21
Skarpnäck
Tel: +46 (0)8 4475 300
www.profoto.com

Turkey

Bowens
Karfo
Ebusuud Cad
Aytac Han No. 36–38
Sirkeci
Istanbul
Tel: +90 (0)212 512 3193
info@karfo-karacasulu.com
www.karfo-karacasulu.com

Elinchrom
Bingor Dis Ticaret Ltd Sti
Asir Efendi Cad. Turkiye Han No.
33 Kat. 4
34420 Eminonu, Istanbul
Tel: +90 (0)212 527 3038
info@bingor.com.tr
www.bingor.com.tr

Multiblitz
Zoom Ithalat
Jirayr GamsaraganAnkara Cad.
Muhsirbasi Sokak
Özkanlar Is Hani 1–3
34420 Sirkeci, Istanbul
Tel: +90 (0)212 511 4640
zoom@zoomithalat.com
www.zoomithalat.com

United Kingdom
Multiblitz
Mr. CAD
68 Windmill Road
Croydon
Tel: +44 (0)20 8684 8282
sales@mrcad.co.uk
www.mrcad.co.uk

Elinchrom
The Flash Centre
68 Brunswick Centre
Marchmont Street
London WC1N 1AE
Tel: +44 (0)207 837 5649
sales@theflashcentre.com
www.theflashcentre.com

Bowens International
355–361 Old Road
Clacton-on-Sea
Essex CO15 3RH
Tel: +44 (0)1255 422807
info@bowens.co.uk
www.bowens.co.uk

ARRI Media
2 Highbridge Oxford Road
Uxbridge
Middlesex UB8 1LX
Tel: +44 (0)1895 457100
info@arrimedia.com
www.arrimedia.com

United States
ARRI
ARRI Inc.
New York Office
617 Route 303
Blauvelt
New York 109131123
Tel: +1 845 353 1400
Arriflex@arri.com
www.arri.com

Bowens USA
P.O. Box 310
West Hyannisport
Massachusetts 02672
Tel: +1 508 862 9274
info@bowensusa.com

Elinchrom
Bogen Imaging Inc.
565 East Crescent Ave
Ramsey
New Jersey 07446-0506

Tel: +1 201 818 9500
info@bogenimaging.com
www.bogenimaging.us

Multiblitz
R.T.S. Inc.
40-11 Burt Drive
Deer Park
New York 11729
Tel: +1 631 242 6801
rtsinc@erols.com

**LIGHTING FILTERS &
DIFFUSERS**

Canada
Rosco Canada Head Office
1241 Denison Street, #44,
Markham
Ontario L3R 4B4
Tel: +1 (1)905 475 1400
info@roscocanada.com

Spain
Rosco Ibérica, S.A.
C/Oro,76 Polígono Industrial Sur
28770 Colmenar Viejo, Madrid
Tel: +34 918 473 900
info-spain@rosco-iberica.com

United Kingdom
Roscolab
Kangley Bridge Road
Sydenham
London SE26 5AQ
Tel: +44 (0)208 8659 2300
sales@rosco-europe.com
www.rosco.com

United States

Rosco Laboratories Inc.

52 Harbor View

Stamford

Connecticut 06902

Tel: +1 203 708 8900

info@rosco.com

www.rosco.com

BACKGROUND PAPERS & PLASTICS

Czech Republic

Colorama Photodisplay Ltd.

FOMEI a.s.

Machkova 587

Hradec Kralove 500 11

Tel: +420 49 5056 500

info@fomei.com

www.fomei.com

France

Colorama Photodisplay Ltd.

Bogen Imaging France

Creteil Parc

8/10 Rue Sejourne

94044 Creteil Cedex

Tel: +33 (1) 45 13 18 60

helpdesk@fr.bogenimaging.com

www.manfrotto.fr

Germany

Colorama Photodisplay Ltd.

Hensel Studiotechnik

Robert-Bunsen-Straße 3

D97076 Wurzburg

Tel: +49 (0)931 278 810

info@hensel.de

www.hensel.de

Greece

Colorama Photodisplay Ltd.

D. & J. Damkalidis S.A.

44 Zefyrou Street

175 64 Paleo

Faliro, Athens

Tel: +30 (010) 9410 888

desk@damkalidis.gr

www.damkalidis.gr

Hungary

Colorama Photodisplay Ltd.

Tripont Ltd.

Tetnyi út 18

1115 Budapest

Tel: +36 1203 2874

info@tripont.hu

www.tripont.hu

The Netherlands

Colorama Photodisplay Ltd.

S-Color-Max

Anthony Fokkerweg 3

1059 CM Amsterdam

Tel: +31 (0)20 6112212

info@scolormarx.nl

www.scolormarx.nl

Russia

Colorama Photodisplay Ltd.

FM Trading

Office 201

Zhebrunova Street 6/1

Moscow 107014

Tel: +7 095 500 67 48

gd@fm-trading.ru

www.fm-trading.ru

Spain

Colorama Photodisplay Ltd.

Bach Import S.A.

Gran Via De Carlos III 58-60D

08028 Barcelona

Tel: +34 93 330 9408

info@bachimport.com

www.bachimport.com

United Kingdom

Colorama Photodisplay Ltd.

Unit 7

Ace Business Park

Mackadown Lane

Kitts Green

Birmingham B33 0LD

Tel: +44 (0)121 783 9931

info@coloramaphotodisplay.co.uk

www.coloramaphotodisplay.co.uk

United States

Rosco Laboratories Inc.

52 Harbor View

Stamford

Connecticut 06902

Tel: +1 203 708 8900

info@rosco.com

www.rosco.com

Information & Inspiration

FURTHER READING

There are many books on lighting for photography generally, and studio lighting in particular. This short list provides a starting point for further research.

Master Lighting Guide for Portrait Photographers
Christopher Grey
Amherst Media, 2004
This book is aimed at aspiring photographers with a basic level of knowledge. Conventional lighting strategies to improve the quality of a portrait are covered, terminology is explained, the equipment needed to create professional results is outlined, and the role that each element of the lighting setup plays in the studio is explored.

Creative Lighting Techniques for Studio Photographers
Dave Montizambert
Amherst Media, 2003
This guide to studio lighting demonstrates universal lighting principles that help photographers master lighting theory and technique. Essential concepts such as why light behaves the way it does, and how to manipulate it to best effect are explained. Practical examples illustrate topics such as shooting light, dark, and reflective surfaces; mastering contrast control; modifying shadow formation; creating definition in black objects; and using Photoshop to fine-tune subjects.

Basic Studio Lighting: The Photographer's Complete Guide to Professional Techniques
Tony Corbell
Amphoto Books, August 2001
Another more basic guide to studio lighting, this book covers correct use of equipment and suggests ways of utilizing color and light to create special effects. It also discusses exposures, accent lighting, backgrounds, setups, and other studio techniques.

Studio Photography: Essential Skills
John Child, Focal Press, 2005
A guide to using studio equipment, communication, and design within the genres of still life, advertising illustration, portraiture, and fashion. The focus is on technique and experimentation.

Studio Lighting Solutions: Expert Professional Techniques for Artistic and Commerial Success
Jack Neubart and PDN Magazine
Amphoto Books, 2005
A guide to still-life photography in a controlled studio environment. Through the projects of professional photographers, this book looks at how to achieve both artistic and commercial success in still-life photography. Information about the assignment and the shoot is given for each shot, including the objectives of the client, logistical challenges, and lighting and other techniques used to get the shot.

Studio Lighting: A Primer for Photographers
Lou Jacobs
Amherst Media, 2005

Aimed at photographers wishing to embark on studio photography, whether that be setting up temporarily in a living room or renting a commercial space. It provides basic advice on selecting equipment, and fine-tuning images for professional results.

Beginner's Guide to Photographic Lighting: Techniques for Success in the Studio or on Location
Don Marr
Amherst Media, 2004

Don Marr views photography in terms of sculpting light. He focuses on selection of light sources and modifiers, and on using different lighting styles to create different effects. It follows a "recipe style," with step-by-step instructions for readers to follow.

The Photographer's Guide to the Studio
Roger Hicks and Frances Schultz
David & Charles Publishers, 2002

This guide provides a grounding in the basic technical and aesthetic considerations of studio photography. It includes a survey of equipment and lighting techniques, and a range of studio subjects, from portraits and nudes to still lifes and macro work.

USEFUL CONTACTS

The following information is correct at time of publication and is meant as a starting point for your research. It is by no means a definitive list.

Adobe Photographers Directory
The Adobe Photographers Directory lists international photography associations, among other resources.
www.photographersdirectory.adobe.com

StudioLighting.net
Another useful resource for studio lighting information
www.studiolighting.net

Australia
Australian Photographic Society
P.O. Box 7339, Geelong West
Victoria 3218
Tel: +61 (0)3 5243 4440
secretary@a-p-s.org.au
www.a-p-s.org.au

Australian Institute of Professional Photography
P.O. Box 372, North Melbourne
Victoria 3051
Tel: +61 1800 686 696
admin@aipp.com.au
www.aipp.com.au

Canada
The Canadian Association for Photographic Art
Box 357, Logan Lake
British Columbia V0K 1W0
Tel: +1 (1)250 523 2333
capa@capacanada.ca
www.capacanada.ca

Germany
German National Association for Professional Photographers
Hohenzollernstraße 10
80801 Munich
Tel: +49 (0)89 38869562
info@awi-online.de
www.awi-online.de

German Professional Photographers' Association
Tuttlinger Straße 95
D-70619 Stuttgart
Tel. +49 (0)711/47 34 22
www.bff.de

Italy

Associazione Nazionale Fotografi
Professionisti TAU Visual

Via Luciano Manara 7

20122 Milano

Tel: +39 (0) 255187195

www.fotografi.tv

The Netherlands

GKf

De Wittenkade 75

1052 AE Amsterdam

Tel: +31 (0)20 612 46 27

info@gkf-fotografen.nl

www.gkf-fotografen.nl

Spain

Associación de Fotógrafos Profesionales

Pl. Narcís Oller, 7 pral. 1ª

08006 Barcelona

Tel: +34 (0)93418 4525

secretaria@afp-online.org

www.afp-online.org

United Kingdom

The Association of Photographers

81 Leonard Street

London EC2A 4QS

Tel: +44 (0)20 7739 6669

info@aophoto.co.uk

www.the-aop.co.uk

British Institute of Professional Photography

Fox Talbot House

2 Amwell End

Ware

Hertfordshire SG12 9HN

Tel: +44 (0)1920 464011

www.bipp.com

The Master Photographers Association

Jubilee House

1 Chancery Lane

Darlington

County Durham DL1 5QP

Tel: +44 (0)1325 356555

general@mpauk.com

www.thempa.co.uk

The Royal Photographic Society

Fenton House

122 Wells Road

Bath BA2 3AH

Tel: +44 (0)1225 325733

reception@rps.org

www.rps.org

United States

Photographic Society of America

3000 United Founders Blvd,

Suite 103

Oklahoma City

Oklahoma 73112

Tel: +1 405 843 1437

www.psa-photo.org

Advertising Photographers of America

P.O. Box 250

White Plains

New York 10605

Tel: +1 (800) 272 6264

www.apanational.com

Professional Photographers of America, Inc.

229 Peachtree St. NE, Suite 2200

Atlanta

Georgia 30303

Tel: +1 (800) 786 6277

www.ppa.com

Glossary

A

ABERRATION The inability of a lens to render a perfect image of the subject at the edges of the lens's field of view. There are seven common lens aberrations in simple lenses which can be reduced with compound constructions. These are: astigmatism, spherical aberration, coma, chromatic aberration, lateral chromatic aberration, curvilinear distortion, and curvature of field.

ACHROMATIC A lens system that has been corrected for chromatic aberration.

AMBIENT LIGHT The light naturally occurring in one's surroundings or environment. This could be daylight or light from an artificial source.

ANGLE OF VIEW Maximum angle of acceptance of a lens that is capable of producing an image of usable quality on the film or CCD.

APERTURE An adjustable circular hole centered on the lens axis. It is part of the lens that admits light onto the CCD receptor or film.

APERTURE PRIORITY CAMERA A semi-automatic camera on which the photographer sets the aperture and the camera automatically sets the correct shutter speed.

APOCHROMAT Lens corrected for chromatic aberration in all three additive primary colors.

ASA (American Standards Association) The arithmetically progressive rating of the sensitivity of film or CCD to light. ASA 100-rated film has, for example, twice the sensitivity of film rated at ASA 50.

B

BACK-PROJECTION A technique whereby an image from a transparency, projector, or light is projected onto a translucent screen from the side opposite the camera to form an image or lighting effect.

BACKGROUND ROLL A roll of heavy-gauge paper used as a background covering. These are available in many colors.

BACKLIGHTING Lighting from behind the subject directed toward the camera position.

BARNDOORS Adjustable flaps that fit at the front of a photographic light to prevent light from spilling out at the sides. Usually consists of two or four hinged flaps on a frame.

BELLOWS A flexible, concertina-like constructed black sleeve connecting the film plane with the lens plane, usually found on large-format plate cameras. Can be continuously variable in length; useful in close-up photography.

BOOM A counterbalanced lighting support that cantilevers, generally horizontally, from a vertical lighting stand. Ideal for suspending lights high up, over the subject.

BOUNCING LIGHT Aiming a light at a large reflective surface, such as a white ceiling, and thus increasing the area of illumination with a soft blanket of light.

C

CAMERA ANGLE A camera's direction of view, particularly in reference to the angle above or below horizontal.

CCD CHIP Charge-coupled device chip. This is one of the two main types of image sensor used in digital cameras. CCD chips are involved in the conversion of light first to electrons, and then to a digital value.

COLOR BALANCE An adjustment made at any point in making a photographic image, from film type to postproduction, that ensures neutral grays in the subject appear neutral in the photograph.

COLOR-CONVERSION FILTERS Series of filters used to convert the color temperature of various light sources so that it matches the color balance of the film in use.

COLOR TEMPERATURE The temperature at which an inert substance glows a particular color. The color temperature in photography ranges from around 2,000 K (reddish colors) to 60,000 K and beyond (bluish colors). White is 5,400 K.

CONTRAST The subjective difference in brightness within adjacent areas of tone. In photographic emulsions it is the rate of increased density in relationship to exposure. Contrast control is an important part of photography and is affected by: subject–lighting ratio, inherent subject contrast, flare factor of lenses, type of film used, printing paper types, and digital postproduction.

D

DEPTH OF FIELD The distance between the nearest and farthest points in a subject that appear acceptably sharp in an image in front of and beyond the critical plane of focus. Depth of field can be increased by stopping the lens down to a smaller aperture.

DIFFUSER A material that scatters transmitted light, increasing its angle of illumination (for example, Rosco Tough Frost or tracing paper).

DIFFUSION The process of scattering light in order to soften and reduce shadow intensity by using a diffusion material.

DIRECT LIGHT READING A method of reading reflected light. See also Reflected Light Reading.

DOUBLE EXPOSURE Making two separate exposures on one single frame or photograph.

E

ELECTRONIC FLASH Light produced by passing a high electrical voltage charge through an inert gas in a sealed transparent glass tube.

ELLIPSOID SPOTLIGHT A type of spotlight, sometimes called a zoom spot, consisting of two lenses that can be adjusted to obtain different diameters of spotlight. This light can be modified and shaped using four internal masking blades. It is also able to accept gobos to project lighting patterns. Commonly used in the theater for stage lighting.

EXPOSURE In photography, the amount of light reaching the film or CCD chip, being the product of intensity and time.

EXPOSURE METER Instrument used to measure light either falling onto or reflected from the subject. Many light meters measure ambient and electronic flash.

F

FILL OR FILL-IN LIGHT The illumination of shadow areas in the subject.

FLAG A matte-black sheet of material held in position between a lamp and the camera to reduce or stop flare.

FLARE Non-image-forming light scattered or reflected from the lens or camera interior. Flare can degrade the image by lowering the image contrast.

FLASH A bright light source created artificially, giving a very short pulse that needs to be synchronized with the time the camera shutter remains open. See also Electronic Flash.

FLASH PACK A term given to the electronic box that generates the power required to fire a flash tube in studio lighting. Sometimes called a power pack. It can also control the light output variably.

G

GOBO A metal disk with different patterns stamped out of it. When used in an ellipsoid spot it will project a pattern into the set. Often used to produce a pattern on backgrounds.

GRADATION The tonal contrast range of an image termed as soft, normal, or contrasty.

GRAY CARD A card used as a standard subject to measure light with a reflected light meter. It reflects 18% of light striking it and represents the midtone in a subject.

GUIDE NUMBER Measurement of light output used to designate the power output of a flash unit. If the guide number is divided by the distance in feet or meters from camera to subject, it gives the aperture setting for a given film speed.

H

HIGH KEY A photograph that contains large areas of light tones, with few midtones and shadows.

HIGHLIGHTS The brightest areas of the subject and of the photographic image.

HONEYCOMB SNOOT A black grid placed in front of a light to control the angle of the light spread to produce a beam of light. Looks like a honeycomb and comes in various degrees of angle.

HOT SHOE The fitting on a camera body used to attach a flashgun or flash trigger. It contains the electrical contacts necessary to fire the flash unit.

I

INCIDENT LIGHT READING The measurement of light falling onto the subject. The light meter is placed close to the subject, pointing at the light source.

ISO (International Standards Organization) Film speed rating, currently internationally accepted. The figures are identical to the ASA standard.

J

JOULE Unit used to quantify the light output of electronic flash. One joule is equal to one watt-second. The unit can be used to compare the flash output of different flash units.

K

KELVIN (K) The standard unit of thermodynamic temperature. Kelvins are used to measure the color quality or balance of light sources that can vary between 2,000 K and 10,000 K, and above.

KEY LIGHT The main light source. It controls the tonal value of the main area of the subject.

L

LCD (Liquid Crystal Diode) Solid-state display used to show information on a camera or other piece of electronic equipment.

LENS SHADE An attachment, also known as a lens hood, that helps reduce lens flare. It fits to the front end of a lens.

LIGHTBOX Translucent surface illuminated from behind giving even, soft light.

LINEAR STRIP LIGHT A light consisting of a straight flash tube, usually 12in (30cm) long, producing an even spread of light. When used with barndoors it produces narrow strips of light.

LUX Unit of measurement of illuminance.

M

MACRO PHOTOGRAPHY Photography that produces an image equal to, or larger than, the life-size of an original subject.

MIDTONE An average level of brightness halfway between the brightest and darkest areas of the subject, equivalent to a reflectance of 18%. See also Gray Card.

MODELING LAMP A continuous lamp positioned alongside the flash tube in a light that is used to show what effect the flash will have in the lighting setup. Modeling lamps are usually tungsten bulbs: they are lower wattage than the flash and do not interfere with the exposure.

MONOBLOC FLASHLIGHT Self-contained flash head that contains the flash generator, control electronics, and flash tube in one unit, therefore requiring no remote pack.

N

NEUTRAL DENSITY FILTER A gray filter that reduces exposure without affecting the color. Usually placed in front of the lens, but also available in sheet form to place over lights to reduce light output.

O

OVEREXPOSURE The expression used when an image has been exposed with excessive light.

P

PHOTO FLOOD A tungsten continuous light source. The color temperature can be balanced to 3,200–3,400 K, producing a warmer color balance than daylight, which is around 5,500 K.

POLARIZATION The action of reducing the random waves of light to a single plane.

POLARIZING FILTER A filter used to polarize the light entering a lens. Often used to reduce reflections in nonmetallic surfaces.

POLYBOARD Term used for a white reflector board, usually made from polystyrene or a foam core board.

Q

QUARTZ HALOGEN LAMP A continuous light source, often used as flash head modeling lights. Its color balance is around 3,400 K.

R

REFLECTED LIGHT READING Exposure measurement taken directly from the subject, measuring the light reflected from it. The usual method in through-the-lens (TTL) cameras.

REFLECTOR A sheet of reflective material, usually white, silver, or gold, used to reflect light into the subject. Also, the light-shaper placed on the lamp head to control light spread and quality.

RING FLASH A circular flash tube that attaches to the lens, encircling it, to produce a virtually shadowless light.

S

SCRIM A mesh-type material placed in front of a light to reduce its intensity. Also diffuses the light. One standard thickness will reduce the light intensity by about one f-stop.

SHADOW DETAIL Detail retained in the darkest part of the image. Will set the lower limit of the exposure.

SNOOT A tapered black cone that fits in front of a lamp to concentrate the light into a circle.

SOFTBOX A commercially made light-shaper consisting of four reflective sides and a white translucent front. Usually square, but can be round. Fits in front of a light head. Produces an even, soft, pure white light. Often known as a "swimming pool" or "fish fryer" in studio jargon.

STRIP-LIGHT SOFTBOX Light shaper similar to a softbox, but long and narrow, producing an even, diffused strip of light. Useful for shooting glassware.

SPOTLIGHT A lamp producing a narrow beam of light, often controllable with the use of an adjustable integral lens.

STROBE A rapidly repeating flash unit. Short for stroboscopic. Also used as a studio term for flashlight.

T

TIME EXPOSURE An exposure of several seconds or more. Usually used in low-light situations or to capture movement.

TUNGSTEN HALOGEN LAMP Efficient tungsten lamp consisting of a filament surrounded by halogen gas, contained in a glass tube. Usually color-balanced to 3,400 K.

TUNGSTEN LIGHT The basic continuous light source used in photography. Balanced at 3,200–3,400 K.

U

UMBRELLA Commonly used light-shaper, similar to a rain umbrella, but translucent and white. Produces a soft light when the light is punched through it. Can also be used to bounce light off depending on the material it is made from. Also availalbe in a silver or gold reflector finish. The gold produces a warm light, often used for portraits.

V

VIEWPOINT The camera position.

W

WATT-SECOND A measurement of energy, often used to express light output. Equivalent to one joule.

Index

About the Author

Calvey Taylor-Haw has been a successful advertising and still-life photographer for more than 30 years. Born in 1957, he came from an artistic family, and was surrounded by paints, canvas, and cameras from an early age. His father was a fine-art lecturer and painter; his mother was a graphic designer and children's book illustrator. At the age of 16, Calvey was offered a job as a studio assistant in a well-known advertising studio in Brighton, England. He had to decide between taking this route and serving an apprenticeship in a working studio, or gaining a formal photographic qualification at an art college. He chose the former, and strongly believes that there is nothing better than hands-on, front-line experience. He gained business acumen and first-hand experience in the fast lane and is proud of the fact that he is almost entirely self-taught. In just three years, Calvey had risen to become studio manager. He was then offered a job in the Middle East as a Unit Stills cameraman in a documentary film company, which appealed to his desire for travel. He jumped at the chance, and at the age of 20 he set off to the land of camels and sand to document the oil pipeline construction for Exxon Mobil and other infrastructure projects throughout the region. Calvey also gained extensive knowledge of 16mm film and sound during this exciting period.

He returned to the UK in the early 1980s and set up his first studio in Brighton. He has been lucky enough to remain in Brighton, where he has carved out a successful career and an enviable reputation as a professional photographer. He has worked for many international clients, including L'Oréal Golden, Unilever, Pilkington, Yves Saint Laurent, and many more. In recent years he has concentrated his efforts into illustrating books. He now has more than 30 cookery books to his name and has worked on many other titles, ranging from lifestyle and health to dogs and cats. Calvey now shoots entirely in digital, having embraced the new technology. However, he is keen to set up his own darkroom again and show his young son Sebastian the joys of how photography used to be! A project for his retirement years, no doubt.

ACKNOWLEDGMENTS

I would like to thank all the kind people who have given me encouragement during the writing of this book. To Tony Seddon and Jane Waterhouse for their guidance and great design work, but a special thank-you to Lindy Dunlop for handling all the stress and agony she has endured in the process of working with me. Sorry Lindy! Peter Richardson for being my longest-surviving client, and lastly my wife Michaela, and my children, Amber, Hebe, and Sebastian, for putting up with Dad while he wrote this book.